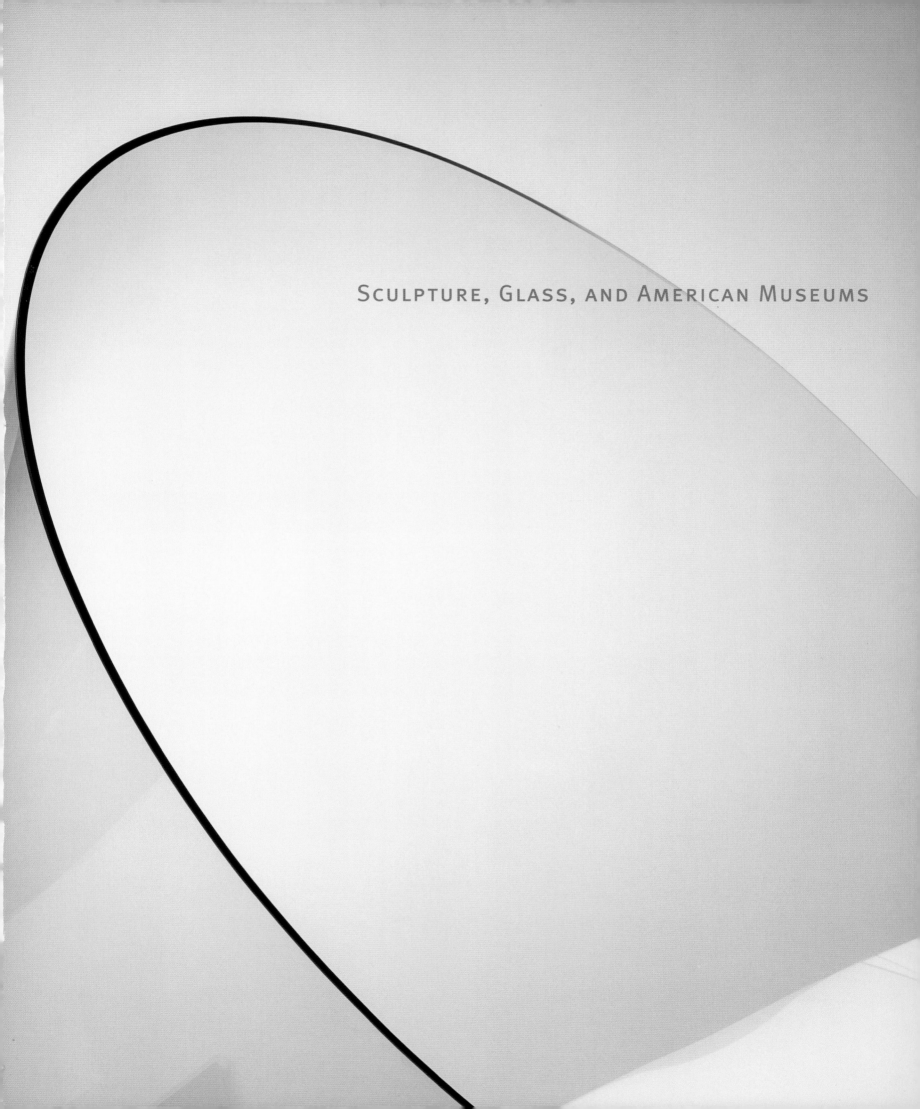

SCULPTURE, GLASS, AND AMERICAN MUSEUMS

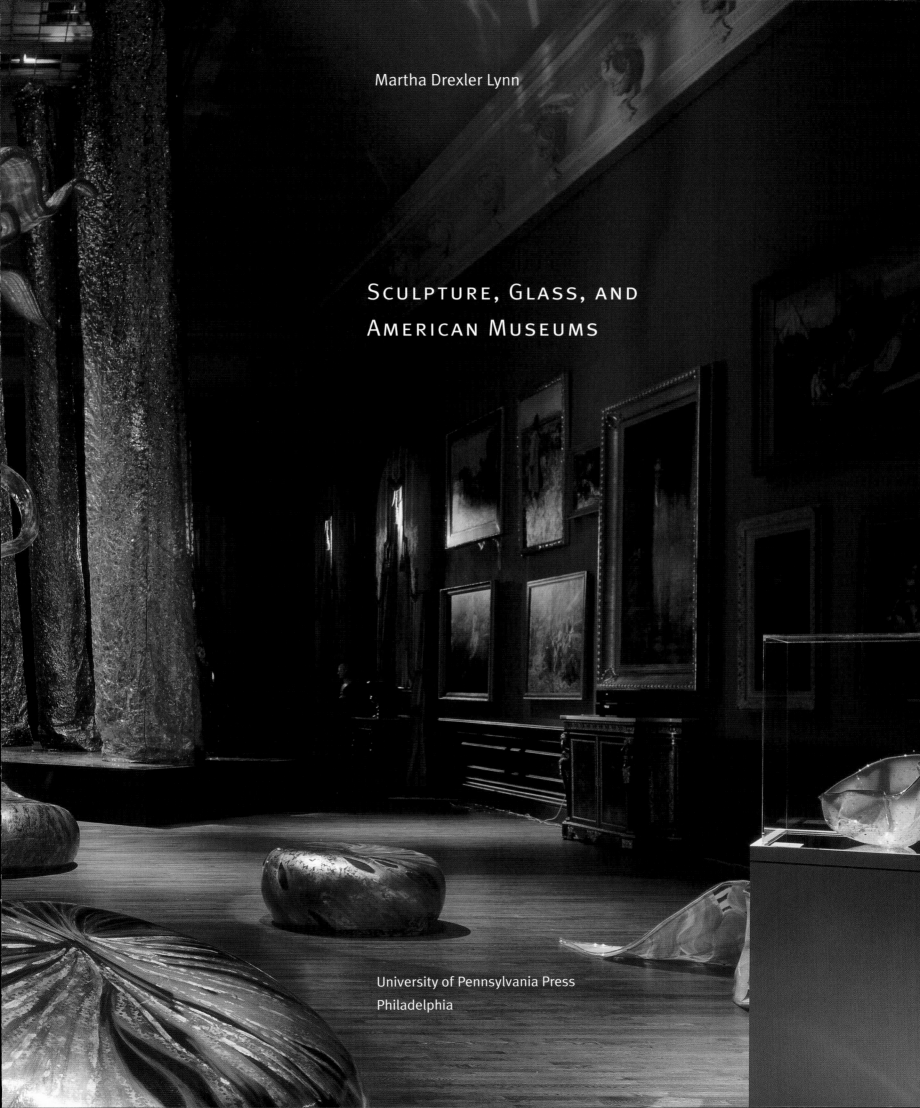

Martha Drexler Lynn

Sculpture, Glass, and American Museums

University of Pennsylvania Press
Philadelphia

Published by
University of Pennsylvania Press
Philadelphia, PA 19104
www.upenn.edu/pennpress

This publication was commissioned by the Art Alliance for
Contemporary Glass.

Library of Congress Cataloging-in-Publication Data
Lynn, Martha Drexler.
 Sculpture, glass, and American museums / Martha Drexler Lynn.
 p. cm.
 Includes index.
 ISBN 0-8122-3896-6 (hardcover : alk. paper)
 1. Glass sculpture—20th century. 2. Glass sculpture—Collectors
and collecting—United States. I. Title.
NB1270.G4L96 2005
748'.09'045—dc22 2005011654

Frontispiece: Installation of Dale Chihuly's work at the Renwick Gallery,
Washington, D.C., April 13–May 10, 1994

Edited by Frances Bowles
Designed by John Hubbard
Separations by iocolor, Seattle
Produced by Marquand Books, Inc., Seattle
 www.marquand.com
Printed and bound in China by C&C Offset Printing Co., Ltd.

ACKNOWLEDGMENTS

A warm and enduring thank you goes to Doug Anderson, who helped conceive this project and bring it to fruition through all of the twists and turns that are inevitable in any multiyear task. He could not have been easier to work with and he gave aid, most graciously, when asked. I also want to thank the Art Alliance for Contemporary Glass (AACG) for funding this project and having the foresight to see its importance.

For each museum profile, numerous people provided assistance and information: at The Chrysler Museum of Art, Gary Baker and Sara Beth Walsh; at Cincinnati Art Museum, Nancy Wolf, Julie Aronson, Anita Ellis, Amy Dehan, and Scott Hisey; at Cleveland Museum of Art, Monica Wolf and Carol Ciulla; at The Corning Museum of Glass, David Whitehouse, Tina Oldknow, Jill Thomas-Clark, and Beth Hylen; at The Detroit Institute of Arts, Rebecca R. Hart; at The de Young Memorial Museum, Timothy Anglin Burgard, Sue Grinols, and Wendy Morris; at The High Museum, Stephen Harrison, Wendy Castenell, and Melody Hanlon; at The Indianapolis Museum of Art, Anthony Hirschel, Barry Shifman, and Ruth V. Roberts; at The Los Angeles County Museum of Art, Howard Fox, Wendy Kaplan, Martin Chapman, Cheryle Robertson, Giselle Arteaga-Johnson, and Shulya Coyl; at The Metropolitan Museum of Art, Jane Adlin and Deanna Cross; at The Milwaukee Art Museum, Glenn Adamson and Leigh Albritton; at The Mint Museum of Craft and Design, Mark Leach, Melissa G. Post, and Kristen S. Watts; at The Museum of Arts and Design, New York, Holly Hotchner and David Revere McFadden; at The Museum of Fine Arts, Boston, Malcolm Rogers, Gerry Ward, Tracey Brainey, Kelly L'Ecuyer, and Lizabeth Dion; at the Museum of Fine Arts, Houston, Cindi Strauss and Marty Stein; at The Norton Museum of Art, West Palm Beach, Christina Orr-Cahall, Jennifer L. Gray, Mark Rosenthal, Roger Ward, and Lisa Heard; at The Oakland Museum of California, Suzanne Baizerman and Bill Morris; at The Racine Art Museum: Bruce Pepich and Davira Taragin; at The Renwick Gallery, The Smithsonian Institution, American Art Museum, Robyn Kennedy, Marguerite Hergesheimer, and Riche Sorensen; at The Seattle Art Museum, Tara Reddy and Scott Nacke; at The Speed Art Museum, Peter Morrin, Scott Erbes, and Lisa Parrott Rolfe; at Tacoma Art Museum, Jacqueline Kosak; at The Tampa Museum of Art, Emily Kass, Elaine D. Gustafson, and Rebecca Sexton Larson; and at The Toledo Museum of Art, Donald Bacigalupi, Jutta-Annette Page, Patricia Whitesides, Nicole Rivette, and Jordan Rundgren.

Additional thanks go to Holle Simmons at William Morris Studio, Ken Clark at Chihuly Studio, Marilyn Holtz Patti at Tom Patti Studio, George Saxe, Jon Shirley, Bruce Bachmann, Mona Mayer, Franklin Silverstone of the Brofmann Collection, Audrey Mann and Joan Barnett, Margareta von Bartha, David Harp, Adele and Leonard Leight, Timothy Hursley, Linda Achard, Marvin Lipofsky, Dena Rigby at Preston Singletary Glass, and Dr. Paul and Mrs. Elmerina Parkman.

I also want to thank Ed Marquand of Marquand Books, in Seattle, for pushing for the project from the beginning and Jo Joslyn of the University of Pennsylvania for her understanding of its potential. I thank John Hubbard at Marquand Books for making it beautiful and Frances Bowles, editor par excellence, for her deft and informed touch in editing it into fine shape. For the critical early work on the project, I want to thank Ruth Roberts and Grant Rusk, who did fine professional jobs with high spirits and generosity. Part of the framing essay was delivered as a lecture at the 2004 Glass Art Society Conference in New Orleans.

—Martha Drexler Lynn

In 1992, under Hilbert Sosin's leadership, the Art Alliance for Contemporary Glass (AACG) began offering grants to encourage critical writing about sculpture made from glass and to support the publication of museum catalogues. Since then, more than fifty such grants have been made.

In 2001, Joan Baxt, then the president of the Art Alliance, convened a meeting that led to the creation of this book. Dale Anderson, Ann and Bruce Bachmann, Stan Epstein, Jane and George Kaiser, Colleen Kotelly, and Nancy Kotler have been wise and supportive. Special thanks go to John Kotelly and Henry Wasserstein for their generosity as attorneys and to Phil Kotler for his publishing savvy.

Having worked with Tina Oldknow on her book *Pilchuck: A Glass School* and with Bill Warmus on his book for the Norton Museum, *Fire & Form: The Art of Contemporary Glass,* I was asked to be the liaison between the AACG and Martha and the people at Marquand Books. They are wonderful professionals and it has been a pleasure.

Dale Chihuly, Marvin Lipofsky, Flora Mace and Joey Kirkpatrick, William Morris, Paul Stankard, and Toots Zynsky saw the value of this project and supported it with exquisite works of art. Bruce Bachmann, the AACG's current president, skillfully converted those gifts into the necessary funds to support this project.

This book is a tribute to each member of the AACG, past and present.

—Doug Anderson
October 2004

Sculpture, Glass,
AND AMERICAN MUSEUMS

Over the past twenty years, glass sculpture has entered American museum collections in unprecedented numbers. A new phenomenon, this reflects new attitudes: an understanding that art making occurs in every medium and a willingness to see glass as an art medium suitable for inclusion in museum collections. This also signals the confluence of focused collecting and promotion by donors, the increased artistic sophistication of the artists working in glass, and the active encouragement of curators and directors. Additionally, it marks the decline in barriers that critics have erected against the acceptance of glass as art. The focus of this book is an exploration of the intertwining nature of these realities, the changes that occurred in the high art world, what it was that brought the necessary forces together in the collecting and institutional worlds, and how these shifts are manifest in museum collections.

Objectively, it is acknowledged that glass, like other media, can express any content desired by the artist, whether subtle or epic. However, because manufactured glass has its roots in the factory, glass as an art medium was incomprehensible to some. This reflected the prevailing modernist dictum that controlled what was considered art. Glass also suffered from another barrier: it was intrinsically beautiful. With its lingering associations with functionality a persistent liability and with its compelling beauty a detraction for some, glass sculpture was barred from the contemporary art world.

The appeal of glass could not, however, be ignored. Adventurous artists, collectors, and gallery owners (peppered with a few curators) formed a community that appreciated these exact qualities. For them, the optical and tactile seduction, the play of light, the intense color, and (in some pieces) the shiny surfaces found in glass were dazzling and compelling. Glass sculpture had an additional lure: it contained a potential for expressing what was described by Donald Kuspit as "a sense of the ineffable—its subtlety as a medium has to do with the fact that it conveys the sense of effortless seeing-through, while also implying that what we see through it is essentialized, while continuing to exist in an ordinary way."[1]

Even with all of these attributes, glass sculpture continued to be viewed with suspicion. Yet it did enter the collections of important American museums (the watchdogs

František Vizner
Czech, b. 1936

Coupe Form—Blue, 1992
Cast glass, cut and polished
4 × 11¼ in. in diameter
Indianapolis Museum of Art, IMA 2000.442
Partial and promised gift of Marilyn and Eugene Glick

Vizner's work centers on the vessel form and, while the pieces are clearly utility referent, they are not utilitarian. Their strength comes from the artist's presenting the seductive beauty of glass, with its engaging ability to glow from within. Vizner's works are objects for contemplation.

of artistic legitimacy) and has been placed there in context with other art masterpieces. This fact is of interest because the arc of the acceptance of glass sculpture parallels and reveals profound changes in the understanding of what constitutes art. It also is symptomatic of the modernist era as it yielded to a postmodern sensibility. The reconceptualization of what belongs in the permanent collections of leading American museums brought these two elements together.

In order to appreciate the significance of this change, the constructed nature of what defines *art* needs examination. A central reality of the high art world is that it adheres to a select list of appropriate media for art making that is presumed absolute but is, in fact, fluid, and was constructed by an elite group that controlled the discourse for political reasons and cloaked it in language that claimed inherent virtue for favored art expressions.[2] Generally, the definition of *art* rested on pre-scribed media, with attendant subject guidelines. At the top of the list of media was paint on canvas, then, in descending order, stone, and metal (sculpture); for subject matter it was religious paintings, history scenes, portraits, and landscapes, with genre scenes at the lowest level. Instituted by academies of art to control the power of artistic expression, this hierarchy became the guide for assessing artistic importance until the twentieth century.[3] Over time, however, it became outmoded, and by the first third of the twentieth century the list had evolved, showing a heartening flexibility by admitting the so-called new media of film and photography, among others. This evolution has continued apace since World War II and indicates a willingness to open up the definition of art, an effect of the new understanding that art resides, not in the medium of its execution, but in the success of the work. This change benefited glass sculpture.

Glass Sculpture in Context

Public institutions of collecting (that is, museums) are an integral part of the art-world complex. They are the end point sought by most practitioners and they work handily with the intermediary players, the gallery owners and collectors. Acting through curatorial staff and museum directors (and sometimes through activist boards of directors),

museums select and display works of art deemed worthy of honor in perpetuity. These judgments place the museums in the role of ultimate validator of cultural and aesthetic taste for the public. Because museums are mandated to display and educate using their collections, the simple inclusion of a class of artwork in a gallery display indicates that it is deemed to be art. This classification is reiterated and endorsed in acquisition policies and is manifest to the public through museum display practices. The discussion below will illuminate the mechanics of these processes and will clarify how glass sculpture conforms to established museum requirements.

First, the emergence of what constitutes modern art needs to be examined. As mentioned, the term *modern art* is not an immutable definition that reflects an agreed-upon canon of valued artifacts. For American art during the twentieth century, the leaders in defining the categories of art worthy of collecting were the Museum of Modern Art (MOMA) in New York and its founding director, Alfred H. Barr Jr. As the head of the first American museum devoted to modern art, Barr played a critical role in establishing what modern art was and in guiding the ways in which that art should be looked at, valued, and understood.[4]

Seeking to tell the story of how modernism had triumphed over past artistic expressions and how it reflected what was modern and new about the twentieth century, Barr divided the museum into seven sovereign curatorial departments: painting, sculpture, drawing and prints, architecture, design, film, and photography.[5] This implied that these were the only areas worthy of examination, either because they had intrinsic merit or because they embodied Barr's definition of modernism. Within these, Barr selected classic works, a selection that privileged painting over sculpture, abstraction over figurative works, and design (mass production) over handmade (one-of-a-kind) pieces.[6] He schematized his history of modern art in a diagram reproduced as the cover illustration for the exhibition catalogue, *Cubism and Abstract Art* (1936; p. 11).

Attempting to rationalize and present a story of seamless fluidity, Barr glossed over or failed to recognize movements and artistic expression that did not fit his vision. He argued that his selections were the

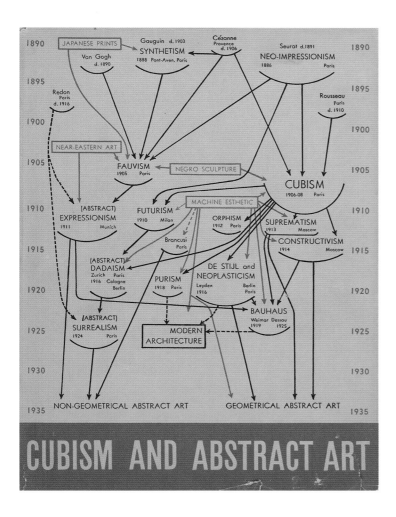

Alfred H. Barr
American (1902–1981)
Cover of the exhibition catalogue for *Cubism and Abstract Art* (1936), Museum of Modern Art, New York
Offset, printed in color
7¾ × 10¼ in.
The Museum of Modern Art, New York, MA 143

This is the cover of the catalogue for the exhibition *Cubism and Abstract Art,* curated in 1936 by Alfred H. Barr Jr., the director of the museum. In this important document, Barr presented a schema for understanding the development of modern art. This version of the "story of twentieth-century art" became the reigning orthodoxy accepted by art historians and museum professionals for decades.

most appropriate manifestations of modernism, good taste, and the embodiment of high culture. Equally important was their presumed superiority in addressing contemporary concerns through avant-garde innovations.[7] In this constructed art world, for example, the regional and figurative artist Thomas Hart Benton was passé, but his student Jackson Pollock, an abstract expressionist (see pp. 12 and 13), was a star. Implicit in these selections was a stipulation about appropriate media. In the world according to Barr, the best medium was paint on canvas, followed by sculpture made of traditional materials. Film and plastic were acceptable; wood, glass, and clay were suspect and considered only if they were connected to mass production (which he designated as design) and were not used for unique artworks (which he dismissed as crafts). Because of the museum's preeminence (resulting in part from its geographical and social location in New York) and its assertiveness in making theoretical claims, MOMA set the standard for the next forty years in many contemporary art departments within large and small museums across the country.

Not until the last quarter of the twentieth century did Barr's classifications and their manifest boundaries begin to break down, as did MOMA's centrality. This was the result of two key changes emanating from the high art community and, as it pertains to glass sculpture, one shift in the glass world itself. First, modernism gave way to postmodernism, in which many of the modernist tenets of universality were questioned, as was its insistence on the positive progression of history. Second, within the high art world, a new art history came to the fore, one that turned from the narrow focus on western European art and addressed itself to cultural and artistic production from around the world. As a result of this reassessment of the discipline, it became clear, for example, that rules that had governed the assessment of European Renaissance artwork (as suggested by the German art historian Heinrich Wöfflin in 1952) were not appropriate for the examination of, for instance, non-Western, often ritually linked and culturally coded African artifacts.[8] A new set of tools was necessary. It became clear that postmodernism and its partner multiculturalism were more appropriate for describing worldwide art in the late twentieth century.

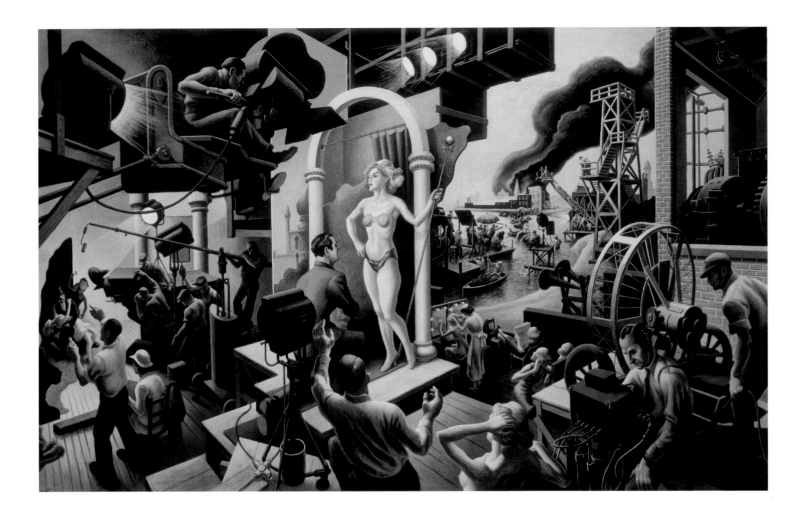

Thomas Hart Benton
American, 1889–1975

Hollywood, 1937
Tempera with oil on canvas mounted on panel
56 × 84 in.
Nelson-Atkins Museum of Art, Kansas City, Mo., F75-21 / 12
Bequest of the artist

A regionalist painter, Benton favored figuration over abstraction.
His student Jackson Pollock rejected figuration and subsequently
became the leader of the American abstract expressionists.

And, as the assumption that one set of criteria is appropriate for all
receded, modernism itself was re-evaluated and demoted from its posi-
tion as the only point of view to just one of several.

Most importantly for art and glass sculpture, a different under-
standing became apparent, an understanding that art is the product
of art practice and is not confined to a set of delimited media. With
art making understood as an artist-centered practice that relied on
the actions and talents of the artist, the potential value of the artwork
ceased to be dependent on or defined by the medium of fabrication.
This broadening of acceptable art-making practice and the expansion of
materials deemed appropriate for art making contributed to the passing
of the hegemony of the modernist age. As art ceased to be defined in
terms of the material used, glass sculpture could attain parity with the
long-accepted media of paint, canvas, metal, and stone.

The Western modernist canon also deemed anything hinting at
utility or skilled craftsmanship less worthy. Such elements were valued
by other cultures and, as the canon of art was broadened, the formal,
symbolic use of utilitarian items such as vessels and chairs was seen
as having artistic potential. In fact, soon such objects moved beyond
their initial functional associations to embody the abstract concepts of

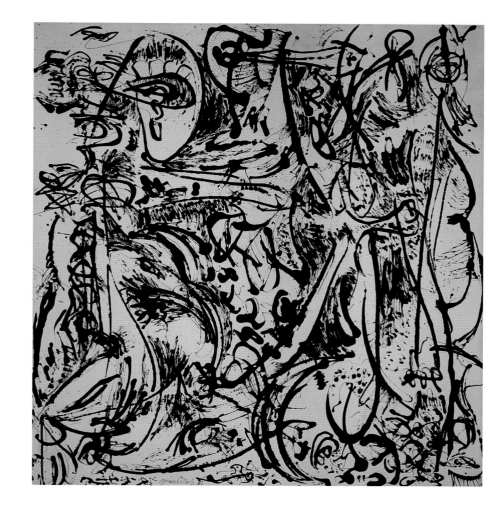

Jackson Pollock
American, 1912–1956

Echo (Number 25, 1951), 1951
Enamel on unprimed canvas
97⅞ × 86 in.
Museum of Modern Art, New York, 241–1969
Acquired through the Lillie P. Bliss Bequest and the Mr. and
Mrs. David Rockefeller Fund

From Jackson Pollock's classic period, this painting illustrates
the lightness and beauty he could achieve by pouring, dripping,
blotting, and sprinkling paint onto canvas. Works from this period
have been described as expressions of the sublime as it was
interpreted by philosophers of aesthetics in the late eighteenth
and early nineteenth centuries.

Hans Hofmann
American, b. Germany, 1880–1966

Radiant Space, 1955
Oil on canvas
60 × 48 in.
Indianapolis Museum of Art, IMA 1996.247
Kathryn A. Simmons Contemporary Art Fund, 1945–present,
Alliance Income Fund, Mr. and Mrs. Richard Crane Fund, James E.
Roberts Fund, Dan and Lori Efroymson Fund, Martha Delzell
Memorial Fund, William Dyer Bequest Fund, Roger G. Wolcott
Fund, Now and Future Purchase Fund, Joseph Cantor Collection,
and the Robert and Trude Hensel Collection by exchange

An early advocate for abstraction in the 1930s, Hofmann preferred
passages of intense color and strong, nonrepresentative shapes.
His work and teaching influenced many students.

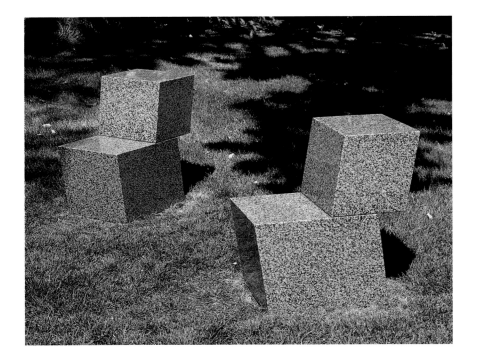

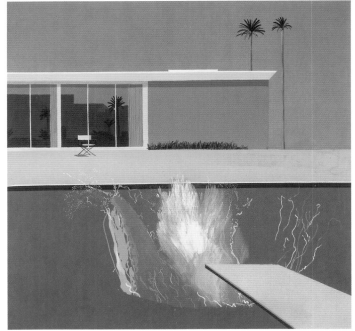

Scott Burton
American, 1939–1989

Pair of Parallelogram Chairs, 1987
Granite
40 × 23 × 26 in. each
Toledo Museum of Art, Toledo, Ohio, 2003.50
Gift of Georgia and David K. Welles

One hallmark of the late twentieth century is the acceptance of new media for art making. Additionally, new subject matter was explored. As a result, works such as Burton's *Pair of Parallelogram Chairs* actively explored the aspects that signify a chair both in form and content.

David Hockney
British, b. 1937

A Bigger Splash, 1967
Acrylic on canvas
96 × 96 in.
Tate Gallery, London

David Hockney intentionally presents an idyllic, sun-drenched scene that leaves only the rustle of water to suggest the transience of the human presence. Through his use of crisp colors and simplified forms, which attest to an oddly vacant life, Hockney confronts the alienation of contemporary existence.

containment and chair-ness. In this way, traditional form was assumed to have a content greater than its formal language or historical antecedents could confer. An understanding of this duality is seen in the work of the sculptor Scott Burton, who used chairlike forms to explore sculptural issues, and David Hockney, who placed garden furniture in his paintings as markers for people (above, left and right). For glass sculpture, this is manifest in works by Howard Ben Tré (p. 15), where he explores issues of time and monumentality through overscaled, utility-referent forms. As both material and forms long associated with utility became appropriate for conveying content, the queasiness initially expressed by public institutions at embracing them receded and works in unsanctified media entered the desirable pantheon of the art museum.

Of additional importance to glass sculpture of the period was the increased production of high-quality sculptural glass that began to appear in the 1980s. Glass can be challenging to work and specific knowledge is required to formulate and fabricate it. As practical issues were resolved, the formal vocabulary available to artists made it easier for them to communicate whatever content they desired.[9] With fewer limits on formal vocabulary and content, artists working with glass could explore the entire range of sculptural concerns. Glass was now poised to be placed alongside masterpiece paintings and other sanctioned artistic expressions within American museums.

The Task of Sculpture

The task of sculpture is governed by unique rules. Paintings present a fixed image and are essentially static; sculpture must actively inhabit space. To do this, sculpture evinces relationships and tensions expressed with solids, void, envelopes, silhouettes, layers, interiors vis-à-vis exteriors, and assembled elements. Unlike painting, which creates the illusion of three-dimensionality, sculpture is inherently three-dimensional. The demands on the viewer are also different. As part of seeing and comprehending sculpture, the viewer is required to move around the work. And this requirement, because of the spatial reality of the forms, necessitates real-time, time-elapsed interaction if the viewer is to grasp the meaning of the work. Sculpture cannot be taken in with a single glance. It must be engaged with for a period of time if one is to comprehend its totality. The power of the sculpture is felt only as the viewer moves, the action of the viewer relates to the inactivity of the

Howard Ben Tré
American, b. 1949

Pilaster #8, from the *Pilaster* series, 1983
Cast white glass with patinated copper inclusions
30½ × 10½ × 5½ in.
Indianapolis Museum of Art, IMA 1991.226
Gift from the collection of Marilyn and Eugene Glick

Both figurative and architectural, Ben Tré's *Pilaster #8* looks as
if it had been fabricated with ancient tools and survived from
prehistoric times. The work addresses power and timelessness
through totemic forms.

artwork to create a dynamic connection between motion and stillness.[10] For a sculpture to communicate successfully, there must be a unity of time and space in its component parts.

All sculpture, notwithstanding medium, has the power to embody ideas and to elicit emotional and intellectual response. Sculptural language, like all artistic communication, is coherent and intelligible only if it addresses itself to underlying conditions of experience. Sculpture, however, has potentially a greater array of visual and intellectual data to display. When placed beside pictorial renderings, "sculpture dramatizes a conflict between the poverty of information contained in the single view of the object and the totality of vision that is basic to any serious claim to 'know' [a work]."[11] It can be asserted that sculpture offers a richer intellectual and aesthetic experience than can be found in its more prized cousin, painting.

Interestingly, neither art history nor its institutional face, the art museum, has been comfortable with sculpture. Consequently, less has been written about sculpture and fewer works are on display. The reasons for this are unclear: perhaps because sculpture is dependent on architecture for validity; perhaps because it takes more room if it is to be displayed and engaged with; perhaps because it does not sit safely out of the way on the wall; or perhaps because it persists in presenting lifelike forms that seem uncomfortably close to animate beings. The fact remains that sculpture commands less scholarly and curatorial attention. Theorists and critics have focused most of their attention on painting, and although significant treatises on sculpture exist, the darling of the establishment art history complex is overwhelmingly two-dimensional and illusionistic flat art. Consequently, there are fewer pieces of sculpture in contemporary museum collections.

Glass sculpture, as a category of sculpture, suffers from this reality. This is ironic because many museums (among them the Metropolitan Museum of Art in New York and the Museum of Fine Arts in Boston) were founded in the nineteenth century as repositories of three-dimensional plaster replica casts of classical sculptural masterpieces that embodied the classical idea of beauty and were displayed to aid the study of ancient sculpture. It was only in the twentieth century that painting took

over as the preferred art format in museums and displaced sculpture as the venerated modality. In addition to sharing the second-class status of sculpture in general, sculpture made of glass displays characteristics unique to the medium that have diminished its standing. Glass in its most familiar form is transparent. This can confuse perception of form and hinder the reading of a work. Also, glass often has a glittering shine and, as noted, this has stood in the way of its being taken seriously as a sculptural medium. This prejudice stems, in part, from the historical use of glass as a substitute for precious stones. The use of one material to imitate another was an offence to modernism's dictum about truth to materials, which equated imitation with fakery. Additionally, glass is made of widely available and inexpensive materials, silica (sand) and alkali (potash or soda), enlivened with colors from oxides. By far the largest liability for glass was, however, its powerful visual impact. This aspect, otherwise known as beauty (and discussed below), served to relegate glass to a lower rung on the art ladder, because beauty was not an acceptable modernist goal for art.

Interestingly, although the versatility of glass proved disquieting for curators and critics steeped in modernist sensibilities, artists (and collectors) have found this attribute a reason to select glass. Often it was these artists who opened the door for glass sculpture to enter museum collections. Lynda Benglis and Larry Bell both found glass and glasslike materials intriguing for their ability to modulate and refract light. Inspired by the transmutative qualities of glass and its path from liquid to solid, Benglis produced a series of sand-cast sculptural glass works that featured both the molten state that glass can pass through in forming and its luminosity when subtle tints and metallic inclusions are incorporated (right). Bell used glass sheets to create boxes (p. 17) with which he explored questions about transparency, reflection, and illusion.

The optical intensity of glass may have been denigrated by the modernists and critics, but it won a following with the makers and, eventually, with the collectors, who ensured its entry into museums. Without a doubt, glass sculpture could successfully fulfill the task of sculpture, and more.

Lynda Benglis
American, b. 1941

MI, 1984
Sand-cast and powdered glass, ceramic oxides, metal inclusions
13½ × 17 × 16 in.
Los Angeles County Museum of Art, M.86.273.1
Gift of Daniel Greenberg and Susan Steinhauser
© Lynda Benglis / Licensed by VAGA, New York, N.Y.

In 1984 and 1985 Lynda Benglis was an artist-in-residence at Pilchuck Glass School, where she explored the possibilities of making glass knots from cast glass.

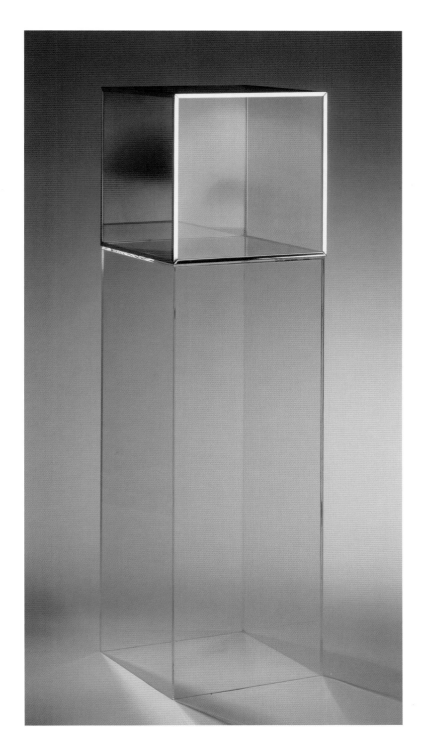

Larry Bell
American, b. 1939

Untitled, 1986
Glass and rhodium-plated brass
14⅛ in. square; Plexiglas base, 36 × 14 × 14 in.
Fine Arts Museums of San Francisco, A358096
Partial gift of Dorothy and George Saxe

The Beauty Factor: Modernist Discomfort and the Postmodern Embrace

> A philosopher can only demand that the beauty be internal,
> and that the connection between it and the meaning of the
> work be accessible through reason.[12]
>
> —ARTHUR C. DANTO

Glass sculpture calls forth a sensual immediacy and complex intelligence that is not essentially verbal or literary. Because the response that glass evokes is partially emotional and cannot be quantified, the medium was viewed with unease by the art-world arbiters. It was the beauty of glass that had caused this unease. Beauty is a slippery concept, intellectually and philosophically, and one that has been either disparaged or ignored by modernists since the early twentieth century. Yet for artists (and collectors), its beauty is a major reason for their being drawn to working with or collecting glass.

Beauty, with connotations of gender, has the reputation for being a snare and is freighted with intimations of forbidden and uncontrollable desires. Typically, artworks are gendered female and the audience is gendered male. Beauty is usually associated with the female form; experiencing it has been equated to an exchange of power between the male viewer and the object of his gaze. Female power unnerves some, and beauty has been cast as a vehicle that holds men unwillingly in its thrall. Those who feared the potency of beauty denigrated it because of the taint of danger and seduction. Interestingly, in the world of art production, as the conventions of what constituted beauty in each era became easier for most artists to achieve, beauty became a cliché and was described as *kitsch.*[13]

Art of the past fifty years was especially lumbered with arcane theory that discouraged the presentation of beauty. Beautiful things were too popular and too unintellectual, incapable of larger content. Within the elite, high art world, for reasons explained below, modernist avant-garde American and European theorists went so far as to vilify beauty and to place any material with visual appeal beyond serious

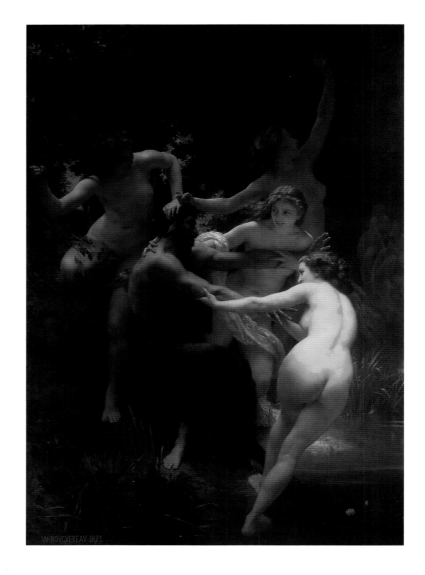

William Bouguereau
French, 1825–1905

Nymphs and Satyr, 1873
Oil on canvas
102⅜ × 70⅞ in.
Sterling and Francine Clark Art Institute, Williamstown, Mass.,
1955.658

By the end of the nineteenth century, painting's veneer of classical subject matter became thin. As with other works of the period, nymphs and satyrs serve as the format for presenting an image that is fashioned to delight its (usually) male viewers. Visually beautiful, the work could be classified as soft pornography if the gloss of classical respectability were removed.

consideration as art. The abstract expressionist painter Barnett Newman proclaimed in 1948 that "the impulse of modern art is the desire to destroy beauty."[14] Artworks continued to be beautiful, but it was unacceptable for an artwork to have that as a primary goal. For sculpture made of the inherently beautiful medium of glass, its beauty was a liability.

This hostility to the reputed power of beauty represents a sharp and intentional break with attitudes of the previous centuries. Beauty was not always seen as a flaw. In the eighteenth century, one of the main tasks of art was to be beautiful, that is, to conform to a generally agreed-upon set of attributes and conventions relating to form and content that was defined as *beautiful.* Controversy raged over how beauty was to be defined and resulted in lengthy tracts, with the arguments often countered by passionate and obscure responses. The debate about the philosophy of aesthetics was joined by scholars, artists, collectors, and connoisseurs. Much of their understanding was based on the study of ancient philosophies, Renaissance texts, and surviving artworks that informed their sense of the correct balance of elements necessary to achieve beauty. They agreed that beauty was informed by taste, honed by a knowledge of proper scale, proportion, and balance, and delivered through expert technical skill. Correct taste guided the selection of subject matter and the degree of verisimilitude permitted in the depiction of people and things, and governed the acceptable content of art.[15]

The history of aesthetics evolved into two opposing positions, each vying for ascendancy: the one that beauty resides solely in the object (it is universal and enduring), the other that it rests with the viewer (it is subjective and mutable). The first position led to a search for universals that favored uniformity over the individual and regional. Differences were homogenized into a seamless blend of ideal attributes. Out of

this desire for uniformity grew a distrust of decoration and pattern; good art must be spare and pared down if it is to reveal the sought-after idealized and universal forms. The vehicle for displaying beauty was often the classical maiden who represented allegorical themes. Aristocratic men commissioned most artworks and, when looking at William Bouguereau's *Nymphs and Satyr* (1873; above), it is easy to assume that the audience for this art was mainly male. Beauty may have been considered a worthy goal for art making, but the subject matter deemed appropriate for investigating beauty was confined, for the most part, to depictions of women (as classical personages) and of nature (as untamed). These subjects remained the dominant manifestations of beauty through the nineteenth century.

The second position on beauty prized a personalized and individual assessment and prevailed in the early nineteenth century with the advent of the Romantic movement. Here the personal, even idiosyncratic or everyday was deemed beautiful (see p. 20, bottom). Because beauty became subject to individual assessment, the label became attached to a wider variety of items. With the definition of beauty expanded and no longer regarded as the sole province of the elite, ordinary people and things came to be seen as having a valid beauty.

Auguste Rodin
French, 1840–1917

Iris, messagère des Dieux
(Iris: Messenger of the gods), 1890–1891
Bronze
19 × 15½ × 9 in.
Musée Rodin, Paris, S.970

Part of Rodin's notorious *Muses* series, *Iris* presents a female figure figuratively and literally centered around her genitalia. Shocking still, this work is an ode to the power of female sexuality, and indicates how a once-taboo subject found acceptance when presented by a leading sculptor.

As Romanticism yielded to realism, taste as previously defined was removed from the aesthetic equation. Subject matter once thought too mundane or too crude to be considered serious enough for art became acceptable and found its way into significant works. By the middle of the century, works such as Gustave Courbet's *Burial at Ornans* (1849; p. 20) appeared. Courbet depicted a country burial scene that included characters drawn from across the classes in an epically scaled work. The size and complexity of this piece mimicked the gravitas that was usually found in works that commemorated battles from antiquity or scenes involving gods and goddesses. Critics bellowed at the debasement of format and subject matter, but the constraints of elite taste were broken.

By the end of the century, as the personal, specific, and intimate experience increasingly became a paramount source of subject matter, the sculptor Auguste Rodin took to rendering his figures in unglamorous but emotionally compelling poses (above). By not reproducing standard renditions of acceptably beautiful forms, Rodin helped to dislodge beauty as a primary goal of art. Clearly, beauty as an end in itself was no longer a valid task for sculpture, and beauty now waited to be recast with a different purpose.

The early twentieth century offered the opportunity. As described by Neal Benezra in an essay in the catalogue for the exhibition *Regarding Beauty,* this shift began in Europe after 1900, largely through the agency of three artists: the painter and sculptor Pablo Picasso, the painter Fernand Léger, and the painter-turned-sculptor Marcel Duchamp. Picasso led the way before World War I using a format (dubbed "cubism") that offered images of women constructed from angular and fractured shapes. Rendered to reveal aspects of the form simultaneously (ironically mimicking the viewing of sculpture), Picasso looked to non-Western ethnographic examples of beauty

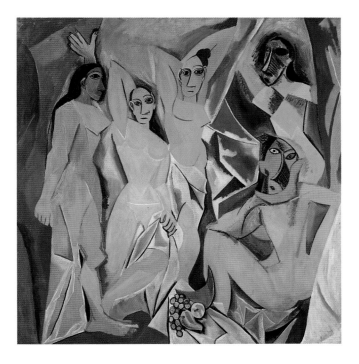

Pablo Picasso
Spanish, 1881–1973

Les Demoiselles d'Avignon, 1907
Oil on canvas
96 × 92 in.
Museum of Modern Art, New York, 333.1939
Acquired through the Lillie P. Bliss Bequest

Renowned as a groundbreaking painting for its striking formal qualities and disturbing subject matter, *Les Demoiselles d'Avignon* began in preliminary sketches with a narrative that included a medical student, a sailor, and five courtesans in a bordello. Picasso edited it down to produce a layered explication of his conflicted response to women. Using compressed space and blunt brush strokes for the sharp faces and forms, Picasso moved beyond the simpler perceptual rendering and created a complex conceptual one.

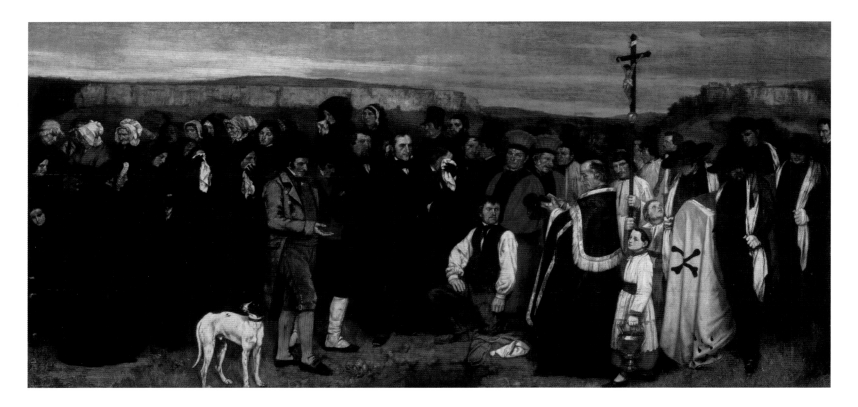

Gustave Courbet
French, 1819–1877

Burial at Ornans, 1849–1850
Oil on canvas
122⅝ × 263 in.
Musée d'Orsay, Paris

The appearance of *A Burial at Ornans* in 1849 marks a shift in the
definition of appropriate subject matter for large-scale oil paint-
ings. Deriving his composition and scale from traditional history
painting, Courbet added the innovation of recognizable, individu-
alized faces. Traditional rules would have required that he cast
all of the attendees in the guise of gods.

Théodore Géricault
French, 1791–1824

The Piper, 1821
Lithograph on paper
19½ × 14¾ in.
Art Institute of Chicago, 1991.228.8
Restricted Gift of Alan Rutenberg; remainder to Committee
on Major Acquisitions

The Piper presents a man playing his bagpipe in an urban street
and accompanied by his small dog. Subject matter centering
on everyday people and situations stood in direct contrast to
the elite depictions seen in history painting and portraits of the
wealthy. This type of genre image was considered suitable for
lithographs, a relatively ephemeral medium, but not for the more
prestigious oil on canvas.

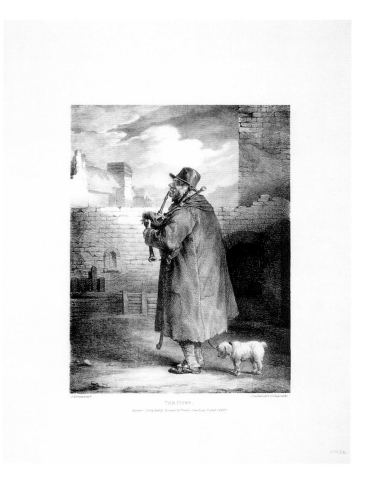

for his models. In his painting *Les Demoiselles d'Avignon* (1907; p. 19), Picasso's new images of women were based on contemporaneous notions about time and space and paired with the abstraction seen in African ritual masks. By choosing norms outside traditional northern European standards of beauty, Picasso displaced the usual personification of beauty as a woman drawn from classical antiquity.

Then Picasso changed sculpture. In his *Guitar* (1912; right), he presented a guitar-shaped object, depicted from multiple angles and fabricated from layers of sheet metal. By shifting both subject matter (the mundane guitar) and the method of fabrication, thereby breaking with the traditions of sculpting that favored carving or modeling marble or clay, he expanded the forming methodologies and subject matter available for sculpture. His use of sheet metal as an art medium made other unconventional media possible.

A few years later as the encompassing destruction, ugliness, and horror of World War I overtook Europe, beauty (however defined) seemed increasingly irrelevant and out of step with the realities of the day. It fell to the Dada movement next to turn beauty on its head. Seeking to protest the war and the horror it brought, the Dadaists, who were in neutral Zurich as refugees from the war, used their artwork to communicate new political and social attitudes. For them, the war revealed the random nature of life and death. Chance, allied more with mathematics than with traditional beauty or philosophy, became an appealing topic for art making. Jean Arp, a founder, examined the concept in his *Arrangement According to the Laws of Chance* (1916; p. 22), in which he arbitrarily pasted casually shaped pieces of paper onto a neutral background. Interestingly, the resulting abstract composition had a simple, uncontrived beauty; gone was the elaborate draughtsmanship favored in nineteenth-century art. An ostensibly scientific interest in the rules of chance had replaced it, and beauty was something to be discovered, not actively created as before. Subject matter, material, and beauty were once again reordered.

Next, Marcel Duchamp, a member of the New York branch of the Dada movement and a disillusioned painter and sculptor, added his avant-garde sensibility to art and the value of beauty. Feeling that

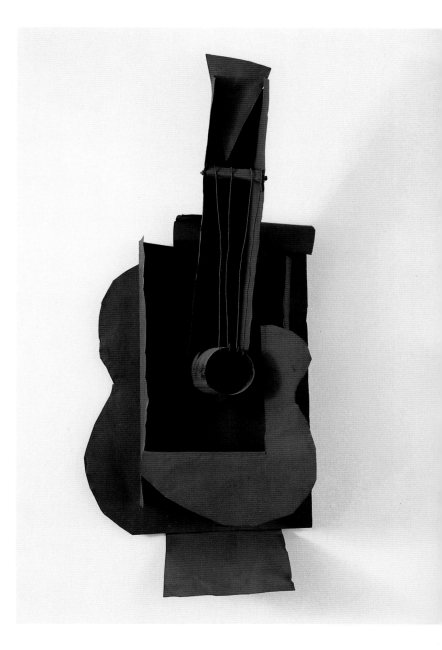

Pablo Picasso
Spanish, 1881–1973

Guitar, 1912–1913
Sheet metal and wire
30½ × 13¾ × 7⅝ in.
Museum of Modern Art, New York, 94.1971
Gift of the artist

In *Guitar*, Picasso redefined the methodology of fabricating sculpture by adding wooden construction to the standard methods of carving and modeling. Here plan and elevation views are seen simultaneously, manifesting the notions about analytical cubism that Picasso had already explored in his paintings.

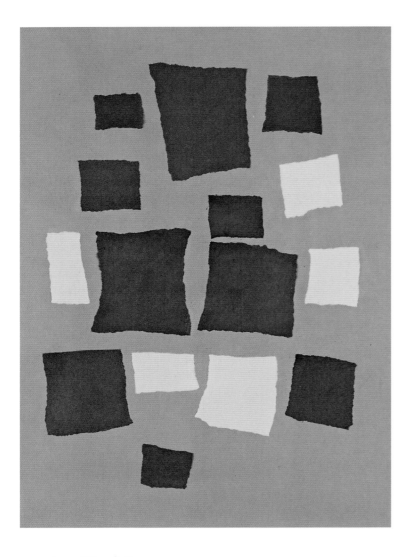

Jean (Hans) Arp
German, 1887–1966

*Arrangement According to the Laws of Chance
(Collage with Squares)*, 1916–1917
Torn and pasted papers, printed papers, and cloth
19⅛ × 13⅝ in.
Museum of Modern Art, New York, 457.1937
Purchase

In this collage, Jean Arp used coincidences to determine
the form of his artwork.

Marcel Duchamp
French, 1887–1968

Fountain, 1917; replica, 1964
Porcelain (unconfirmed), 14³⁄₁₆ × 18⅞ × 24 in.
Tate Gallery, London
Purchased with assistance from the Friends of the Tate
Gallery, 1999

Duchamp felt that beauty as defined in the nineteenth century
was a worn-out artistic strategy. He also renounced the notion
that taste and skill were key to the making of art. Once he had
rejected these restrictions, he realized that anything could be
art. The definitive statement of that realization is his famous
Fountain, with which he transformed sculpture from an exer-
cise for beautiful expression to a public dialogue about what
art could be.

beauty was a symbol of a worn-out artistic nineteenth-century tradition,
Duchamp proceeded to reject aspects of beauty that are pertinent to
glass sculpture. First, he renounced the notions that taste and skill were
necessary for the making of art. Once art is freed from these restric-
tions, he maintained, anything may be considered as art. As an example,
Duchamp offered his famous *Fountain* (1917; p. 23), fashioned from a
urinal. Duchamp placed the sanitary ceramic on a pedestal and embel-
lished it with the crudely written letters "R. Mutt 1917." This appeared
to be the artist's signature; it was, in fact, the name of the ironworks
where the urinal was manufactured. Both the subject matter and the
mass-production aspect of its creation intentionally contravened the
traditional conventions of subject matter and fabrication. Also, by pro-
claiming a mass-produced object to be a work of art, Duchamp under-
cut the imputed value of unique and skilled artistic expression. This
exchanged the artist's once-prized skill in fabrication for an impersonal
mass-production process.

Duchamp also worked directly with glass in his nine-foot by five-
and-a-half-foot freestanding *The Large Glass (The Bride Stripped Bare,
by Her Bachelors, Even)* (1915–1923). Termed a "delay in glass" instead
of a "painting" or a "sculpture," the piece presents a series of images
rendered in dust and oils, among other materials, and sandwiched
between two layers of sheet glass that are now shattered and held in
place by the aluminum support. Delving into the realities of the human
sexual comedy presented in "mechanico-erotic language," this complex
work has for more than seventy years spawned controversy over its
exact meaning and has influenced innumerable artists, especially those
working in glass.[16] Its importance for later sculptural glass is that the

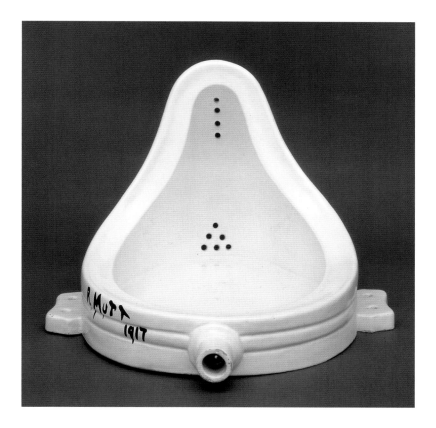

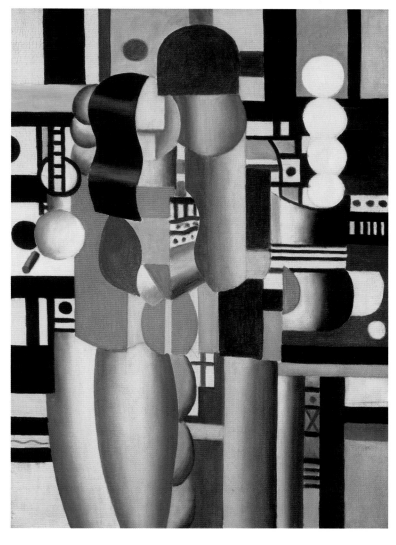

Fernand Léger
French, 1881–1955

Man and Woman, 1921
Oil on canvas
36¼ × 25½ in.
Indianapolis Museum of Art, IMA 52.28
Martha Delzell Memorial Fund

Fernand Léger found inspiration and beauty in the modern sleekness of machines. Conforming to his new definition of beauty, he juxtaposed abstracted blocks of color to create the image of a man and woman kissing.

leading thinker in early twentieth-century art chose the transparency of glass as an integral part of his expression. The irony of its being broken in transit and of Duchamp's refusal to fix it, attests to the inherent fragility of glass as part of the underlying content.

Duchamp continued his assault on traditional artistic conventions by producing a series of what he called "readymades," mundane objects displayed as art and works created from startling combinations of everyday items. By presenting banal items and labeling them art, Duchamp successfully aestheticized unorthodox objects and created a conceptual vocabulary of irreverent ideas associated with them. "Duchamp's ideas were considered exemplary, and his espousal of readymades, chance, and accident has an enormous effect in fostering the widespread reaction against beauty."[17] With this liberation of content, material, and form, beauty as part of artistic practice was further devalued.

One result of the Dadaist rejection of beauty as a goal of art making was that anything associated with traditional beauty became linked to conservatism, both aesthetic and political. The pursuit of traditional beauty became "an ignoble ambition to be shunned at all costs."[18] With this point of view prevalent, the generous beauty that had often inflected eighteenth- and nineteenth-century work was discarded as an artistic strategy.

Fernand Léger then added his own redefined subject matter, fabrication methodology, and aesthetic. Léger looked to the modern sleekness of machines for his definition of beauty. Simplified, abstracted, and visually assembled, his *Man and Woman* (1921; above, right) rejects factual rendering and delivers juxtaposed blocks of color that form an assembled rendering of two figures. The works of Picasso, Duchamp,

and Léger presented new paradigms of what constituted beauty and the subject matter that art could convey. Nevertheless, although beauty was not the focus of the avant-garde, it could not be eradicated; rather it was transformed by the Dadaists, Léger, and Duchamp, who cast themselves as avant-garde thinkers and artists who fancied a more hard-edged beauty. "Modern artwork may have been profoundly beautiful, but [it] was a tough beauty, hedged with deprivation, denial, revolt."[19] The beauty of ugliness was born.

The next development that adversely affected sculpture made of glass was the rise of abstraction as the favored artistic convention. Abstraction (especially that practiced in the United States and Europe through abstract expressionism) built on the geometric abstraction already seen in the work of the Dadaists, Picasso, and Léger. It appeared in the mid-twentieth century and was promoted by Clement Greenberg. In his articles and reviews, Greenberg, an art critic based in New York, championed abstract expressionism (exemplified by Jackson Pollock) in painting over the figurative, representational art of the 1930s and 1940s (exemplified by Thomas Hart Benton) and even prized pure abstraction over the figurative abstraction of painters on the West Coast.[20] The figurative impulse sought to depict recognizable forms: people and things as seen in life. Indicative of a populist sensibility, representational art by the late 1930s seemed to lack the vitality, movement, energy, and kinetic nature necessary to convey the complexity and angst of the time. Abstract expressionists, in contrast, rooted their work in action and process. It was assumed that the subconscious and chance as sources for compelling content would provide more direct connections between the artist, the work, and the audience. This assumption shifted the emphasis to the individual artist (away from the idealized) and to the act of creation. As a result, the art-making process itself vied with the completed art object for primacy, and the artistic moment became the art methodology.[21]

For the artists who reveled in the objecthood of their art (figurative artists and craftsmen), this approach to making and valuing art debased their work and rendered it passé. For Greenberg, the approach produced the art most appropriate for expressing the capitalist world view and particularly America's ascendancy following World War II. Along with disparaging what he referred to as "kitsch"—extraneous forms and decoration—Greenberg preferred his art to be self-referential, with content limited to the actual art material itself and its application methodology: art for art's sake.[22] By talking only about paint on canvas, Greenberg effectively disparaged works made in other media.[23]

Interestingly, unlike Barnett Newman and others of the period, Greenberg did espouse beauty, believing it was best realized in abstract, nonfigurative artwork. For him, beauty was achieved by the supremacy of the formal qualities located on and confined to the surface of paintings. This effectively reduced the creation of beauty to a delimited set of conventions related to the surface of the canvas.

For Greenberg and the painters he favored (Jackson Pollock, Morris Louis, and Helen Frankenthaler, among others), works that expressed themselves provided visual satisfaction and through abstracted forms embodied a truth made more direct for its lack of representation. As part of this approach, work that had connections to the historical past fell from favor. Glass, with its roots as a luxury material since ancient times, was removed from consideration. As for beauty in abstract expressionist paintings, it is interesting to note that Pollock, one of the leading exponents of the movement, featured sumptuously beautiful veils of paint that he built up layer by layer on the surface of the canvas. He achieved this through the unconventional method of dripping paint from a stick and spattering the work with a brush. While not trying to negate beauty, as it seemed to the general public, Pollock created many sensual paintings.

He also liberated artistic practice from the technical limitation of paint applied with brushes. As he transformed the act of painting from brushing to dripping, his seemingly casual and random method chipped away at the value of technical skills and made paint itself the subject of the artwork. Again, unorthodox art-making methodologies had encouraged a new leniency; in this case, technical skill and the literal were devalued. This debasement of figuration and skill affected glass sculpture, because, for many of their glass pieces, the early artists wrestled with technical issues in their exploration, at midcentury, of the vessel form

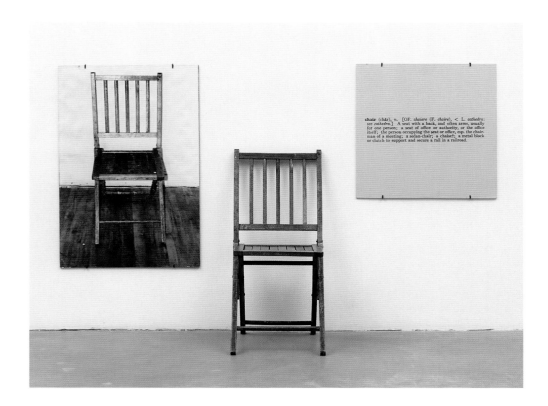

Joseph Kosuth
American, b. 1945

One and Three Chairs, 1965
Wooden folding chair, photograph of a chair,
and a photographic enlargement of the dictionary
definition of the word *chair*
Chair: 32⅜ × 14⅞ × 20⅞ in.; photo panel,
36 × 24⅛ in.; text panel, 24 × 24⅛ in.
Museum of Modern Art, New York, 383.1970a–c
Larry Aldrich Foundation Fund

One and Three Chairs is a classic piece of conceptual
art. It presents three ways to signify the concept
of chair that highlight the dissonances and incom-
plete meanings inherent in the same object when it
is represented in different formats. This essentially
linguistic artwork uses visual terms to illustrate the
gaps between medium and meaning.

(a format that parallels the figurative impulse). Because of their links to literal representation and their functional references, vessel forms were discredited as potential art objects, regardless of their content.

Then another radicalism appeared, one that gave short shrift to sculptural glass and other artistic expressions in which their essence was located in the reality of the object created. Conceptual art entered the contested territory of contemporary art in the late 1960s and early 1970s. The name comes from a phrase that Sol LeWitt used to describe work he made to engage the mind of the audience rather than the eye or emotions. Growing out of minimalism, conceptualism declared the artwork, as an object, irrelevant (as had Marxist theorists). This shifted the value of the artwork to its underlying concept and away from its physical presence. With intellect placed higher in value than the physical rendering of it, beauty, located in the real nature of the object, had no position. Typical of this new approach was Joseph Kosuth's *One and Three Chairs* (1965, above). Made of three parts (an actual folding chair, a photograph of the same chair, and a written definition of a chair), the piece illustrates the focus of conceptualism on linguistics and communication over originality of form.[24] By the 1970s, conceptualism and the Greenbergian abstract expressionism were at war, and beauty was not even a contender. But, fortunately for glass, the theoretical underpinnings of art were changing as modernism's hegemony was waning in favor of postmodernism.

This development affected both glass sculpture and beauty. Art professionals in the early 1980s thought that any interest in beauty was recherché. In academia, the study of art history pertained more to critical theory analysis than to the art object itself; doctoral candidates, for example, were writing dissertations that included few or even no images,

but had copious references to linguistics. Considerations of beauty were regarded as pornographic or, perhaps worse, the uninformed comments of a rube.[25] The focus on critical theory and linguistics, even with the resulting insightful readings of artworks, made art inaccessible to the average museum patron and placed the keys of art understanding within the hands of a few self-selected art historical elites.[26]

Then an even newer art movement dealt another blow to beauty and to glass as an art medium. In the 1980s, the neo-expressionists, lead by the German Joseph Beuys and insisting that the artist be a political and social activist, focused artistic expression within the actions of the artists, not on any tangible item they might produce (p. 26). While the works created were intellectually interesting, the desire for tactile, sensual, and physical art was discounted. By centering art activity on the act of the artist and placing politics as the main focus of its content, art of the 1980s seemed to accomplish the early twentieth-century Dadaists' intent: the art object was now superfluous.

But then in the 1990s glass was reinstated as an art medium. By that time modernism—with its passion for the new and its uneasiness with beauty—had run out of steam. The relentless push for the cutting-edge avant-garde (now not always seen as a virtue), with its strict delineations of what format was acceptable, and with its rejection of art that actively engaged the senses, seemed out of step with prevailing interests. The world was being seen as multicultural, with no universal standard to unite all. Newness for newness' sake had not solved intractable problems. As modernism gave way to postmodernism, two important qualities previously undervalued were revived. First, the types of media acceptable for art making broadened. Now glass and other media (video, plastic, fiber, and so on) could be used for art. Second, beauty

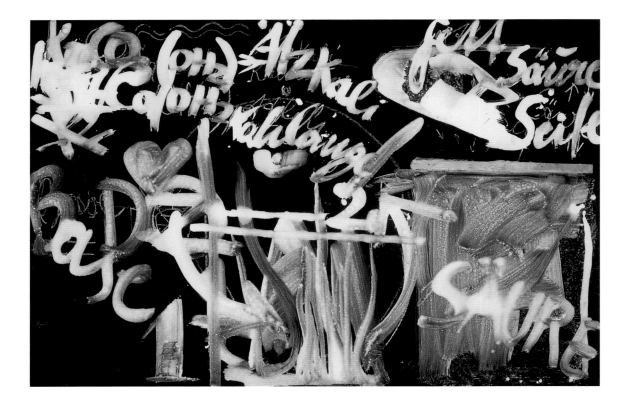

Joseph Beuys
German, 1921–1986

Virgin (Jungfrau), April 4 / June 23, 1979
Chalk, tempera, wood, and soap on
blackboard
Approx. 33¼ × 48⁵⁄₁₆ in.
Solomon R. Guggenheim Museum, New York,
94.4264

was once again appreciated, desired, and recognized as a worthy component of artistic expression. This occurred because beauty was recast as a complex of cultural constructs that were embedded within contemporary attitudes. With this view, beauty could be acknowledged, appreciated, discussed as a cultural artifact, and even enjoyed as a pleasure. Objects that had forms, textures, and proportions that pleased the eye, and content that satisfied the intellect, found a new audience in the world of high art.

Evidence of this shift is seen in the number of public institutions that participated in this resurrection. Works from previous eras, such as Bouguereau's *Nymphs and Satyr* (see p. 18), which had languished in the basement because they were merely beautiful were moved from vaults onto gallery walls. Art books and exhibition catalogues began to mention beauty and even acknowledge it as a topic for intellectual exploration.[27] It became evident that the communication of content was not necessarily obscured by beauty and might even be enhanced by it. Art professionals discovered what the makers and collectors had long known: when viewers are not barred from art because of complex theorizing, they derive pleasure from it. As the fashion for tough art faded (was it really as widespread as the critics and purveyors maintained?), accessible and delightful beauty became once again acceptable. Its inherent beauty would no longer disqualify glass as an art medium.

The Historical Development of Sculptural Glass

Contemporary sculptural glass grew out of a marriage between the interest in working with glass that had been initiated by the American studio glass movement and the impulse to create sculptural works out of glass. Indeed, the history of sculptural glass in the United States is,

in large part, the history of the rediscovery of glass as a medium for artistic expression.[28] Because of the spread of industrial processes of glassmaking in the nineteenth century, a technical disjuncture had developed that was perpetuated into the twentieth century. This led to a separation of the sites for glassmaking: one became the factory, where skill in forming resided, the other became the studio, where the independent, solitary glassmaker struggled to form glass often using techniques borrowed from clay technology. In this way, during the first third of the twentieth century, isolated proto–studio glass artists formed objects out of glass for their own artistic expression. It was not, however, until 1962 that artists intent on making art with glass came together at the Toledo Workshops in Ohio in a serendipitous melding of industry-based skills and art ambitions. These workshops ignited an enthusiasm for glass as an art medium and led to the emergence of the American studio glass movement, the direct forerunner of the sculptural glass phenomenon.

As interest in glass for art making grew, the early practitioners needed to develop a daunting range of technical expertise. Building furnaces, selecting the right glass cullet, mixing and melting the batches, finding appropriate colorants, learning how to use traditional tools, inventing new tools when necessary, and then successfully creating desired forms, were all adventures into the unknown. As was to be expected, the formal vocabulary used by the early glassmakers was limited. Many pieces produced in those first decades were essentially vessels because vessels are easily fashioned on the end of a blowpipe and because many early glassmakers were attuned to the vessel sensibility as a result of their studies in clay.[29] Eventually the formal language matured to incorporate complex shapes capable of communicating the

entire range of sculptural vocabulary. As technical issues receded, true sculptural glass emerged.

Many (often disparate) art styles are linked under a single named movement (as in the case of impressionism or abstract expressionism); however, the artists who chose glass as their medium did not espouse a unified set of goals or a unified formal identity, nor did they have a written manifesto that was supported and adhered to by members of the group. With no overarching uniformity of vision relating to their artistic goals, the makers were linked by raw enthusiasm for the material itself and for its unlimited potential for artistic expression. As the artist Dana Zámečníková (see p. 208) states, "My idea was to use glass simply as one of the many materials available because it offered the best possible way for expressing my ideas—not to use glass because I am a 'glass artist.'"[30]

Of great importance to the emergence of sculptural glass was the introduction of education about glass in the university system. This began in 1963 when Harvey Littleton organized the first class about glass in the art department at the University of Wisconsin. The model was subsequently taken up by other universities from coast to coast,[31] and students of glass acquired an education with the same theoretical grounding in critical theory and artistic practice as that offered to those whose artistic media were paint on canvas or photography.

An important boost to the increased visibility of glass as an art medium came from the high art world when established artists, known for their work in other media, chose to work with glass and, conversely, when a select group of glass artists had work displayed in the high art galleries. The allure of glass as a medium for artistic expression was often predicated on its optical features and, as such, it had intrigued several artists, among them, Josef Albers, Arman, Alexander Calder, Joseph Cornell, Salvador Dalí, Marcel Duchamp, Felix Droese, Lucio Fontana, Barbara Hepworth, Vassily Kandinsky, Mario Merz, Henry Moore, Meret Oppenheim, Lucas Samaras, Robert Rauschenberg (see above), Robert Smithson, DeWain Valentine, David Smith, Vito Acconci, Nicolas Africano (see p. 78), Larry Bell (see p. 17), Lynda Benglis (see p. 16), Laddie John Dill, Donald Lipski (see p. 112),

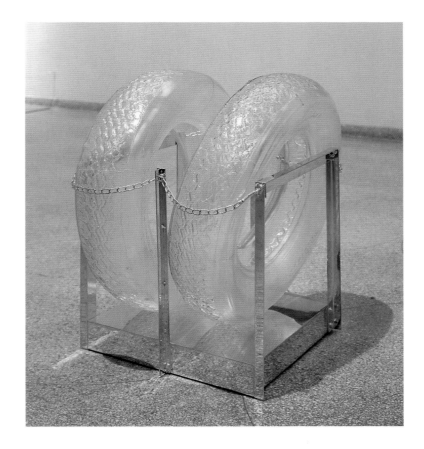

Robert Rauschenberg
American, b. 1925

Untitled (glass tires), 1997–1998
Blown glass and metal
Approx. 30 × 30 × 30 in.
Solomon R. Guggenheim Museum, New York
© Robert Rauschenberg / Licensed by VAGA, New York, N.Y.

This installation view of the exhibition *Robert Rauschenberg: A Retrospective* (September 1997 to January 1998) illustrates the attraction that glass has for artists who work in other media. Here Rauschenberg formed tires out of glass. A contradiction on the face of it, the work has a formal simplicity and aesthetic elegance that would be possible only in glass.

Italo Scanga, John Torreano, James Turrell, and Christopher Wilmarth (see p. 181). Many used glass in conjunction with other materials or by itself, their choice confirming the recognition of glass as an art medium. Another fortuitous aspect of the crossover was the intense interaction between the glass community and leading artists who were working in other media. In 1984 the sculptors Christopher Wilmarth and Lynda Benglis attended Pilchuck Glass School and Benglis returned in 1985. Larry Bell, Donald Lipski, and Italo Scanga, among others, also attended Glass Art Society conferences and made presentations at them about their work.[32]

When they began accepting work by artists who are more usually associated with glass (most notably Howard Ben Tré and Dale Chihuly), the large urban galleries influenced what collectors and curators were seeing. Both Chihuly and Ben Tré were eventually represented by the

Charles Cowles Gallery in New York, as were Tom Patti (see pp. 74, 121, 146), Dan Dailey (see pp. 75, 134), and Paul Stankard (see p. 97). Chihuly was also represented by the Marlborough Gallery in New York, which was known for its support of established sculptors of all media. The interchange had other benefits. It helped to attract an audience to glass that was different from the one that frequented galleries that showed only glass. These new collectors relished the large-scale pieces and, with scale an important criterion for categorizing work as sculptural, encouraged the development of glass as sculpture. They also prized the inherent physical properties of glass less and looked for compelling content in their art purchases.

Museums as Cultural Arbitrators

Value is attributed entirely on the basis of evaluations of quality by experts, including critics, museum curators, and, to some extent, eminent collectors.[33]

—DIANA CRANE

Art museums function as cultural validators. Supported and staffed by elites, museums work to select the best from our visual culture and to display and preserve it for future generations. The process of selection requires that all media meet a uniformly high standard of achievement in order to be termed *art* and to be permitted to join the permanent collections of leading museums. The need to attain this standard has favored a conceptualization of art that focuses on the masterpiece, and has cast museums as disinterested "accumulators of only the very 'best' quality, making their decisions objectively and not intuitively, as might the private collector."[34] To identify the best, a professional staff (curators and directors) is guided by deep knowledge of the field, a well-tuned sensitivity to the nuances of individual artworks, an understanding of the creative process, and an appreciation of the work's relationship to other pieces in the collection—this last consideration being relevant for each of the museums profiled in the second part of this volume. Curators, in forming public collections, are thus required to evidence

knowledge that is broadly historical and more culturally attuned than that demanded of individual collectors.

In addition to this overarching curatorial mandate, museum curators have a role as teachers. They are charged with using their collections to broaden the understanding of the art in their communities. They are required to formulate and present new insights and fresh perspectives using the exhibition as their educational format. Relatively few display strategies are available for teaching through exhibitions. Commonly, juxtapositions among artworks are used to reveal connections of content, form, and attitude and, thus, to communicate concepts not only within each artwork but also among the pieces as a group. Exhibitions in which the art is presented in a lineal, time-sequenced manner are blunt tools for making nuances clear. The related catalogues, brochures, and scholarly writings will, it may be hoped, permit the communication of the curators' knowledge about arcane material in a coherent, engaging, and nuanced manner. Interestingly, these written records survive long after the close of a traveling exhibition or the changing of a permanent installation.

The twin curatorial tasks of arbitrating what enters a museum collection and teaching about the art are not culturally passive. In these roles, curators establish the rules for what is considered art and, consequently, appropriate for inclusion in perpetuity in museum collections. Indeed, over the past twenty years, individual curators (as related in the accounts of the Metropolitan Museum of Art, the Milwaukee Art Museum, and the Speed Art Museum), encouraged by devoted glass collectors, have shifted the boundaries defining the art that is deemed acceptable for their permanent collections. This aspect of the museum as activist agent and teacher warrants our attention and serves as the second focus of this book.

The Dynamics of Institutional Collection Building

The definition of acceptable art has, as we have already noted, proved to be highly fluid, with identifiable modifications over time. In the process, museums as embodied in their professional staff have been active partisans in the discussion. During the twentieth century, museums

(among them the Museum of Modern Art in New York and the Los Angeles County Museum) aggressively championed contemporary art and became the prime movers in the acceptance of the avant-garde (read abstraction) as *the* art of the twentieth century. Indeed, modernism's confrontational agenda found its most persuasive and far-reaching venue for promulgation within the standard museum exhibition format. These crafted displays operating under the guise of education sold the so-called truth of modern art's reification to the public. While fellow museum professionals and critics judged and wrote enthusiastically, the public was more reticent. The professionals (and their confreres in universities) prevailed, and their success in persuading the public that they were, indeed, the arbiters of taste was expressed in the marketplace, where works purchased within five years of having been displayed in museum exhibitions have tripled in value.[35] This effect attests to the force of museums as artistic validators and teachers, who shape public taste.

Professional collection building differs from the activities of a private collector: collectors can properly indulge their personal taste; curators need to understand their own personal prejudices and to collect without expressing them. With curators trained to bring an educated, experienced eye (connoisseurship) and knowledge of larger histories (both artistic and social), and responsible for acquiring only the best, institutional collecting would appear to be a cool activity—impartial and detached. Instead, it is inflected with many practical realities, salted with institutional politics, and plagued by vagaries of personality. As observed in the following profiles of individual museums, it was often these fluctuating anomalies that proved to be fortunate for sculptural glass.

Curators are charged with forming permanent collections that reflect the focus of their institutions. If the institution is a glass museum, as is the Corning Museum of Glass, only material related to glass is appropriate; for a general encyclopedic museum, as are most of those described here, there is a broader mandate. As a rule, museums that are not specifically dedicated to contemporary art wait until contemporaneous material has achieved an art-historical track record and a clear position in the market (manifest in validation by dealers and collectors)

before adding it to their permanent collections. Generally, curators do not seek to make the market, but their actions can (and do) direct attention toward artists and media already recognized by the market.

In their capacity as cultural arbiters and collection builders, curators (and often directors functioning as curators) are responsible for acquiring works of art for the permanent collections. Works may be acquired in one of three ways and each carries a discrete meaning. A purchased work indicates that the curatorial and directorial staff felt strongly enough about it to spend (undoubtedly) limited acquisition funds; a work secured by donation means that the curator worked with a collector (or other donor) who already owns the work. The second method is the more common for building collections of contemporary material in all media. When relying on donations from preexisting collections, curators look to sources: artists, dealers, and collectors. When the artist is the donor, the curator and the artist confer, often with the aid of the artist's dealer. When a dealer makes a donation, the deal is struck between the curator and the dealer. When a collector makes a donation or offers to make a purchase on behalf of the museum, the curatorial eye is able to lead the acquisition. Such transactions are more complex and will be discussed below.

Each method carries within it distinctive perspectives that can be discerned in the objects. When objects are purchased by a curator without the intercession of a donor, the selection rests on the application of a professional eye, and the curator may be scouting for work outside the usual sources as well as within them. Artists and dealers are well aware of the value of institutional validation and will offer the best works for inclusion in permanent collections. The felicitous result of curatorial discretion can be seen in the collections of the Corning Museum of Glass, the Museum of Fine Arts in Houston, the Chrysler Museum of Art, and the Toledo Museum of Art, to name a few, where independent institutional funds have supported acquisitions that are outside the ordinary and evince a deep sophistication.

Working with individual collectors has a different set of realities. Private donations to museums may be motivated by several concerns: on the practical side some collectors want more room for new pieces, or

they seek tax deductions, or, as is often the case with sculptural glass, they may feel passionately about their chosen medium and wish to increase its exposure in the validating setting of the art museum. All of these motivations, or a mix of certain aspects, have prompted the acquisition of sculptural glass for permanent museum collections. Frequently, to accommodate the varying concerns, the curator will suggest that some pieces be donated and others purchased by the museum. On the institutional side of the transaction, curators attempt to create a balance between what is offered and what fits in. Curators must select works according to criteria that determine suitability for their institution and their existing collection. This "principle of selection," which is coupled with curatorial knowledge, is made up of a number of factors ranging from the mundane to the esoteric: the appropriateness of the piece to the collection as a whole (its relationship to works already in the collection), the physical stability of the artwork, its potential usefulness in communicating an understanding of art, its standing within the artist's oeuvre, the essential quality of the artwork (a test of connoisseurship), the museum's ability to store the piece properly and eventually to display it, and whether or not the curators actually like the work. The weight of each of these factors can be different for each work. In the contemporary field, where the sheer number of items that potentially could enter a collection would swamp any institution, the application of this principle is critical. Consequently, each glass sculpture that resides in a public collection has survived a multilayered process of assessment. When a curator is offered works from an entire private collection, not all of the pieces will fit the museum. It is at this point that the principle of selection is used with curatorial finesse to select the most suitable pieces.

The nuts-and-bolts application of the principle of selection is seen in action at the museum acquisition meeting, when works are presented to colleagues and the appropriateness of the potential acquisition is discussed. Here, behind closed doors, the real-life ramifications of art classifications and the practical realities of caring for works of art are felt. When a work is acquired, it is granted (in theory) the care of the institution in perpetuity and, although issues related to storage sound as if they should be minor concerns, they are in fact a continuing challenge in all museums. It is expensive to store works of art. Many have stringent requirements for level of light, moisture, heat, and vibration, and the museum must employ staff to maintain records of scholarship, locations, and insurance coverage, among other activities. When it is determined that all of these requirements can be met and that the work is suitable for furthering the institution's goals, the piece is deemed acceptable for inclusion in the museum's permanent collection.

Display Strategies

All museums have more works in their collections than they have out on display; consequently, the professional staff must choose what to show. Shaping such decisions are considerations of the space itself and the curatorial department that controls it, the importance of the work of art, its size in relation to that of the gallery (will it fit?), the insights that might be conveyed through the juxtaposition of the piece with various other artworks, and so on. In assessing the display of sculptural glass in museum collections, practical choices align hard realities with philosophical underpinnings.[36]

Much has been written about the politics of display (and most of that critical of the Western Eurocentric attitudes that are evident in traditional museum display practices). Equally important is the architectural imperative inherent in each museum complex. Large-scale, mid–twentieth-century paintings and sculptures do not fit into small galleries, so the small gallery spaces are often turned over to more appropriately scaled objects; the sculptural glass gallery on the third floor of the Anderson Building at the Los Angeles County Museum of Art is a case in point. The Renwick Gallery, designed in the nineteenth century, has tall ceilings and articulated moldings on the windows and doorways; sadly, these distinctive spaces are not well suited to the display of large, contemporary art pieces. While museums are, in the main, architecturally fluid places, with the gallery configuration changing for each installation, the realities of the building structure and the budgets allocated to reinstall galleries impose limitations on the possibilities of reshaping galleries.

All museum exhibitions (whether defined as permanent or travel-ing) are temporary. If they are associated with a traveling show, they are up for only a few months; even if they are regarded as permanent, they remain only until the display looks worn, bugs invade, or new scholar-ship forces an update. Budget can affect the frequency of reinstalla-tions and, in this contemporary period of great museum expansion, access to expanded gallery space can lead to a reshuffling of whole categories of objects (as has been done in the new de Young Museum in San Francisco).

Because gallery spaces tend to be linear, so are displays. This pre-sentation is expected and understood by the public, the viewers "read-ing" the exhibition as a progression from one artwork to the next in an interactive series of confrontations between audience and artwork. The presentation relies on the visual impact of the art augmented by the written word in the form of labels and wall panels. Placement, light levels, and flow through the galleries influence the effectiveness of the display and the success of its communication of both new insights and relevant information.

Within this construct, types of display are also limited; they may be chronological, thematic, oppositional, or uniform. Chronological displays tell a narrative; thematic displays use a variety of works to explore an idea or present a thesis; oppositional displays thrive on vivid contrasts between artworks to make points; uniform displays—of works linked in subject, form, attitude, or even tonality—can commu-nicate a whole greater than the parts. Thus the tactics used in display are limited, but their application can be varied and will reflect curatorial skill and insight.

In installing (or hanging) a gallery (the latter a freighted term reveal-ing the pesky privileging of painting over three-dimensional artworks), decisions about the type of display to be used for the specific exhibi-tion are made by the professional staff. A persistent historical notion rules that paintings should be hung in galleries, without the intrusion of sculptural works. Historically paintings were hung vertically up the walls, with the lesser pieces placed above eye level.[37] The custom of presenting painting without the intrusion of other art formats reflects both a bias and a desire to preserve sight lines and to focus on one form of art making. This approach remains the standard. In some institutions paintings are put on the walls and sculpture placed in the center of the rooms; in more enlightened museums art made of all media is placed in a chronological, thematic, or formal organization. For example, the Toledo Museum of Art is known for its inclusive policies of displaying all media from the same period together, a variant of the single-medium, chronological approach seen in dedicated painting galleries. The dis-play of glass is a particularly difficult task. Because of its (often) shiny surface, natural reflections can bedevil any display. Direct lighting from above can prove too harsh, with the reflections overpowering the overall sense of the work. In a dark, interior gallery glass is best lit from under-neath, the objects set on thick, frosted Plexiglas above a diffuse light source. Glass is not affected by natural light—so galleries that would be unsuitable for paintings, drawings, textiles, or other light-sensitive media are perfect for glass.

Notes

1. Donald Kuspit, *Chihuly* (New York: Harry N. Abrams, 1977), 31.

2. For the purposes of this discussion *high art* is defined as any art executed in the sanctified artistic media of painting on canvas (or wood) and sculpting in stone (granite, marble, and so on). The emphasis is on the medium coupled with the intent of the artist—one without the other does not suffice.

3. Painting was not always a privileged art format. In the ancient world, architecture was considered the queen of the arts and sculpture was its handmaiden. Only as painters became more politically assertive did they have painting (first on wood and then on canvas with oil paints) classified as an important artistic format.

4. Artists were also important in this classification system, but because the focus of this book is on museums, Alfred Barr, as an arbiter and museum professional, is singled out. It was his conceptualization of modern American art that became the guiding perspective for museums across the country.

5. For a detailed discussion of the display practices used at the Museum of Modern Art, see, for example, Mary Anne Staniszewski's *The Power of Display: A History of Exhibition Installations at the Museum of Modern Art* (Cambridge, Mass.: MIT Press, 1998).

6. See James T. Soby, "The Collection of the Museum of Modern Art: Four Basic Policies," *Art in America* 32, no. 4 (October 1944): 235; and R. Craig Miller, "Betwixt and Between: Contemporary Glass in American Art Museums," *Glass Art Society Journal* (1991): 27–32.

7. Emma Barker, Introduction, in *Contemporary Cultures of Display* (New Haven: Yale University Press, 1999): 8–20.

8. The standard of the original investigation of art was established in Heinrich Wölfflin's *Classic Art: An Introduction to the Italian Renaissance* (London: Phaidon, 1968).

9. Also of great importance to the development of fine glass sculpture was the shift in the location of the education of the glass artists. From the 1980s, glass artists studied the same university art curriculum that had been previously reserved for painters and sculptors in other media.

10. Rosalind E. Krauss, *Passages in Modern Sculpture* (Cambridge, Mass.: MIT Press, 1996), 3–4, 23, 45.

11. Ibid., 45.

12. Arthur C. Danto, "Beauty for Ashes," in Neal Benezra, *Regarding Beauty: A View of the Late Twentieth Century,* exh. cat. (Washington, D.C.: Hirshhorn Museum; and Ostfildern, Germany: Hatje Cantz, 1999), 196.

13. See Clement Greenberg, "Avant-Garde and Kitsch," in *Art and Culture: Critical Essays* (Boston: Beacon Press, 1961), 3–21.

14. Neal Benezra, "The Misadventures of Beauty," in *Regarding Beauty: A View of the Late Twentieth Century,* exh. cat. (Washington, D.C.: Hirshhorn Museum; and Ostfildern, Germany: Hatje Cantz, 1999), 20–21.

15. For a lively set of essays about changing aspects of the subject, read Stephen Bayley's *Taste: An Exhibition about the Values in Design* (London: Victoria and Albert Museum, Boilerhouse Project, 1983).

16. In 1934 Duchamp published an edition of 320 copies of the variant called *The Bride Stripped Bare by Her Bachelors Even* (no commas), colloquially titled *Green Box.* Many scholars believe that the two works should be viewed in tandem. See Thomas Singer, "In the Manner of Duchamp, 1942–47: The Years of the Mirrorical Return," *Art Bulletin* 86, no. 2 (June 2004): 346–48. Also see Thierry de Duve, *Kant After Duchamp* (Cambridge, Mass.: MIT Press, 1996), 134–35, 401–409; and Calvin Tomkins, *Duchamp: A Biography* (New York: Henry Holt, 1996), 1–14.

17. Benezra, "Misadventures of Beauty," 23. This discussion is not to say that artists did not make items that could be enjoyed as beautiful. Many works did offer visual pleasure and formal elegance, but they were not considered the equal of works that were intentionally visually distressing and unlyrical.

18. Benezra, "Misadventures of Beauty," 17.

19. Wendy Steiner, *Venus in Exile: The Rejection of Beauty in Twentieth-Century Art* (New York: Free Press, 2001), xv.

20. See Susan Landauer, *The San Francisco School of Abstract Expressionism* (Berkeley: University of California Press, 1996); and Caroline A. Jones, *Bay Area Figuration 1950–1965* (Berkeley: University of California Press, 1990).

21. Founded a few years after the Dada movement, as a direct offshoot of Dadaism, and predating abstract expressionism, surrealism flourished in Europe and the United States. Begun as a literary movement by André Breton, it developed out of Freudian concepts of free association and dream analysis. The movement is not discussed here because it did not have a direct impact on sculptural glass.

22. See, for example, Greenberg, *Art and Culture,* for a discussion of the role of New York in this transformation of styles; see also Serge Guilbaut, *How New York Stole the Idea of Modern Art: Abstract Expressionism, Freedom, and the Cold War,* trans. Arthur Goldhammer (Chicago: University of Chicago Press, 1983); and Diana Crane, *The Transformation of the Avant-Garde: The New York Art World, 1940–1985* (Chicago: University of Chicago Press, 1987).

23. Clay was less vulnerable as it is not viewed as an inherently beautiful medium.

24. See Lucy Lippard, *Six Years: The Dematerialization of the Art Object from 1966 to 1972* (Berkeley: University of California Press, 1997).

25. Several books of the period reveal this deep bias, for example, Hal Foster's *The Anti-Aesthetic: Essays on Post-Modern Culture* (Seattle: Bay Press, 1983).

26. As part of the new art history, traditional areas of art history such as ancient art (Greek and Roman) were disparaged as archeological studies.

27. It should be noted that during this period museums located outside large urban centers did not always display this uneasiness with glass as both an art medium and a carrier of beauty. Many had accepted donations of glass sculpture to their collections. Whether it was enlightened curatorial perception or something more practical, these works moved from collectors' homes into institutions. Long popular with the public, these works are now seen with new eyes, and it is recognized that artists who work in glass are equal to those working in other media.

28. For a complete retelling and an assessment of the American studio glass movement, see Martha Drexler Lynn, *American Studio Glass 1960–1990: An Interpretive History* (New York: Hudson Hills Press, 2004).

29. By the early 1960s, as a result of the work of Peter Voulkos and Robert Arneson, among others, clay had become a sculptural medium. Glass would not make that shift until the late 1970s, when blowing ceased to be the favored forming method.

30. Dr. Kristian Suda, "Dana Zámečníková: Artist and Magician," *Glass* 45 (fall 1991): 35.

31. For example, as part of his work as a ceramics instructor there, André Billeci set up a glass-forming class at the State University of New York in Alfred, New York.

32. See James Turrell, "Light in Space," *Glass Art Society Journal* (1983–1984): 5–10; Melinda Wortz, "Larry Bell," *Glass Art Society Journal* (1986): 58–61; and Neil Goodman, "Vito Acconci," *Glass Art Society Journal* (1986): 118.

33. Crane, *Transformation of the Avant-Garde,* 112.

34. A. Deirdre Robson, *Prestige, Profit, and Pleasure: The Market for Modern Art in New York in the 1940s and 1950s* (New York: Garland, 1995), 17.

35. Crane, *Transformation of the Avant-Garde.*

36. Display strategies have received much attention in academic writing and the museum world in the past few years; they will not, however, be the focus of this discussion. But, see "The Problematics of Collecting and Display, Part 1," *Art Bulletin* 77, no. 1 (March 1995): 6–24; and "The Problematics of Collecting and Display, Part 2," *Art Bulletin* 78, no. 2 (June 1995): 166–85. See also, Werner Muensterberger, *Collecting: An Unruly Passion* (Princeton, N.J.: Princeton University Press, 1994); and Susan M. Pearce, *Museums, Objects, and Collections: A Cultural Study* (Washington, D.C.: Smithsonian Institution Press, 1992).

37. A detailed discussion of this phenomenon is found in David H. Solkin, ed., *Art on the Line: The Royal Academy Exhibitions at Somerset House, 1780–1836* (New Haven and London: Yale University Press, 2001).

Museum Profiles

The twenty-six museums profiled here were chosen for their commitment to and their significant holdings of sculptural glass. The aim of each profile is to reveal the artistic and cultural contexts in which the holdings dwell. Although the history and collecting goals of each museum are unique to the institution, all the museums have prospered through their curators' insight and their donors' enthusiasm, and they present uniformly fine works of art to the public.

Most of the museums included here are encyclopedic; one (the Corning Museum of Glass) is dedicated to a single medium; one (the Oakland Museum of California) shows the work from a prescribed geographic locale. Many have artworks from the categories of art that are expected in American museums: impressionism, postimpressionism, and contemporary art, both European and American. Only a few of the institutions, among them the Museum of Fine Arts in Boston and the Museum of Fine Arts in Houston, have been particularly adventurous in their exploration of new areas of collecting. Many, such as the Tacoma Art Museum and the Milwaukee Art Museum, have strong regional commitments, and several are undisputed leaders in the field: the Metropolitan Museum of Art and the Museum of Modern Art in New York, the Los Angeles County Museum of Art, the Museum of Fine Arts in Boston, and the Toledo Museum of Art. A few are over a hundred years old; others only a decade or so. Each of these realities influences the breadth of the collections and the structure of the museums and, consequently, the depth and breadth of their sculptural glass holdings.

Several interesting themes are evident within the profiles. There was a burst of museum-building in the late nineteenth century, and a parallel one suffused museums in the late twentieth and early twenty-first centuries. During the first boom, there was a drive to educate the public by presenting artworks with the stated goal of elevating morals and taste. During this current era, as museums have come to be seen as gatekeepers and social validators, the drive is to expand top-tier collections and to exhibit

a more comprehensive representation of the art of the world. In the oldest American museums, the model was the Victoria and Albert Museum in London; the newer ones emulate the Musée du Louvre in Paris. Many of the East Coast museums considered here were founded by financiers; in the Midwest, it was women of means—either with their husbands or with other women—who were the founding force. On the West Coast, nineteenth- and twentieth-century commercial expositions provided the impetus. One museum grew from the 1970 exhibition, *Objects: USA.*

Women, as both guiding lights and financial backers, have been integral to the growth of museums in the United States. Like the settlement movement and the crusades on behalf of the downtrodden, museums seem to have offered women an accessible vehicle for changing society during the nineteenth century. Equally interesting is the early and honored place for amateur scholars before the field of museology became professionalized. They served as directors and curators, bringing a private passion to their public work. Indeed, several privately amassed collections became the kernel from which the later institution grew, the Seattle Art Museum and the Chrysler Museum of Art being examples.

The valuing of volunteerism within the culture of museum is also evident and may reflect the notion that the institution was envisioned as providing a larger social good to the community, offering cultural uplift and exposure to the finest. In the United States, unlike Europe, there is little publicly funded support for museums, and all the institutions profiled here depend on the largess of volunteers, private donors, and philanthropic organizations. Only two, the Corning Museum of Glass and the Liberty Museum, derive support from corporate entities. Also common to all of the museums profiled here is a passion for sculptural glass on the part of its collectors. Without that passion, these individuals would not have become collectors and, in time, donors, and the public would not enjoy as many fine artworks.

CHRYSLER MUSEUM OF ART
Norfolk, Virginia

The Chrysler Museum of Art comprises a fine art museum and two important historic houses, the Willoughby-Baylor House and the Moses Myers House. Guided by the mission to "bring people and original works of art together,"[1] the museum grew from the efforts of two women, Irene Leache and Anna Cogswell Wood, who in 1871 founded the Leache-Wood Female Seminary in Norfolk, Virginia. As befitted a school that educated women of that era, the appreciation and study of fine arts were a key part of the original curriculum. After Irene Leache died in 1900, Anna Wood established several organizations with the ultimate goal of opening an art museum. It was not, however, until 1933 that the first wing of the Norfolk Museum of Arts and Science opened in its newly designed Florentine Renaissance–style building.

The museum was transformed through the involvement of the art collector Walter P. Chrysler Jr., the son and heir of the founder of the Chrysler Corporation. Preferring art to autos, Walter Jr. had begun collecting at the age of fourteen with a small watercolor by Auguste Renoir. After college in the 1930s, he traveled to Europe to meet the avant-garde artists of the period, among them Pablo Picasso, Georges Braque, Juan Gris, Henri Matisse, and Fernand Léger. Upon his return, he helped found the Museum of Modern Art in New York and, later, volunteered for service in the United States Navy during World War II. While stationed in Norfolk, Virginia, he met and married Jean Esther Outland.

By the time of his marriage he had embraced the life of an art collector. He added works incessantly, especially glass, having been inspired by Louis Comfort Tiffany, his neighbor on Long Island. Over time, Chrysler amassed a collection of eight thousand glass objects. Encouraged by his father to place the collection permanently on public display in a museum, Chrysler Jr. sought an appropriate home for it. His gaze fell upon the museum in Norfolk and he indicated his interest in making the institution his beneficiary. In honor of that interest, the museum changed its name to the Chrysler Museum of Art, and from 1971 to 1976

Chrysler served as the director, one among several amateur directors of museums across the country.

The museum was further enriched by the Chrysler family when Chrysler Jr.'s sister, Bernice, and his brother-in-law, E. W. Garbisch, donated American folk paintings, including a version of Edward Hicks's famous *Peaceable Kingdom*. This painting joined portraits by John Singleton Copley and nineteenth-century American landscapes by Albert Bierstadt and Thomas Cole. With strengths in twentieth-century art that are augmented by choice French impressionist and postimpressionist works, the museum boasts an important cache of photographs of the Civil War and of the civil rights movement. The collections now extend to holdings of Asian, African, and pre-Columbian works. Current collecting activity is supported by private donations and endowment funds, with 40 percent of the museum's budget provided by the city of Norfolk. The existence of an acquisition budget is revealed in the fine works the museum has collected.

With collections expanding during the 1980s, the museum added an award-winning building designed by Hartman Cox that opened in 1989. It features a grand entrance with a great hall and double stairs leading to the upper galleries. Situated alongside an inlet of the Elizabeth River, the building appears to float upon the water. In 1997 a new wing was added for educational activities and the display of American neoclassical sculpture. Used as a backdrop, the building became the site of an installation of neon sculptural glass by Stephen Antonakos (p. 37).

Most important for the growth of sculptural glass within the collection was the fact that Walter Chrysler Jr. had a passion for glass and acquired large holdings of work by Louis Comfort Tiffany, Frederick Carder, Emile Gallé, Orrefors Glasbruk in Sweden, and the René Lalique factory in France. The commitment to glass continues with the collecting of contemporary glass, and the museum's display practices are egalitarian: past installations have, for example, placed a piece by

Harvey K. Littleton en suite with a painting by Ellsworth Kelly. Recent exhibitions have included *Art of Glass* (2003), in which works from several aspects of the collections were combined to serve as the visual arts cornerstone of the Third Virginia Waterfront International Arts Festival, and *Hot Glass, Flat Glass & Neon: William Morris—Therman Statom—Stephen Antonakos* (1999), an exhibition of sculptural glass installations by the three artists. In 2002 the museum initiated the touring exhibition *William Morris: Elegy*. The Chrysler Museum of Art continues to add sculptural glass to its fine and diverse holdings.

Site-specific neon installation by Stephen Antonakos (American, b. 1926) for the exhibition *Art of Glass: Hot Glass, Flat Glass, & Neon,* April 18 to August 29, 1999, Chrysler Museum of Art, Norfolk, Virginia

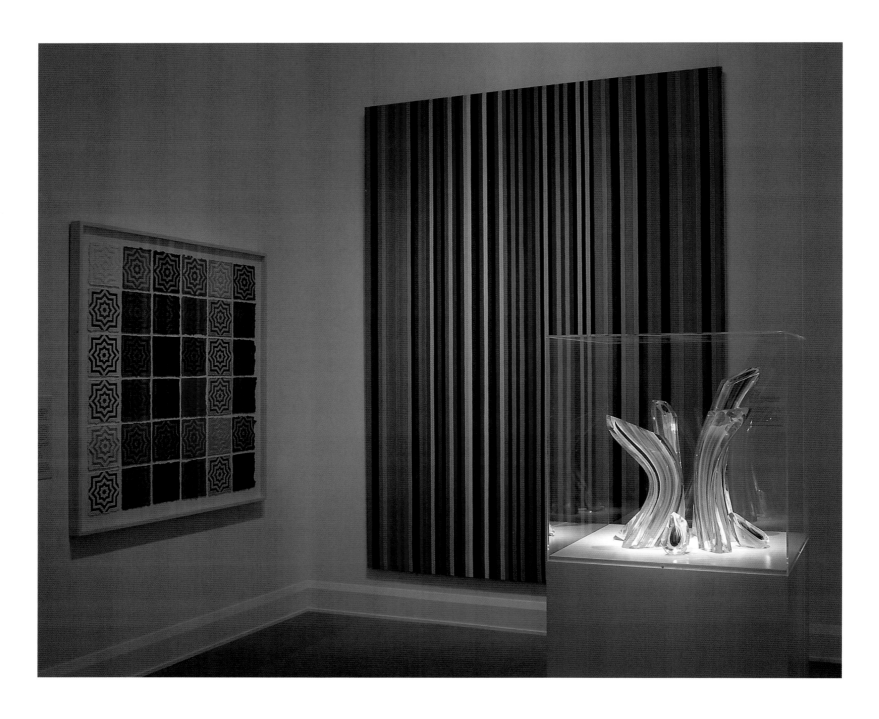

Installation view with works (above, left to right) by Sol LeWitt
(American, b. 1928), *Eight-Pointed Stars,* 1996; Gene Davis
(American, 1920–1985), *Shabazz,* 1965; and Harvey K.
Littleton (American, b. 1922), *Lemon/Ruby/Blue Vertical
Group,* 1989
(For additional credits, see p. 223)

Robert Willson
American, 1911–2000

Desert Cactus, 1994
Glass with colored inclusions and gold foil
17¾ × 13¼ in.
Chrysler Museum of Art, Norfolk, Va., 96.17
Gift of the Duncan Foundation

Erwin Eisch
German, b. 1927

Night of Crystal Death, 1991
Enameled, mirrored, and mold-blown frosted
and plate glass; paint, and wood
18 × 14½ in.
Chrysler Museum of Art, Norfolk, Va., 93.7
Museum Purchase with funds donated by the
Children of Art and Annie Sandler in honor of
Sam Sandler

Howard Ben Tré
American, b. 1949

Column 20, 1984
Glass and copper
86 × 18 × 13⅛ in.
Chrysler Museum of Art, Norfolk, Va., 92.13
Purchase and anonymous gift, dedicated by the Trustees to
Richard F. Barry III in gratitude for his long and distinguished
service to the Chrysler, June 2004

41

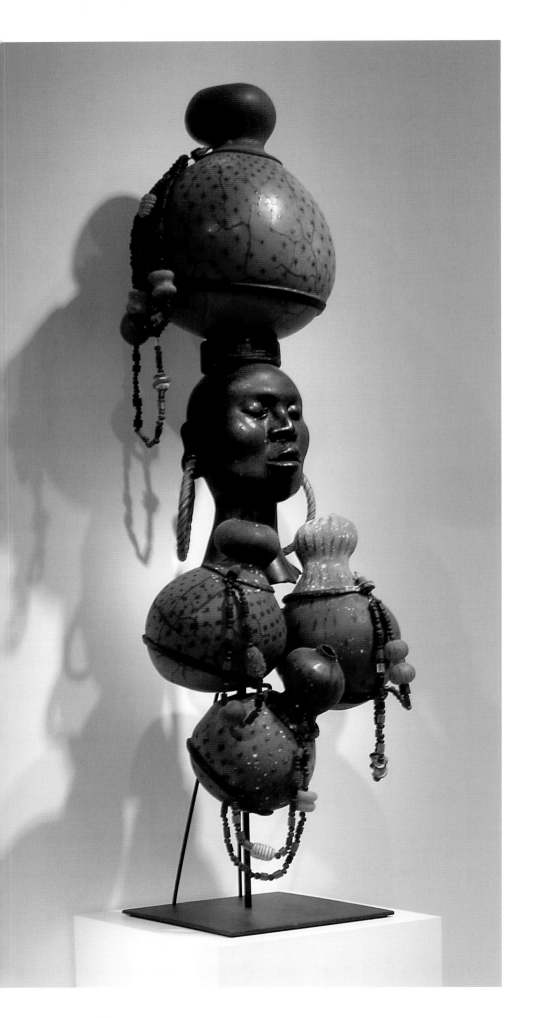

William Morris
American, b. 1957

Nuba Woman II, 2001
Blown glass, metal
53 × 17 × 19 in.
Chrysler Museum of Art, Norfolk, Va., 2002.16
Museum purchase: Gift of Walter P. Chrysler, Jr. by exchange
and Walter P. Chrysler, Jr. Endowment Fund; Scott D. Waitzer;
Lane Killam in memory of Kathryn K. Porter; and other donors

Lino Tagliapietra
Italian, b. 1934

Flying Boats, 1998
Blown glass, filigree canes
42 × 128 in.
Chrysler Museum of Art, Norfolk, Va., 99.18.1–6
Purchase, acquired in honor of Harry T. Lester
and gift of Heller Gallery and the artist

CINCINNATI ART MUSEUM
Cincinnati, Ohio

The city of Cincinnati has been called America's gateway to the West and this pioneering spirit marked the founding of the Cincinnati Art Museum. In 1876, Maria Longworth Nichols, who enjoyed china painting (then a popular diversion for young women),[2] attended the Centennial Exhibition in Philadelphia. In viewing the objects on display, she realized the potential of ceramics and ceramic decoration as art. This persuaded her to open, with her husband, Rookwood Pottery, which in time became one of the preeminent art potteries in the United States.

Not content with that, Nichols and a group of friends went on to found the Women's Art Museum Association, the goal being to establish a museum. Within three years, Charles West contributed the then-princely sum of one hundred and fifty thousand dollars, permitting the Cincinnati Art Museum to open in 1886 on Mount Adams in Eden Park, Cincinnati. Housed in a fashionable Romanesque-style building, the museum, part of the late nineteenth-century museum boom, was soon dubbed "The Art Palace of the West" and went on to collect across a wide spectrum of times and cultures. In January 1993, the museum completed a thirteen-million-dollar renovation that restored the grandeur of the exterior and added climate control and more gallery space.

Known as an encyclopedic museum, Cincinnati Art Museum boasts some unusual collections, among them the largest collection of Nabatean art from Khirbet Tannur, Jordan, and the Procter and Gamble collection of coffee-related historical silver. The collections include more standard masterpiece fare, such as works by Andrea Mantegna, Titian, Sandro Botticelli, Francisco de Zurbarán, and Hans Memling. The American collections include portraits by John Singleton Copley and Charles Willson Peale, and landscapes by John Singer Sargent. Post-impressionists are represented by Vincent van Gogh and early twentieth-century work by Amedeo Modigliani. Cincinnati has a strong collection of regional art, including work by Frank Duveneck, Robert S. Duncanson, and Grant Wood.

With the founding impulse generated by an aficionado of contemporary ceramics, it was not a reach to collect clay's sister medium, glass. The sculptural glass holdings are the outgrowth of a larger collection of fine decorative arts. Within the glass collections there is historical glass, with the most relevant twentieth-century sculptural glass being the Tiffany Glass Collections.

Exterior of the Cincinnati Art Museum, Cincinnati, Ohio,
August 29, 2002

The permanent gallery installation of glass in the second floor ambulatory, Cincinnati Art Museum, Cincinnati, Ohio, 2003

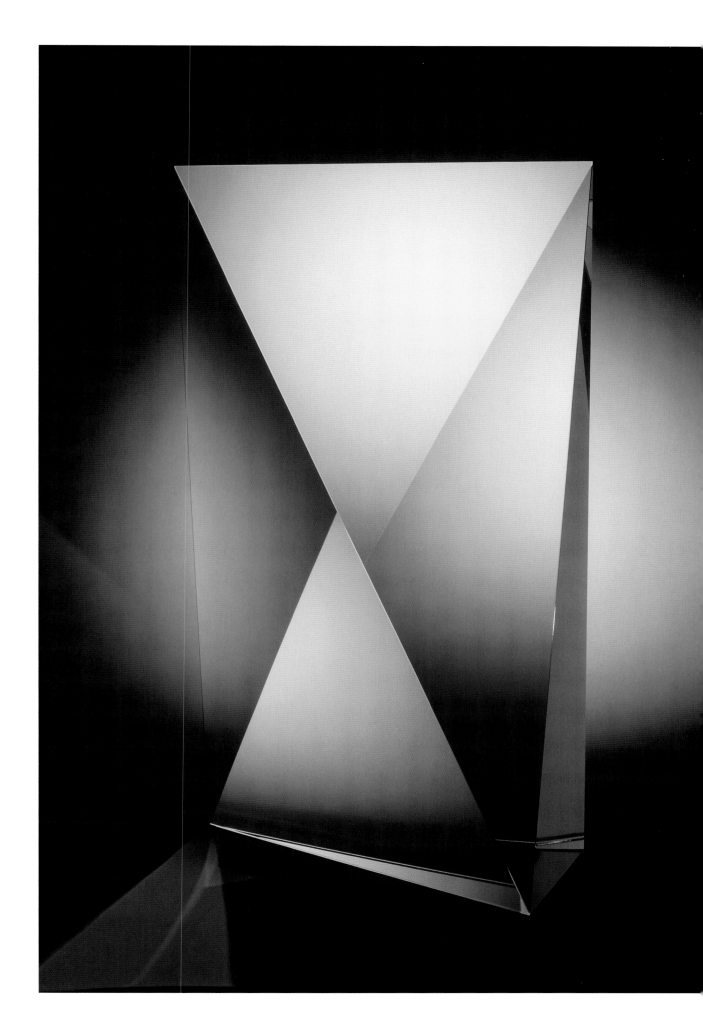

Christopher Ries
American, b. 1952

Topaz, 1982
Cast and polished glass
29⅞ × 18½ × 8⅝ in.
Cincinnati Art Museum, 2000.3
Gift of Stanley and Louise Rowe

Therman Statom
American, b. 1953

Untitled (chair), 1983
Glass, paint, wood, and paper
42 × 22 × 19 in.
Cincinnati Art Museum, 1996.42
Gift of David and Nancy Wolf

Dante Marioni
American, b. 1964

Yellow Leaf Vase, 1994
Blown glass
32¼ × 7½ × 2½ in.
Cincinnati Art Museum, 1998.74
Gift of Joan Cochran Rieveschi

CLEVELAND MUSEUM OF ART
Cleveland, Ohio

The Cleveland Museum of Art collects and displays art of all cultures, with particular strengths in Asian material and the art of the United States, including contemporary works. Incorporated in 1913 and opened in 1916 in a marble-clad Beaux-Arts building designed by Hubbell and Benes, the museum was conceived of as existing "for the benefit of all the people forever."[3] Later, the German expatriate, Bauhaus architect, and teacher Marcel Breuer and his firm designed a structure that was worthy of this goal. As in many Midwestern museums founded in the early twentieth century, a number of world-renowned historical works grace the halls: Michelangelo de Caravaggio's *Crucifixion of Saint Andrew,* Georges de La Tour's *The Repentant Saint Peter,* Jacques-Louis David's *Cupid and Psyche,* and works by Claude Monet, Paul Gauguin, and Vincent van Gogh. Cleveland also boasts superb Asian art collections developed by the noted scholar, author, and curator Sherman E. Lee between the late 1950s and the early 1980s. Another area of leadership is children's art education, for which many innovative programs have been developed. All of these activities have been supported by wide-ranging local generosity. This has permitted the creation of funds for the purchase of art, consisting, in part, of a gift of $342 million from Leonard Hanna.

Support for sculptural glass falls under the care of the Baroque and Later Decorative Arts and Sculpture Department. *Glass Today: American Studio Glass from Cleveland Collections* was organized in 1997 by the curator Henry H. Hawley. The exhibition and catalogue focused on glass made during the past thirty years and included objects in the museum's permanent collection. Indeed, there is a strong local history of studio glass, the precursor of sculptural glass: in the mid-twentieth century, Edris Eckhardt (1910–1998), a pioneer in independent glassmaking, worked in Cleveland, and the city also felt an affinity with the groundbreaking technical and artistic accomplishments of Dominick Labino (1910–1987). These associations led eventually, in the 1970s, to the inclusion of glassmaking in the curriculum at the Cleveland Institute of Art, which produced one of the field's young stars, Brent Kee Young. At Kent State University, not far from Cleveland, Henry Halem (see p. 55) headed one of the premier national glass programs and wrote the influential *Glass Notes: A Reference for the Glass Artist.* It is fitting that the Cleveland collection (the result of generous donations from Francine and Benson Pilloff, Dan and Linda Silverberg, and Mike and Annie Belkin, among others) should have impressive sculptural glass holdings.

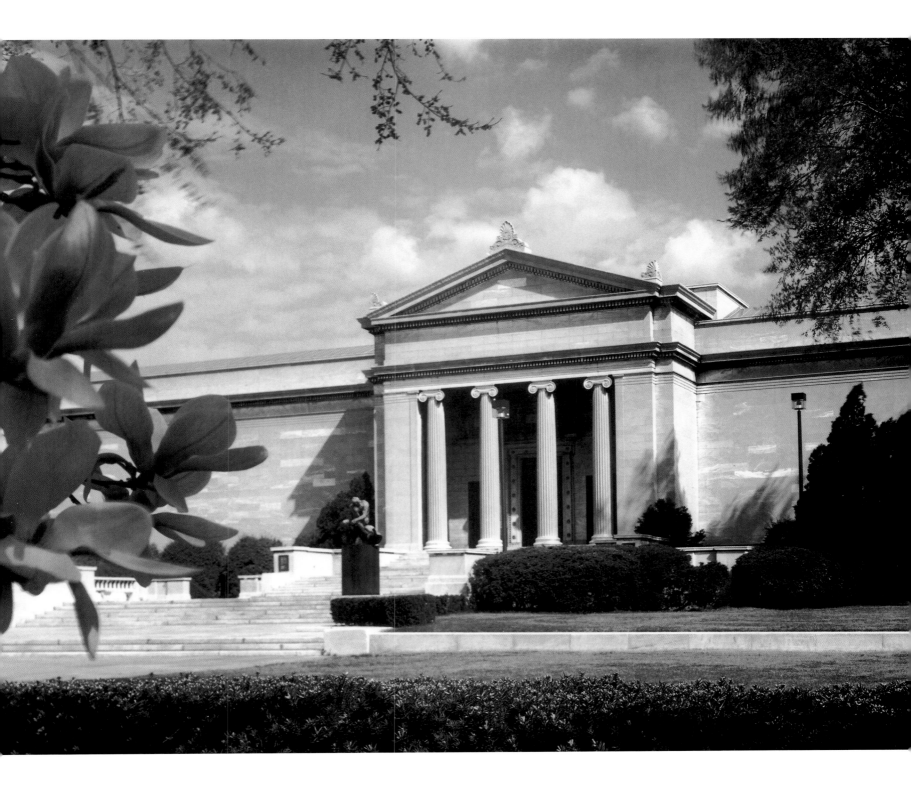

The south door of the Cleveland Museum of Art, Cleveland, Ohio

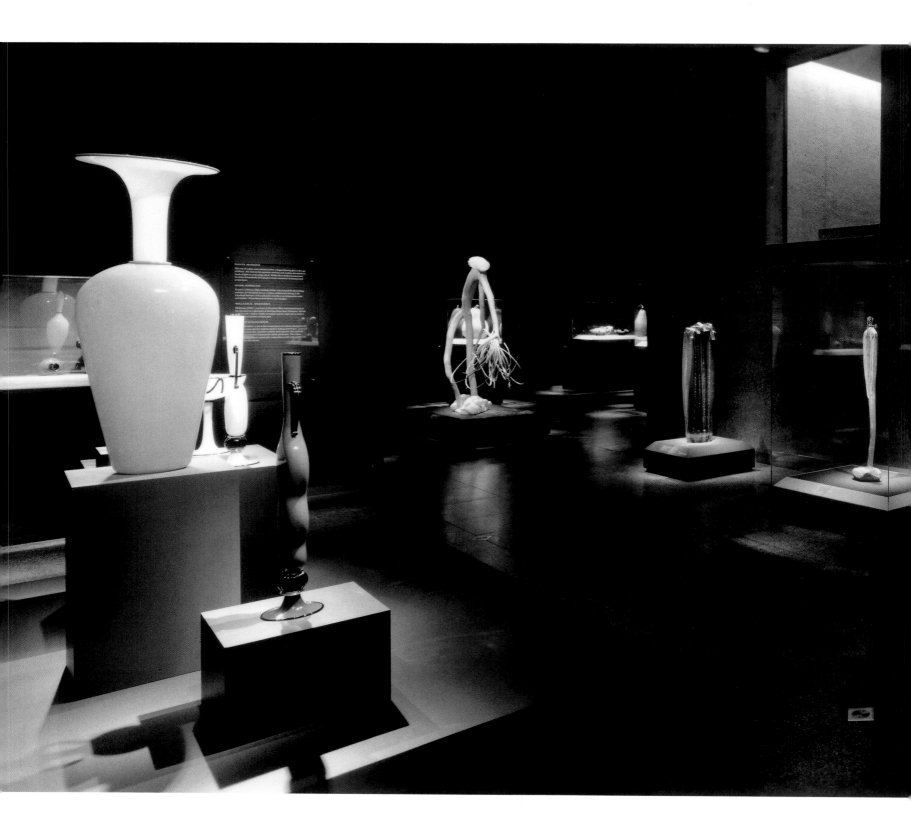

Installation of *Glass Today: American Studio Glass from Cleveland Collections*, June 22 to September 14, 1997; Dante Marioni, *Red Leaf* (1995) and *Giant Whopper Vase* (1992); Flora C. Mace and Joey Kirkpatrick, *Seasonal Spire* (1994); William Morris, *Standing Stone* (1989); Robin Grebe, *The Cultivation* (1993); Sherry Markovitz, *Swoosh* (1991); and Janusz Walentynowicz, *The Bundle* (1995)

Visitor Comments Welcome

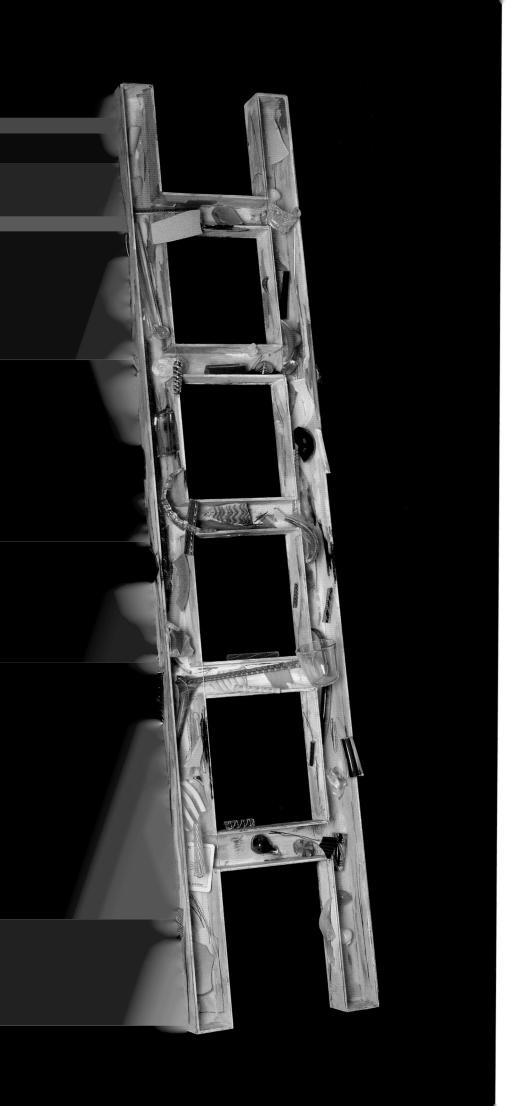

Therman Statom
American, b. 1953

Ladder, ca. 1990s
Painted glass and mixed media
85 ¼ × 175 ³⁄₁₆ in.
Cleveland Museum of Art, 1999.310
Gift of Mike and Annie Belkin

Henry Halem
American, b. 1938

Figure 1, 1988
Vitrolite and painted enamel
25½ × 19 × 3½ in.
Cleveland Museum of Art,
1997.165
Gift of Mike and Annie Belkin
in honor of the exhibition
Glass Today

Dalibor Tichý
Hungarian, b. 1950

Sea (Beaker-shaped), ca. 1980
Blown and manipulated glass
8 in. high
Cleveland Museum of Art, 1998.260
Gift of Don and Carol Wiiken

Mary Kay Simoni
American, b. 1955

No Mo, 1989
Laminated glass with plastic additions
20¹³⁄₁₆ × 10¹⁄₁₆ in. in diameter
Cleveland Museum of Art, 1997.168
Gift of Heinz and Elizabeth Wolf in
honor of Dr. Robert L. and Mrs. Dolores
Tannenbaum

CORNING MUSEUM OF GLASS
Corning, New York

Founded in 1951 as "an educational institution dedicated to the history, art, and science of glass,"[4] the museum was conceived as the cultural component of the Corning Glass Works by Arthur A. Houghton Jr., the president of Steuben Glass, a subsidiary of the Corning Corporation, and the Honorable Amory Houghton, the chairman of the board. Located in the rural city of Corning in western New York, the glassworks already offered a Hall of Science and Industry and the Steuben Glass factory as tourist attractions, but the new museum was planned not only to showcase the products of Corning but also to present the history of glass worldwide.

Coinciding with the hundredth-year anniversary of the opening of the glassworks, the museum was established as a nonprofit, tax-exempt, educational institution dedicated to the art, history, research, and exhibition of glass. Its comprehensive collection is supported by extensive holdings in the Rakow Research Library, which collects everything printed about the history and making of glass and maintains a unique collection of ephemera relating to glass technology and aesthetics. "The Corning Museum of Glass is not an art museum, nor is it a science, history, or technology museum. It is a museum about a material, and as such, it encompasses all of these areas," notes Tina Oldknow, the curator of modern glass.[5]

Corning differs from the other museums profiled here in that it is a specialized institution devoted exclusively to glass. It contains the world's largest glass collection, spanning ancient production to contemporary glass worldwide. Its numerous treasures chronicle the history of glass, beginning with ancient vessels and concluding with contemporary glass sculpture, and illustrate the varieties of glass items that can be fashioned by techniques ranging from the simple to the complex and the varieties of craftsmanship, artistry, and industrial processes.

The museum employs a professional curatorial staff to build and care for the collection and derives most of its funding from its corporate sponsor, Corning Incorporated. The galleries are installed chronologically, with the twentieth-century presentation enhanced by an overview of international, contemporary glass sculpture that is installed in the Sculpture Gallery and presented without vitrines or other barriers to inhibit the viewer's visual interaction with the works. The effect is an immediate connection between artwork and viewers, who can, thus, appreciate the works as dynamic entities occupying the same space as they themselves do.

The museum also offers public, narrated glassblowing demonstrations and teaches glassworking in its Studio. Producing and disseminating exhibitions about glass is the another key activity. In its first few years, the museum organized several exhibitions devoted to historical and contemporary glass, but by far the most significant in terms of the development of sculptural glass was an exhibition organized by the museum's founding director, Thomas S. Buechner, who was inspired by the series of contemporary design shows presented in the 1950s by the Museum of Modern Art in New York. Corning made its own assessment of the developments in contemporary glass worldwide, and the result was an international survey exhibition, *Glass 1959: A Special Exhibition of International Contemporary Glass,* produced in collaboration with the Art Institute of Chicago, the Metropolitan Museum of Art, the Toledo Museum of Art, and the Virginia Museum of Fine Arts in Richmond. The exhibition was curated by a panel of jurors who selected 292 objects from 1,814 submissions made by 173 manufacturers located in 23 countries. The most expressive work (featuring enameling, engraving, blowing, and casting) came from Czechoslovakia and Italy, confirming the seminal position of those countries and their long history of glassmaking. These pieces stood in contrast to the spare, modern aesthetic of northern Europe and Scandinavia.

The second influential exhibition to expand the audience for glass was *New Glass: A Worldwide Survey,* organized in 1979 by Buechner and William Warmus, then-curator of twentieth-century glass. Presented in conjunction with the Victoria and Albert Museum, London, and supported partially with funds from the National Endowment for the Arts and the corporate entities Owens-Illinois and Owens-Corning, the exhibition comprised 275 objects made by 196 glassmakers, designers, and manufacturers. This exhibition, unlike its predecessor, *Glass 1959,*

Exterior view of the Corning Museum of Glass, Corning, New York, with *The Glass Wall* by Brian Clarke (1998, stained glass, aluminum, and steel cable, 20¹³⁄₁₆ × 73¹³⁄₁₆ ft., Corning Museum of Glass, 99.2.4)

The Glass Wall, which measures more than a thousand square feet, is dedicated to the late Linda McCartney, the wife of the musician Sir Paul McCartney, who was Clarke's cherished friend and collaborator in photography and stained-glass projects. With painterly use of color and light, Clarke's distinctive stained glass features a repeating fleur-de-lis motif based on the lily, a favorite flower of McCartney's that for centuries has served as a symbol of royalty.

included a much higher percentage of studio glass than of commercial production. The exhibition opened in Corning, New York, and toured to the Toledo Museum of Art, the Renwick Gallery in Washington, D.C., the Metropolitan Museum of Art in New York (a last-minute addition to the venue list; see p. 104), and the California Palace of the Legion of Honor in San Francisco. It then traveled to the Victoria and Albert Museum in London, Le Musée des arts décoratifs in Paris, and to Japan, marking the first time American studio glass was shown there. The lavishly illustrated, 288-page catalogue attracted attention from private and institutional collectors. Although essentially a picture book, with only brief biographical data on the artists and statements from each juror, the catalogue provided enticing illustrations and basic information to potential collectors. The California collectors George and Dorothy Saxe recall seeing the catalogue at a friend's house, leafing through it, and being attracted to the medium. Indeed, for a time, this publication served as a guidebook for many collectors.

Since then, many more exhibitions at Corning, together with their accompanying publications, have disseminated information about contemporary glass sculpture, among them, *Thirty Years of New Glass 1957–1987: From the Collection of the Corning Museum of Glass* (1987), *Contemporary Glass: A World Survey from the Corning Museum of Glass* (1989), and *The Glass Skin* by Suzanne K. Frantz, the then-curator of twentieth-century glass. The museum also initiated the *New Glass*

Review, which is now a stand-alone, juried publication that features contemporary studio glass from around the world. Further documentation of the field and of Corning's collection was seen in *Masterpieces of Glass: A World History from The Corning Museum of Glass*, by Robert J. Charleston, published in 1990, *A Decade of Glass Collecting 1990–1999*, by David B. Whitehouse, which was published in 2000, and in a series of videos about leading contemporary glassmakers. Among the most recent exhibitions was that in the new West Bridge Gallery in the spring of 2004 entitled *The Italian Influence in Contemporary Glass* and illustrating the links between Old World and New World glass.[6]

Corning's holdings continue to give vital recognition to sculptural glass. Curatorial discretion rules the collection of modern glass under the fine leadership of Tina Oldknow, who cogently states that the collection focuses both "on historical twentieth-century glass and on contemporary glass, which includes design, craft, architectural glass, and fine art—that is, painting and sculpture."[7] Looking "for a strong and original idea that is well communicated" in each work selected,[8] and provided with discretionary acquisition funds and with the prestige of the preeminent glass museum behind her, she is in a position to search out the best works available, circumstances that permit her honed curatorial sensibility to be seen in the sophistication of the sculptural glass collection.

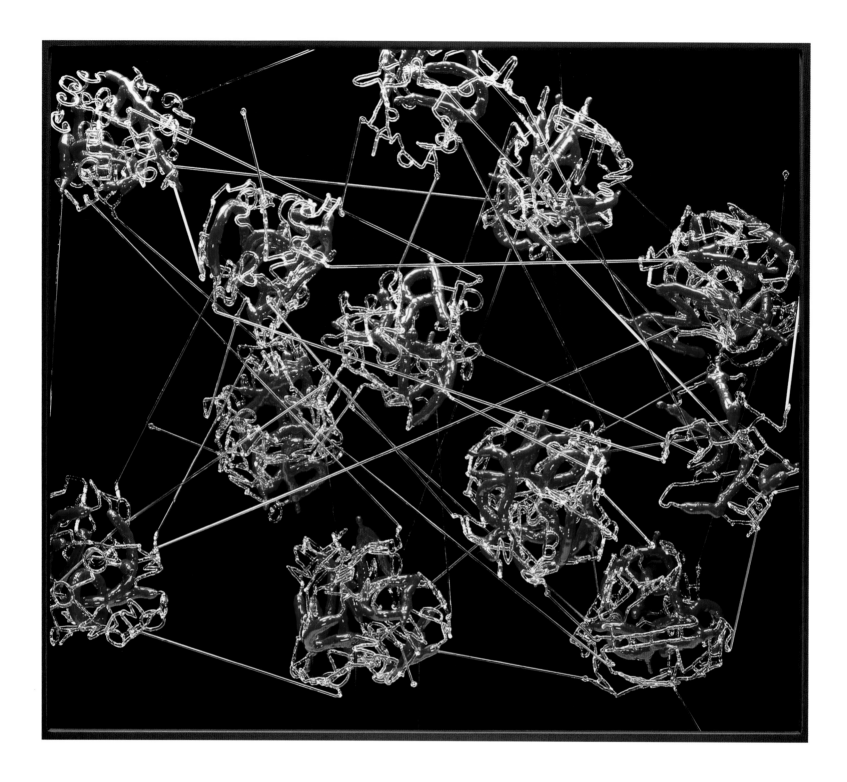

Jill Reynolds
American, b. 1956

Family Matter, 2002
Flameworked glass; glycerin, pigment, cork, and wax
52 × 57 × 27 in.
The Corning Museum of Glass, Corning, N.Y., 2002.4.64
The Seventeenth Rakow Commission

Interested in relationships among art, science, and nature
and focusing on the intersections of the body, landscape,
language, consciousness, and time, Jill Reynolds created
Family Matter as a portrait of herself and her eleven siblings
as interconnected molecules.

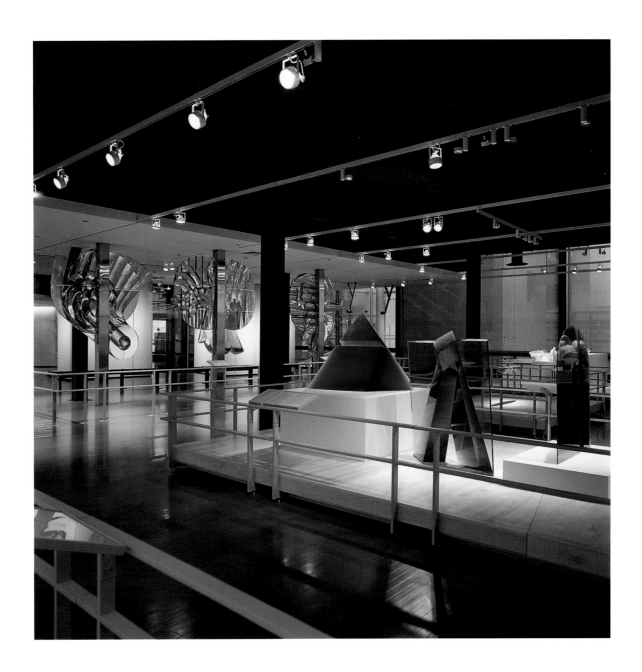

The Sculpture Gallery at the Corning Museum of Glass, with
sculptures by Stanislav Libenský (Czech, 1921–2002) and
Jaroslava Brychtová (Czech, 1924). Left to right: *Meteor/
Flower/Bird*, 1980; *Red Pyramid*, 1993; *Contacts*, 1984–1987;
Big Arcus/Arcus III, 1993
(For additional details and credits, see p. 223)

Tina Oldknow of the Corning Museum of Glass notes that "Stanislav
Libenský and his wife Jaroslava Brychtová are internationally
acclaimed artists who have pioneered, explored, developed, and
defined glass as a medium for modern sculpture." The Corning
Museum of Glass has the most comprehensive collection of their
work in the United States.

Josiah McElheny
American, b. 1966

Untitled (White), 2000
Blown, cased, and cut glass; display cabinet and lighting
22¼ × 86⅟₁₆ × 16 in.
The Corning Museum of Glass, Corning, N.Y., 2000.4.9
The Fifteenth Rakow Commission

Playing with themes of modernism and design, Josiah
McElheny creates thought-provoking works about the
history of art and of glassblowing.

Donald Lipski
American, b. 1947

Water Lilies #52, 1990
Machine-made industrial glass, metal, carrots,
preservative solution
11⁷⁄₁₆ in.
The Corning Museum of Glass, Corning, N.Y., 92.4.5
Gift of Maureen and Roger Ackerman

Donald Lipski works in mixed-media installations and
sculptures that question the conventional definitions
of art. Here industrial glass manufactured to contain
toxic substances is used instead to preserve fragile
organic elements.

Marian Karel
Czech, b. 1944

Black Cube, 2000
Glass and wood
40¾ × 40⅜ × 40⁵⁄₁₆ in.
The Corning Museum of Glass, Corning, N.Y., 2000.3.63
Gift of the artist and Heller Gallery, New York

Marian Karel uses glass to investigate properties of light
and illusion through minimal sculptural forms.

Alessandro Diaz de Santillana
Italian, b. 1959

West Sky, 1997
Blown, silvered, and assembled glass; steel
102⅜ × 10⅝ in.
The Corning Museum of Glass, Corning, N.Y.,
2000.3.25

DETROIT INSTITUTE OF ARTS
Detroit, Michigan

The Detroit Institute of Arts has a history of buying avant-garde works for its collection: *Self-Portrait* (1887), for instance, was the first van Gogh painting to enter an American museum, and in 1922, was joined by Henri Matisse's *The Window* (1916). Long before these works became part of the sanctified canon of premodern and modern art, the Detroit Institute of Arts committed city funds to add them to its collection. The building and collection are owned jointly by the city of Detroit and the Founders Society, the latter a private not-for-profit corporation that provides substantial funding for art acquisitions and other activities.[9] This division of responsibilities (a situation similar to that pertaining at the Los Angeles County Museum of Art, see p. 98) permits the art activities to be separate from the more mundane concerns about the physical plant and operations. In recent years, the state of Michigan has been contributing to the funds for general operations.

The museum was founded, "for the cultivation of art," in the mid-1880s by a group of affluent Detroiters who embodied the democratic and community-minded ideals of the period. Also in step with the period was the museum's first major gift, eight old-master paintings. Many early benefactors were leaders in the automobile industry, and they saw education as a central tenet of the museum's role, so in 1905, school children began visiting the collections regularly. The 1920s were a time of abundant funding from the city and as noted, that led to perceptive purchases to expand the collections, including works by Claude Monet, Paul Cézanne, Eugène Boudin, Edgar Degas, John Singer Sargent, and Jan van Eyck.

In 1927, the museum's Beaux-Arts building, designed by Paul Philippe Cret (primarily know for the Folger Shakespeare Library and the Federal Reserve Building, both in Washington, D.C.), opened to the public.[10] While in Berlin, William R. Valentiner, an adviser for the project, had designed galleries by grouping objects executed in a variety of media together by cultural area rather than by format or medium—an original notion at the time, and one that he suggested to Cret. Construed as re-creating the period in which works were made, this approach was popular in German installation design in the early twentieth century; during the same time, American museums were organizing displays around the art formats, with paintings displayed together and sculpture relegated to its own separate space.[11] In 1966, the North Wing (to house Asian and Islamic art along with twentieth-century art) and the South Wing (to house African Art) were added. In 1990, the architect Michael Graves was commissioned to design a new master plan to improve the integration of the museum structures. In September 2003, the curatorial departments were reduced from ten to eight and reorganized. The result of a strategic plan and a desire to provide an innovative reinstallation of its galleries, this plan, like those at the Museum of Fine Arts in Boston and at the Los Angeles County Museum of Art, links expertise by geographical location rather than along traditional curatorial lines. As with all new conceptualizations of culture, this change has spurred controversy.[12]

Commissions, in addition to the purchase of works, have long been used to augment the holdings. In 1931, during the Depression, when donations merely trickled in, the Mexican artist Diego Rivera was commissioned by Edsel Ford (under the guidance of William Valentiner) to paint a series of murals celebrating American industry, the assembly line, electricity generation, and the then-scandalous depiction of the birth of a child. These ambitious works are now on display in the Garden Court, with the cartoons for them, once thought lost, rediscovered in 1978. The Detroit Institute of Arts also supports important institutions related to American art. While he was the director, Edgar P. Richardson

Detroit Institute of Arts, exterior of the Main Auditorium; designed
1925; Paul Philippe Cret (American, 1876–1945), architect

helped to found the Archives of American Art in 1954 to document and encourage "the talent of our own day."[13]

Glass first entered the museum in 1970, with a gift from Mr. and Mrs. Walter E. Simmons. The donation included works by Harvey K. Littleton and six pieces by Dominick Labino, Littleton's fellow pioneer in glass. In 1980 and 1981, Jean and Hilbert Sosin gave eleven works by John Lewis, Charles Lotton, James Lundberg, John Nygren, and Sylvia Vigiletti. In 1987, Joan and Bernard Chodorkoff gave twenty-seven pieces in memory of their son David Jacob Chodorkoff. This gift was honored in 1991 with an exhibition *Studio Glass: Selections from the David Jacob Chodorkoff Collection,* and was timed to coincide with the longstanding annual Michigan Glass Month. An additional twenty-one pieces were gifts or purchased with funds from the local community.[14] *A Passion for Glass: The Aviva and Jack A. Robinson Studio Glass Collection* (1998) honored the gift of seventy-eight pieces and the endowment of a gallery for the display of twentieth-century decorative arts and design. Rebecca R. Hart, assistant curator of contemporary art, commented that "the DIA is committed to collecting sculptural glass [and has] enjoyed enormous support from several important collectors, who have helped shape our holdings in decorative arts."[15]

Mary Shaffer
American, b. 1947

Pouring Ribbon, 1992
Glass and metal
Each 70 in. high
Detroit Institute of Arts, 1994.5.A
Founders Society purchase, Hilbert and Jean Sosin
Contemporary Studio Glass Fund, funds from the
Decorative Arts Group, and the Twentieth Century
Decorative Arts and Design Fund

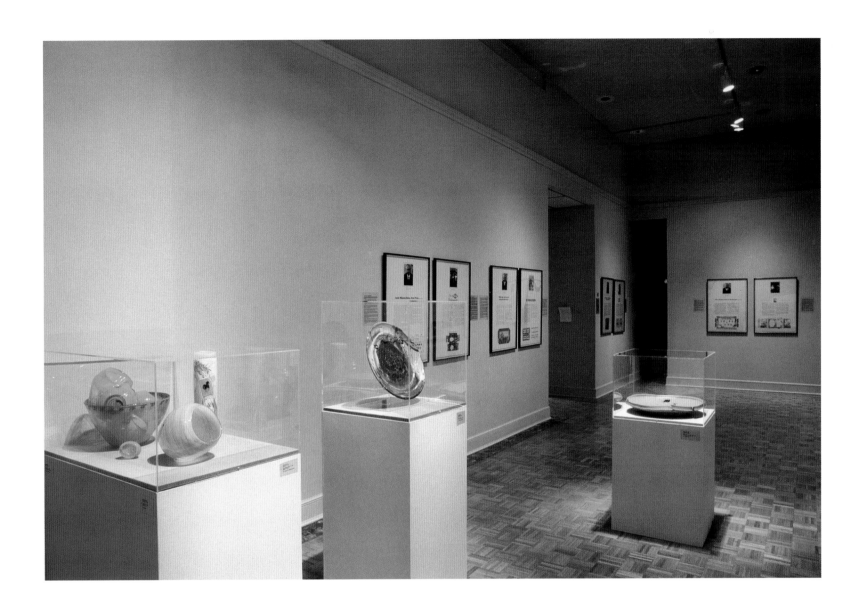

Installation photograph of the exhibition *Contemporary Art in Detroit* (1981), including Dale Chihuly's *Korallot Basket Series*, 1977 (blown glass, six pieces, approx. 13 × 16 × 16 in., Detroit Institute of Arts, 1996.92.A, gift of the Jack A. and Aviva Robinson Collection)

Michael Glancy
American, b. 1950

Terra-cotta Crown Jewel, 1985
Blown and sandblasted glass, electroformed
copper
5¼ × 9 in.
Detroit Institute of Arts, 2000.145
Gift of Drs. Joan and Bernard Chodorkoff
for the David Jacob Chodorkoff Collection

Robin Grebe
American, b. 1957

Garden Repose, 1990
Cast glass, concrete, glazed earthenware,
and carved wood
37½ × 16 × 8¼ in.
Detroit Institute of Arts, 1999.1389.A
Gift of Drs. Joan and Bernard Chodorkoff
for the David Jacob Chodorkoff Collection

M. H. DE YOUNG MEMORIAL MUSEUM
San Francisco, California

The Fine Arts Museums of San Francisco comprise two institutions: the M. H. de Young Memorial Museum located in Golden Gate Park and the California Palace of the Legion of Honor situated near the Pacific Ocean in Lincoln Park. The once-rival institutions were placed under a single umbrella organization in 1972, which led to a consolidation of activities and a redistribution of the collections. The Legion of Honor is devoted to the arts of France and the de Young displays art from all other nations as well as contemporary art. Both museums, like so many on the West Coast, owe their existence to a nineteenth-century international exposition.

The de Young Museum, which houses the sculptural glass collection, grew out of the California Midwinter International Exposition, held in 1894. Planned as part of a boosterism campaign led by Michael de Young, the youthful publisher of the *San Francisco Chronicle,* the exposition featured products and artifacts from exotic climes. This meant that the de Young's founding collection was more diverse than that of most art museums, as it included both artworks and artifacts of material culture. De Young was not a trained museum professional, and when he began to expand the collection, he keenly felt his lack of expertise. However, following his own taste, he assembled a collection of curious and ornamental objects (typically from the South Pacific and Native American cultures), as well as painting, sculpture, arms and armor, and fine porcelains.

After the exposition, the museum was erected on the same spot in Golden Gate Park, facing the Music Concourse and the California Academy of Sciences. In an attempt to create links to the other "lands of sunshine," the original museum building was designed in the Egyptian Revival–style, reflecting de Young's own eclectic taste. The first museum building expanded several times during the early 1920s, but it was demolished in 1929 for safety reasons, just as its successor would be in 1989, after the Loma Prieta earthquake. Currently the museum is being completely rebuilt and its galleries reorganized, events that have proved fortuitous for sculptural glass.

The collections are wide ranging. In the 1950s, the de Young received a major gift from the Kress Collection that included important pieces by El Greco (Domenikos Theotokopoulos), Pieter de Hooch, Salomon van Ruysdael, Titian, and Tiepolo. These were soon joined by the Oakes Collection, containing masterpieces by Peter Paul Rubens, Jan van Dyke, and Thomas Gainsborough. In 1973, the de Young became a center for American art when, under the leadership of Ian White, it began hosting the West Coast Area Center of the Archives of American Art, a bureau of the Smithsonian Institution. Later, the museum received a gift from Mr. and Mrs. John D. Rockefeller of more than a hundred additional works of art.

Historical glass has always been part of the de Young's holdings, but during the early years the museum did not actively collect sculptural glass, even though it mounted the occasional glass exhibition, such as *The Art of Louis Comfort Tiffany* in 1981. It was an important donation that sparked institutional interest: George and Dorothy Saxe donated a significant portion of their collection to the museum. An exhibition, *The Art of Craft: Contemporary Works from the Saxe Collection,* in 1999 and an accompanying catalogue honored their promised gift of more than 220 artworks in ceramics, glass, fiber, metal, and wood—the museum's first large donation of contemporary craft.[16] The Saxes have extended their support for sculptural glass through an endowment for curatorial purchases. Under the talented guidance of Tim Burgard, the Ednah Root Curator of American Art and curator in charge of the American Art Department, whose philosophy of collection building entails the

Rendering of the exterior of the new de Young Museum,
San Francisco, scheduled to open in 2005

"serious art-historical consideration [of art objects] within a larger cultural context,"[17] the past and the potential of sculptural glass has been aptly weighed:

> Most observers would agree that the greatest obstacle to the interpretation of crafts within a broader cultural context has been their exclusion from the mainstream art world. Yet, ironically, while this external prejudice has fostered internal solidarity, it also has led the craft community to perpetuate its marginalized status through the creation of specialized schools, galleries, periodicals, critics, collectors, support groups, museums, and curators. Until craft institutions strike a balance between unalloyed advocacy and the application of rigorous art-historical standards, and until mainstream institutions broaden their limiting definitions of art and craft, this potent combination of pride and prejudice will continue to diminish the cultural landscape. Ultimately, collectors may provide the solution to this equation, as they use their collections to engage in mutually enlightening dialogues with mainstream museums.[18]

The reconceptualized de Young will open in 2005 in a building designed by the Swiss architectural firm of Herzog & de Meuron and, in Burgard's nuanced installation of sculptural glass alongside other arts from the Americas, glass will be accorded the same standing as paintings and other sculptural and decorative arts objects in the new galleries.

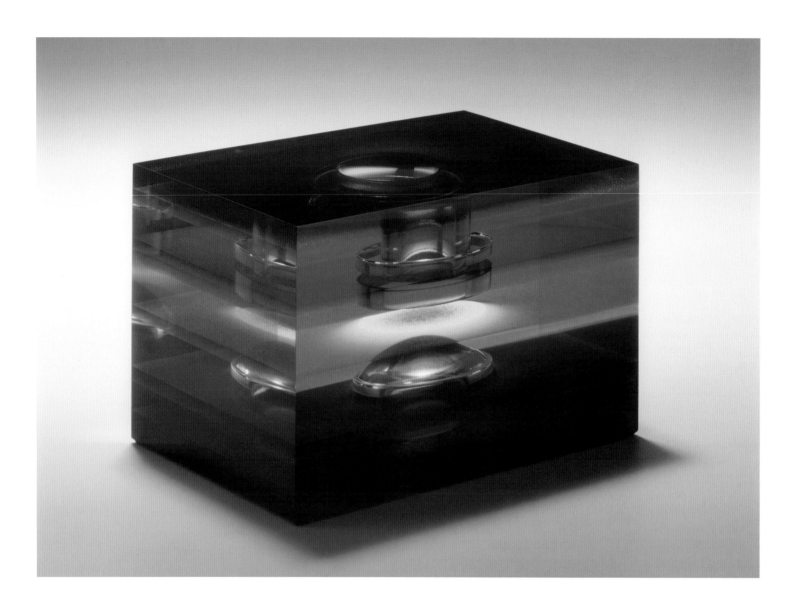

Thomas J. Patti
American, b. 1943

Spectral Starphire with Amber, Blue, Green,
Red, and Black, 1996
Float glass
1¹⁄₁₆ × 6¼ × 4⁷⁄₁₆ in.
Fine Arts Museums of San Francisco, A358220
Promised gift of Dorothy and George Saxe to the
Fine Arts Museums of San Francisco

Dan Dailey
American, b. 1947

Baboon (no. 14), 1994
Blown glass
15¼ × 11½ × 12 in.
Fine Arts Museums of San Francisco, A358129
Promised gift of Dorothy and George Saxe to the
Fine Arts Museums of San Francisco

Betty Woodman
American, b. 1930

Triptych A, 1993–1996
Blown glass
Left: 22 × 19½ × 6 in.; center: 16 × 21½ × 6 in.;
right: 23¼ × 17 × 6¾ in.
Fine Arts Museums of San Francisco, A358314
Promised gift of Dorothy and George Saxe to the
Fine Arts Museums of San Francisco

Nicolas Africano
American, b. 1948

Woman Eating Fruit, 1997
Cast glass
15 × 8³⁄₁₆ × 8⅛ in.
Fine Arts Museums of San Francisco, 2002.148.1
Partial gift of Dorothy and George Saxe to the
Fine Arts Museums Foundation

William Morris
American, b. 1957

Garnering #3, 1991
Blown glass
36 × 24 × 24 in.
Fine Arts Museums of San Francisco
Gift of Dale and Doug Anderson, Sam and Eleanor
Rosenfeld, Ron and Anita Wornik, and William Morris
in honor of George and Dorothy Saxe

High Museum of Art

Atlanta, Georgia

The High Museum of Art grew from the Atlanta Art Association, which was founded in 1905 to support the applied and fine arts, to host lectures, to offer practical instruction and, eventually, to open a museum. The first permanent home came from Hattie High, a local citizen who donated her Tudor-style house to the association in 1926. The museum was there until 1955, when it moved next door to a new, larger facility with climate controls for the protection of the artworks. In 1962, one hundred and twenty-two patrons of the arts from Georgia were killed in a plane crash while on a museum-sponsored European art tour. The Atlanta Arts Alliance was created in their honor and opened the museum in 1968.

By 1979, the museum and its expanded programming had outgrown its physical plant and a new building was needed. Robert W. Woodruff, an executive with the Coca-Cola Corporation, offered a challenge grant for $7.5 million, and this offer was followed by a burst of civic fundraising that resulted in groundbreaking in 1981. The new facility, which opened on October 15, 1983, was designed by Richard Meier and Associates of New York, an international architectural group later renowned for the stately J. Paul Getty Museum complex in Los Angeles. In this third iteration of the High Museum, Meier was successful in harmonizing the existing structures, setting them within a unified urban space, and creating the main facility in the midtown. The resulting museum now comprises the High Museum of Folk Art and the Photography Galleries in the Georgia-Pacific Center and the midtown facility.

Meier's design embodied the museum's goals—its mission being to provide "a place of aesthetic illumination,"[19]—for the High has become the leading art museum of the southeastern United States, with encyclopedic collections of African and folk art, modern and contemporary art, fine nineteenth- and twentieth-century American furniture, and the Kress Collection of historical Italian paintings and sculpture. Decorative arts occupy a prized position with a collection that spans the period between colonial times and the present. In the late 1980s, the High undertook a partnership with the Georgia-Pacific Center in downtown Atlanta to accommodate traveling exhibitions in the forty-five-hundred-square-foot gallery space there. In time, these galleries came to house the photography collection. Currently, the Woodruff Arts Center is being upgraded by the Italian architect Renzo Piano and is scheduled to open in the spring of 2005. This rapid growth and the selection of a world-renowned architect places the status of the High Museum on a secure national footing.

The art installations at the museum are usually presented in thematic groupings that permit the cross-pollination of ideas through the placement of works from different eras and stylistic periods side by side, permitting the viewer to see the art in new and unexpected ways and breaking old patterns of familiarity. This display strategy has spurred the High to collect in areas outside those usually frequented by American museums. When Fred and Rita Richman made their donation in 1972, the museum became an early holder of African art and for this collection dedicated the gallery space in 1977. The High also has an impressive holding of nineteenth- and twentieth-century photography. Sculptural glass became part of the collection through the largess of Daniel Greenberg and Susan Steinhauser, Ron and Lisa Brill, and the Elsons, and takes its place beside the museum's other fine holdings.

Exterior of the High Museum of Art, Atlanta, Georgia

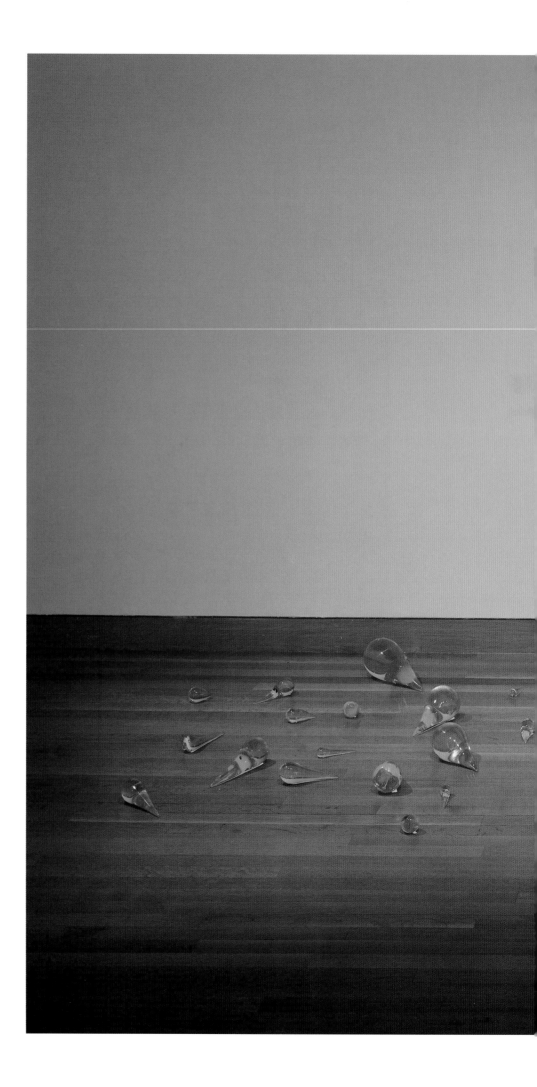

Kiki Smith
American, b. Germany 1954

Mother, 1992–1993
Glass and steel
Installation, size variable
High Museum of Art, 1993.111
Purchase for the Elson Collection
of Contemporary Glass

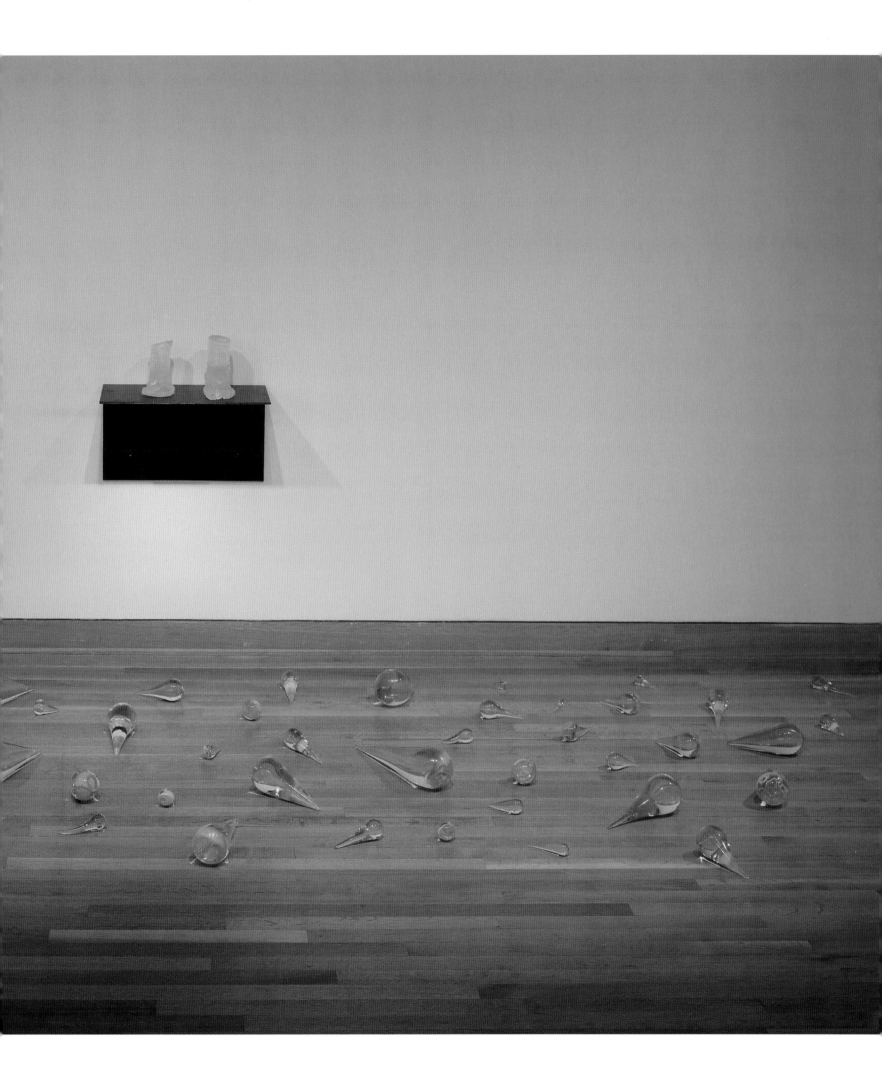

Joel Philip Myers
American, b. 1934

C Four Blue HGD, 1989
Blown glass, glass shards
15 × 14 × 14 in.
High Museum of Art, 1989.53
Purchase in honor of Nancy Wendling Peacock,
president of the Members Guild, 1989–1990

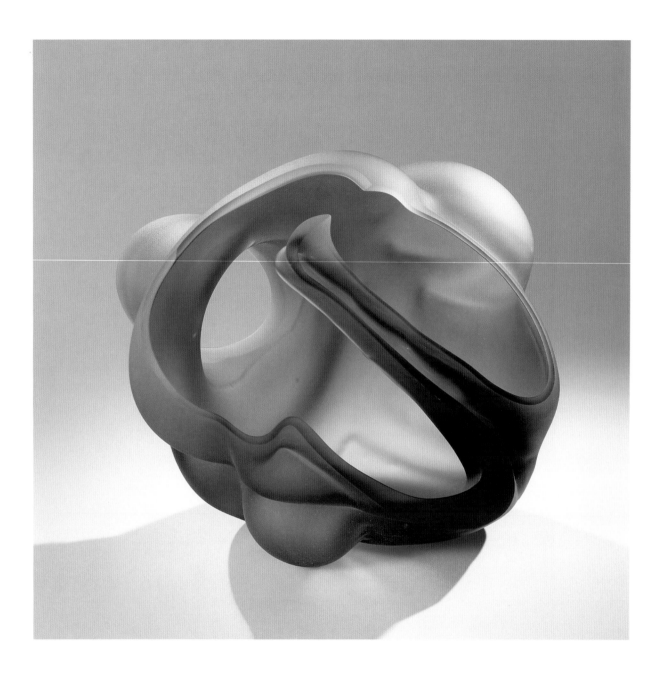

Marvin Lipofsky
American, b. 1939

Süssmuth Series, 1980–1981
Mold-blown glass, cut and acid polished
10 × 8½ in.
High Museum of Art, 1984.26
Purchase for the Elson Collection of Contemporary Glass
and gift of Dr. Stanley Cohen through the 20th Century Art
Acquisition Fund

Harvey K. Littleton
American, b. 1922

Sympathy, 1978
Barium/potash glass with cased double overlay of
Kugler colors drawn and cut on a lead optic base
16 × 10 × 8½ in.
High Museum of Art, 1984.36
Gift of the artist

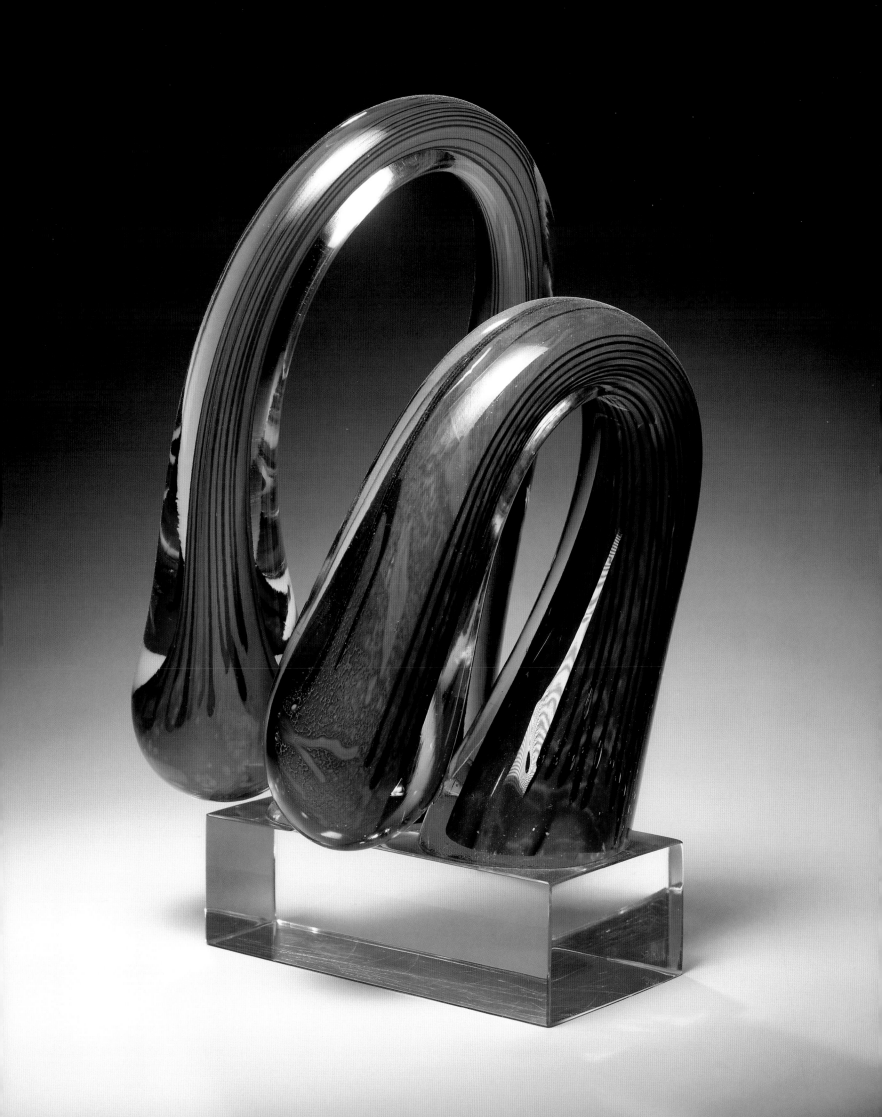

INDIANAPOLIS MUSEUM OF ART
Indianapolis, Indiana

The Indianapolis Museum of Art, renowned for its fine international art collection, became a leader in the sculptural glass world in the late 1990s when Marilyn and Eugene Glick donated selections from their collection of contemporary glass. As a result of their generosity, the museum now has 225 donated or promised works of contemporary sculptural glass and, in 1997, became the first American museum to publish a catalogue of its permanent collection of studio glass. This collection catalogue, *Masters of Contemporary Glass: Selections from the Glick Collection,* honoring the gift, is devoted exclusively to glass and was one of the first publications in which contemporary glass was treated with the rigor regularly applied to historical material.[20]

The Indianapolis Museum of Art is an encyclopedic museum that was founded in 1883 during the great wave of museum building that swept the United States at the end of the nineteenth century. Wide-ranging in its holdings, the museum boasts a number of "collections within collections"—old-master works, American painting since 1800, Asian art (with an emphasis on Chinese art), and African, South Pacific, pre-Columbian, and Native American art.[21] As with so many major American museums, it grew from an exhibition-oriented arts organization and eventually attracted the interest (along with significant donations of artworks and money) of Dr. George H. A. Clowes and several generations of the Eli Lilly family. Continuing that generosity, in 1968 Josiah Lilly donated the historic 1930s Oldfields House (now included on the National Registry of Historic Places) and its fifty-two-acre estate. The property is now used to display period decorative arts. The core of the art museum is located in adjoining pavilions: the Kannert Pavilion (American, Asian, and contemporary art), the Clowes Pavilion (old-master paintings), and the Mary Fendrich Hulman Pavilion (European painting and sculpture). Currently undergoing additional building, the museum has plans for a seventy-five-million-dollar addition to comprise the Oval Entry Pavilion, the Gallery Pavilion, and the Garden Pavilion that will complete the multifaceted complex and increase the display space by 50 percent. Also part of the museum is the one-hundred-acre Virginia B. Fairbanks Art and Nature Park, which is to open in 2005.

Sculptural glass resides in the decorative arts department, together with eighteenth-century French, English, and American porcelain and glass, such as works by René Lalique, Emile Gallé (French), Louis Comfort Tiffany (American), and Josef Hoffmann (Austrian), and the *Gazelle Bowl,* ca. 1939, by Sidney Waugh (American). The addition of contemporary sculptural glass broadened the scope of the decorative arts and contemporary arts holdings and is an effect of the enthusiasm and assistance provided by collectors and the receptivity of the curators within the department.

Marilyn and Eugene Glick had amassed a blue-chip collection during the 1980s. Spurred by Mrs. Glick's enthusiasm, this undertaking had been transformed from a desire to enhance their home and Mr. Glick's office to the creation of a prominent selection of glass artworks. Interested in glass since the early 1970s, Mrs. Glick had visited exhibitions of glass at the Toledo Museum of Art (see p. 202), but did not become smitten until her friend and fellow collector Dorothy Gerson reintroduced her to it in the early 1980s. After the initial acquisition of a piece by Harvey Littleton, the quest for sculptural glass became a serious occupation.

To expand her knowledge, Mrs. Glick contacted Robert Yassin, then the director of the Indianapolis Museum of Art, and Penelope Hunter-

The Mary Fendrich Hulman Pavilion, Indianapolis Museum of Art, completed in 1990 and housing the museum's European painting and sculpture collections, the latter including glass sculpture

Stiebel, who was then on the curatorial staff at the Metropolitan Museum of Art in New York. At Hunter-Stiebel's suggestion, Mrs. Glick traveled to Heller Gallery in New York and to Habatat Gallery near Detroit. In 1988 Mrs. Glick approached her hometown museum and sought to establish a relationship that could result in a substantial donation to the museum over time. She began working with Barry Shifman, the curator of decorative arts. Shifman, a recognized scholar of European eighteenth-century decorative arts, took to the challenge of learning about glass, offering direction to Mrs. Glick with enthusiasm. "Mrs. Glick," he notes, "is the best donor in the country."[22] This relationship between the collector and the curator resulted in the initial gift, in 1997, of fifteen works and the partial gift of another fifty-five that

was honored with the collection catalogue mentioned above. The exhibition that was mounted in September of 1997 to honor the museum's acquisition for its permanent collections marked a milestone in the acceptance of sculptural glass by the museum world.

The Indianapolis Museum of Art will, in time, have works by more than a hundred artists, including stellar pieces by the Americans Howard Ben Tré and Harvey K. Littleton, the Czechs Stanislav Libenský and Jaroslava Brychtová, and the British artist Colin Reid. These internationally known artists are all recognized for their monumental glass sculpture, and their work is well placed in the museum's collection alongside other masterworks by Hans Hofmann, Pablo Picasso, and Fernand Léger.

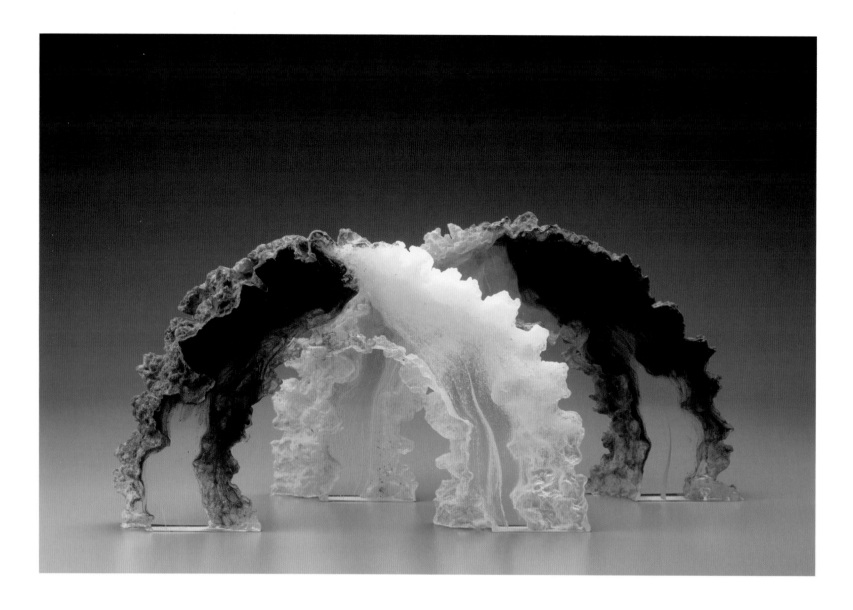

Colin Reid
British, b. 1953

Double Arches, 1986
Kiln-formed lead glass
Each part 11½ × 19 × 1½ in.
Indianapolis Museum of Art, IMA 2001.67
Partial and promised gift of Marilyn and Eugene Glick

The arch by its nature moves through space and links two
points on the earth. Reid included grit in the form of ordinary
dirt to create a rough texture that he then contrasted with the
still sheen of the polished areas to animate the surface and
underscore the content.

Stanislav Libenský and Jaroslava Brychtová
Czech, 1921–2002, and Czech, b. 1924, respectively

Head I, 1957–1959
Mold-formed glass, cut and polished
14½ in. high
Indianapolis Museum of Art, IMA 2001.21
Partial and promised gift of Marilyn and Eugene Glick

This work is known in two versions and its twin is at the
Corning Museum of Glass, New York. Shown at Corning's
Glass 1959 exhibition, it was the first of the two artists'
collaborative works to be shown in the United States.

Installation view of the Fesler Gallery, Indianapolis
Museum of Art, with Bertil Vallien's *Calendarium*
(1990) from the Marilyn and Eugene Glick collection

Harvey K. Littleton
American, b. 1922

Blue Crown, 1988
Cased glass
Approx. 20 × 16 × 13 in.
Indianapolis Museum of Art
Gift of Marilyn and Eugene Glick

During the 1980s Littleton explored the possibilities of making
color compositions with cased and drawn glass. This work
captures his dual interests in sculpture and in the technical
ability to form such large glass pieces.

Howard Ben Tré
American, b. 1949

Second Vase, 1989
Cast glass, gold leaf, and bronze powder
71½ × 23¾ in. in diameter
Indianapolis Museum of Art, 1989.113
Gift of Marilyn and Eugene Glick

Second Vase, fabricated from cast glass, gold leaf, and bronze powder, is an overscaled vessel sculpture. Consisting of a circular form out of which rises a long neck, the work evokes an ancient ritual object. The complementary and perfectly integrated shapes have a Cycladic clarity and totemic mystery. As with all of Ben Tré's works, this object is a masterpiece of restraint, the rough cast glass and its surface imperfections balanced by perfect proportions.

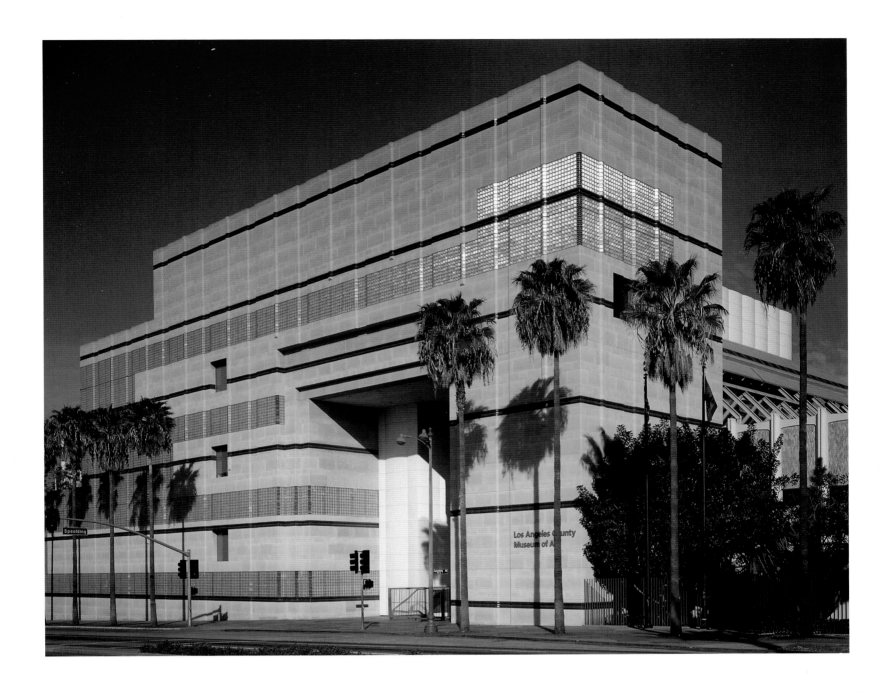

collection of contemporary paintings and sculptures located on the second floor. This installation underscored the museum's commitment to sculptural glass. Pieces from several donors have since been accessioned by both the Contemporary Art Department and the Decorative Arts Department, and have resided in the Anderson Building and throughout the museum. In 2004 another gift from Mr. Greenberg and Ms. Steinhauser enhanced the first and prompted the production of a permanent collection catalogue, to be written by Howard Fox of the Contemporary Art Department of the Los Angeles County Museum of Art and Sarah Nichols of the Carnegie Museum of Art, Pittsburgh, and published in 2005.

Exterior of the Los Angeles County Museum of Art, California, 1995

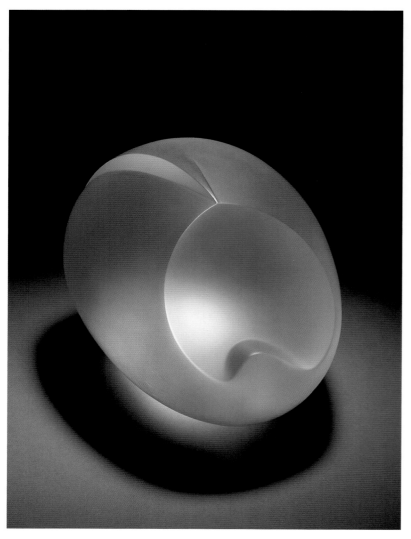

Sherrie Levine
American, b. 1947

Crystal Newborn, 1993
Cast glass
5 × 8 × 5½ in. in diameter
Los Angeles County Museum of Art, AC1997.249.31
Gift of Daniel Greenberg and Susan Steinhauser

Sherrie Levine
American, b. 1947

Black Newborn, 1994
Cast and sandblasted glass
5 × 8 × 5½ in. in diameter
Los Angeles County Museum of Art, AC1995.87.1
Purchased with funds provided by Daniel Greenberg
and Susan Steinhauser

Clifford Rainey
Irish, b. 1948, active in the United States

Hollow Torso, No Step is Final,
2000–2001
Glass, Napa River stone, maple, iron,
chain, C-clamps, gold leaf, and pigment
34½ × 12 in.
Los Angeles County Museum of Art,
M.2001.152.1–.3
Purchased with funds provided by the Glass
Alliance of Los Angeles and the Decorative
Arts Council

Ginny Ruffner
American, b. 1952

Beauty's Alter Ego as a Tornado, 1990
Glass and paint
18 × 11 × 11 in.
Los Angeles County Museum of Art, M. 91.18
Gift of Brendan Walter and Ginny Ruffner

Kéké Cribbs
American, b. 1951

Sailing to Byzantium, 1986
Sandblasted glass, gold leaf, wood, paint, and papier mâché
18¹³⁄₁₆ × 17⅞ × ⅝ in.; 11½ × 29⅛ × 7 in.
Los Angeles County Museum of Art, M.90.9a–b
Gift of Maxine Mayo

METROPOLITAN MUSEUM OF ART
New York

The Metropolitan Museum of Art, New York ("the Met," as it is known worldwide), is the preeminent encyclopedic museum in the United States. Located in the financial capital of the country, it was established by a group of businessmen and financiers intent on bringing art and art education to the people of New York. Many books have been written on the Met and its history, so only a few details will be recounted here.

Founded in 1870 as an expression of the ebullient cultural expansion of late nineteenth-century America, the Met opened one year after its rival across Central Park, the renowned American Museum of Natural History. Among the founders were John Jay, William Cullen Bryant, and that larger-than-life character, J. P. Morgan. It was patterned originally on the South Kensington Museum (later the Victoria and Albert Museum) and the British Museum by its first director, Luigi Palma di Cesnola (known as "the General" for his service in the Civil War and his actions as a somewhat shady procurer of objects for the Met's collections).[27]

The Met's first collections consisted of plaster-of-Paris reproductions of antique artworks selected in conformity with the prevailing nineteenth-century art tastes, that is, selected to reflect the so-called best art of the past and to educate the taste and morality of working-class New Yorkers. Almost immediately the institution fell short of accomplishing its goals: the only day that the working classes could go to the museum was Sunday, when the building was closed in deference to the middle-class religious sensibilities of the august board of trustees.[28] Subsequently, when J. P. Morgan became president, the collections began their rise to world-class status and the staff became professionalized. Throughout the years, many expansions and reorganizations have occurred as the museum increased its extensive holdings of masterpieces and came to provide visitors with an unparalleled selection of art from around the world and across all time periods and cultures.

The relationship with sculptural glass can be traced to the *International Exhibition of Contemporary Glass and Rugs,* organized by the American Federation of Arts in 1929–1930, and to, among other things, the display of works by the early glass artist Maurice Heaton in selected industrial design shows. In the late 1950s, the Met collaborated with the Corning Museum of Glass, and three other participating institutions— the Art Institute of Chicago, the Toledo Museum of Art, and the Virginia Museum of Fine Arts in Richmond—in presenting *Glass 1959: A Special Exhibition of International Contemporary Glass* (see the Corning Museum of Glass, p. 58).[29] In the early 1970s, the Met installed the traveling show *Objects: USA,* in which a selection of glass objects was included.

The museum made several key acquisitions of glass for its permanent collections during the period between the mid-1960s and the late 1970s. These were prompted in part by increased interest in what the high art world called "new media" and in part by curators who were actively interested in the medium. Henry Geldzahler, then curator of contemporary art, saw a piece from Dale Chihuly's *Navajo Blanket Cylinders Series* (1976) and promptly purchased it for the collection. The next year he accessioned *Amber Crested Form* (1977) by Harvey Littleton.

The significance of these acquisitions underscores two points that are important to the growth of sculptural glass: first, the works entered the museum early in the development of sculptural glass; and second, they were brought in under the aegis of the contemporary art department. Given the hierarchy among museum departments, the status of sculptural glass is immediately enhanced when it is acquired by a department linked to painting and sculpture. The department that accessions a work is not mentioned on the label copy or in other public notices, but it is known within the art and museum world. Writing in 1990, Geldzahler discussed his acquisitions by linking them to historical works and noting a similarity between the visual impact of glass and the "great traditions of watercolor and color field painting" in America.[30] He positioned Chihuly within the American watercolor tradition and the color field painting school, connecting his work to the "veils of Morris Louis, the chevrons and stripes of Kenneth Noland, and the large stained chromatic landscapes of Helen Frankenthaler."[31]

Of further importance to sculptural glass at the Met was the traveling exhibition *New Glass: A Worldwide Survey.* Organized in 1979 by the

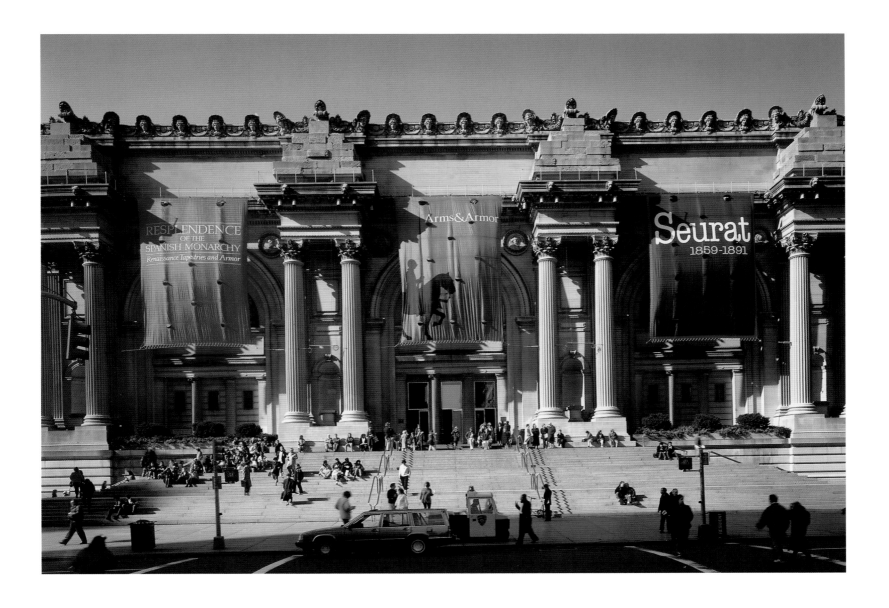

The Metropolitan Museum of Art, New York, exterior, view to the west; façade with MMA banners; photographed in 1991
The Metropolitan Museum of Art © 1991

Corning Museum of Glass, in conjunction with the Victoria and Albert Museum in London, and supported in part by the National Endowment for the Arts, the survey offered another, serendipitous boost to the standing of sculptural glass at the museum. As a last-minute add-on venue, a result of the interest of the curator, Penelope Hunter-Stiebel, the Met presented an edited version of the original show. The influence of the exhibition on the sculptural glass movement can be gauged by the observation, made by Doug Heller, a dealer in glass, that it "was a landmark exhibition in many ways." He felt that the validation from the Met could not have come at a better time or from a better institution.[32]

Subsequently during her tenure in the early 1980s, Hunter-Stiebel actively exhibited glass and added it to the Met collections. Deploying a time-honored curatorial gambit, she secured gifts from artists and donors instead of finding money to purchase artworks directly. In 1981, she published a seminal article in the high art world magazine, *ArtNews*, in which she recounted the development of glass.[33] The essay was widely read and helped to pique interest through its profiles of several prominent studio glass artists. In 1996, after some years of

quiescence, Jane Adlin, then an assistant curator, mounted an exhibition, *Studio Glass in the Metropolitan Museum of Art,* of thirty-nine glass artworks and wrote the accompanying catalogue. Her work on this project was aided by Dale and Doug Anderson, who generously gave their time, resources, and expertise to the creation of this exhibition, as they encouraged fellow collectors to donate sculptural glass that greatly enhanced the Met's collection.

Over time, the Met has acquired works by Howard Ben Tré, William Carlson, Dale Chihuly, Dan Dailey, Michael Glancy, David Huchthausen, Joel Philip Myers, Narcissus Quagliata, and Steven Weinberg, among others, for its permanent collection. Chief among its important holdings are works donated by Dale and Doug Anderson, and Doug and Michael Heller that join the museum purchases.

Michael Glancy
American, b. 1950

Pie-R-Square, 1980
Glass, silver, and copper
Vase: 4¾ in. in diameter; base: 1 × 8 × 8 in.
The Metropolitan Museum of Art, 1980.371ab
Gift of Douglas and Michael Heller, 1980
Photograph © 1995 The Metropolitan Museum of Art

Richard Posner
American, b. 1948

The Persistence of Vision, 1975
Glass, metal, wood, and mirrored glass
24¾ × 27½ in.
The Metropolitan Museum of Art, 1982.121
Purchase, Best Products Foundation Gift, 1982
Photograph © 1996 The Metropolitan Museum of Art

William Morris
American, b. 1957

Suspended Artifact, 1993
Glass and iron
24 × 26 × 7 in.
The Metropolitan Museum of Art, 1994.386a–d
Gift of Dale and Doug Anderson, 1994
Photograph © 1994 The Metropolitan Museum of Art

MILWAUKEE ART MUSEUM
Milwaukee, Wisconsin

The Milwaukee Art Museum collects a wide range of art, from ancient to contemporary, and presents a selection of art for every taste, with particular strengths in American decorative arts (augmented by the collaborative relationship with the Chipstone Foundation, known for its collection of historical American decorative arts), master paintings by Jean-Honoré Fragonard, Francisco de Zurbarán, and Gustave Courbet, and sculpture by Auguste Rodin, Alexander Archipenko, and Donald Judd.

In the 1880s, Milwaukee was a thriving port city populated by a stream of northern European immigrants, among them a group of German panorama painters, who depicted biblical or historical scenes in this once-popular public art format and served as the force behind the founding of Milwaukee Art Association. Merging with other arts groups after World War II, the association then commissioned a building designed by the Finnish architect Eero Saarinen in 1957 to house an umbrella group called the Milwaukee Art Center. In 1975 an addition was designed by Kahler, Fitzhugh, and Scott of Milwaukee, and in 1980 the center changed its name to the Milwaukee Art Museum.

The museum has a long history of glass collecting and exhibition. In the mid-1960s glass by Harvey K. Littleton joined the collection, and traveling exhibitions that included glass were prominent: *Objects: USA* (shown in 1971), a show of Littleton's glass in 1985, and *Craft Today: Poetry of the Physical* in 1988, to name a few. In 1993, glass was the focus of the exhibition *Tiffany to Ben Tré: A Century of Glass,* curated by the longtime supporters and donors Audrey Mann (in her capacity as volunteer curator) and Joan Barnett. That was followed by *Recent Glass Sculpture: A Union of Ideas* in 1997.[34]

The museum's collection of contemporary glass sculpture began with a donation of fifty pieces by Dr. Sheldon and Mrs. Joan Barnett; the donation was honored in 1990 with an exhibition. Other donations included about twenty-five pieces from Don and Carol Wiiken. In addition to individual glass artworks, the museum has incorporated glass as part of the structure: Dale Chihuly's chandelier is installed in the Quadracci Pavilion (see p. 113). Part of an installation that began as sketches by Chihuly in February 1994, the works were blown by Chihuly and his team in collaboration with artisans in five countries, United States, Finland, Ireland, Mexico, and Italy. A piece was made for each participating country and reflects the local glassmaking tradition. In their first installation, the chandeliers were suspended over the canals, gardens, and piazzas of Venice in September 1996. Installed since then in a number of venues, the works were assembled in a unique configuration for each setting. When the chandeliers arrived in Milwaukee, Laurie Winters, the curator of earlier European art and sculpture, selected as context several sixteenth- and eighteenth-century paintings by the Venetians Jacopo and Francesco Bassano, Tintoretto, Veronese, Tiepolo, Sebastiano Ricci, and Francesco Guardi to be displayed with the chandeliers.

While the museum's collections have grown, its display practices for glass have remained traditional, and sculptural glass is not intermingled with other art media. Instead, it is installed independently in a dedicated space. Currently, the museum holds about 150 pieces of sculptural glass, which are displayed on the mezzanine level of the building designed by Kahler in 1975. The future of glass within the museum is being challenged by the Racine Art Museum's enthusiastic attention to glass. Glenn Adamson, the curator at the Milwaukee Art Museum, comments that "studio glass seems to me to be a point of entry to the art world—a medium that gives the public, and beginning collectors, a chance to involve themselves deeply in aesthetic experience. Much like impressionist paintings, studio glass is easy to like; but, also like impressionism, it can . . . offer surprising depth. As the glass field moves forward into a new century, one hopes that younger makers will recognize this potential, and pull the medium's adherents into ever more adventurous territory."[35] With Adamson in charge, the Milwaukee Art Museum will certainly explore interesting and adventurous territory in its appreciation of sculptural glass.

Exterior of the Milwaukee Art Museum, showing the Burke
brise-soleil and Quadracci Pavilion and Suite, designed by
Santiago Calatrava, 2001

Donald Lipski
American, b. 1947

Waterlilies #51, 1990
Glass tubing, roses, water solution, and hardware
60 × 72 × 3 in.
Milwaukee Art Museum, M1997.188
Purchase, with funds from Karla and Walter Goldschmidt,
Judith J. and George A. Goetz, Ann and Bruce Bachmann,
and Jean and Wayne Roper, and various donors by exchange

Dale Chihuly
American, b. 1941

Isola di San Giacomo in Palude Chandelier II, 2000
Blown glass
103 × 86 × 86 in.
Milwaukee Art Museum, M2001.125
Gift of Suzy B. Ettinger, in memory of Sanford J. Ettinger

William Morris
American, b. 1957

Petroglyph Urn with Antler, 1991
Blown and hot-worked glass; painted steel base
30 × 26 × 7 in.
Milwaukee Art Museum, M1999.197
Partial and promised gift of Jane and George Kaiser
and gift of Dale and Doug Anderson

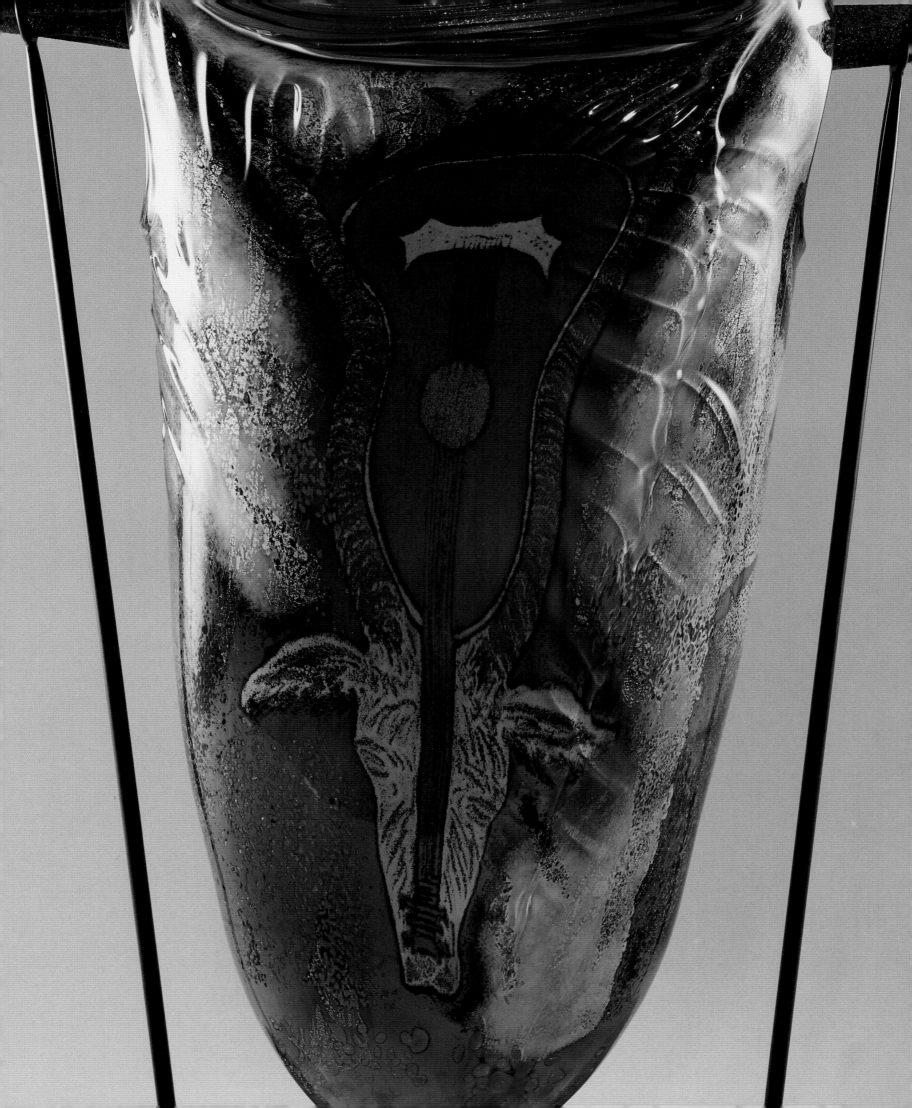

Harvey K. Littleton
American, b. 1922

Do Not Spindle, 1975
Kiln-slumped plate glass and brass
18 × 12 × 12 in.
Milwaukee Art Museum, M1990.78
Gift of the Sheldon M. Barnett family

Therman Statom
American, b. 1953

Yellow Field Color, 2000
Painted plate glass with etched glass forms and paint
86 × 15 × 2 in.
Milwaukee Art Museum
Dr. Robert W. Mann Memorial Fund; gift from Judith
and Arthur Salzstein in memory of Sheba Jacobson

MINT MUSEUM OF CRAFT AND DESIGN
Charlotte, North Carolina

The Mint Museum of Craft and Design, housed in a converted department store, is the only museum in the country to have a collection devoted exclusively to sculptural objects of untraditional media. The museum is part of the larger Mint Museum of Art (North Carolina's oldest art museum), which was founded in 1933. Both entities focus on crafts, but when the Mint's craft collections were augmented by a four-hundred-piece donation of contemporary ceramics by the New York real estate developer Allan Chasanoff and the 120-piece collection of wood art by Jane and Arthur Mason, a separate museum dedicated to craft and design was called for. With these and other collections, the museum ably documents contemporary craft from its historical roots in the nineteenth century through to its relationships to traditional decorative arts and industrial design.

The new museum opened in 1999, just two years after receiving, as a donation from the Bank of America, a four-story building in downtown Charlotte, North Carolina, that used to house the Montaldo department store. Designed by a local architect, Louis Asbury, and opened in 1953, the store sold imported couture fashion. Previously, the site had been occupied first by the Wadsworth Livery Stable and then by the J. M. Harry Funeral Home.

When the Mint Museum of Art sought to create a new center for craft, it was with the understanding that the center's mission would be to collect and display the best examples of craftwork—including sculptural glass—available. Mark Leach was appointed the founding director of this new "museum within a museum," and he gave the physical plant—both interior and exterior—(see p. 119) the important task of displaying the best art made of untraditional materials. To achieve this, several site-specific works were commissioned from artists who work in glass: *Royal Blue Mint Chandelier* (1998) by Dale Chihuly is in the lobby, the twenty-five-foot-by-forty-foot *Spectral Boundary* (1998) by Tom Patti is part of the carriageway hall (see p. 121), and *Relations* (2001) by the Czech artists Stanislav Libenský and Jaroslava Brychtová (who were sponsored by the glass collectors Lisa and Dudley Anderson) serves as the hallmark of the Mint's identity. All of these contribute to an art experience that places sculptural glass at the core of the collection.

Exterior of the Mint Museum of Craft and Design, Charlotte, North Carolina

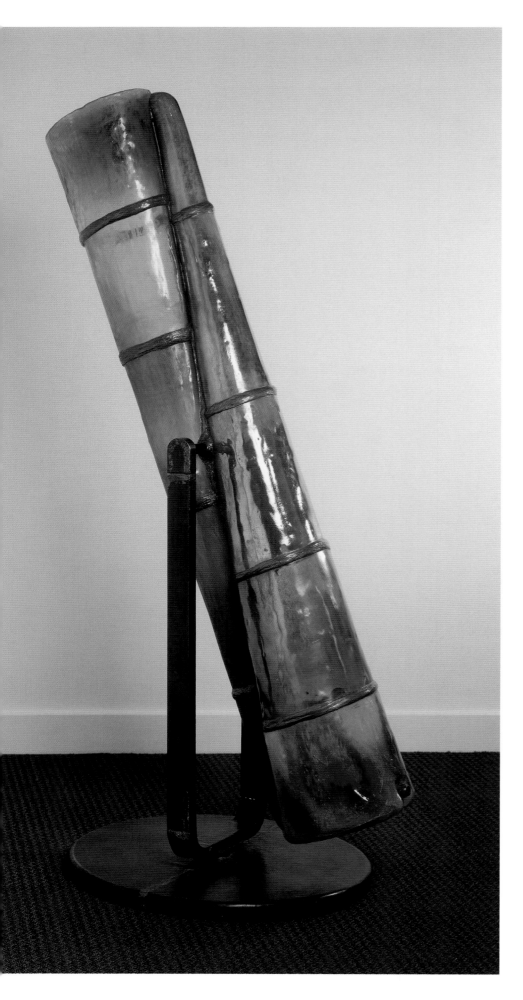

Michael Scheiner
American, b. 1956

Telescope, 1993
Glass, steel, lead, and fiberglass
81 × 31 in.
Mint Museums, Charlotte, N.C., 1998.22a–f
Gift of Dr. and Mrs. Joseph A. Chazan

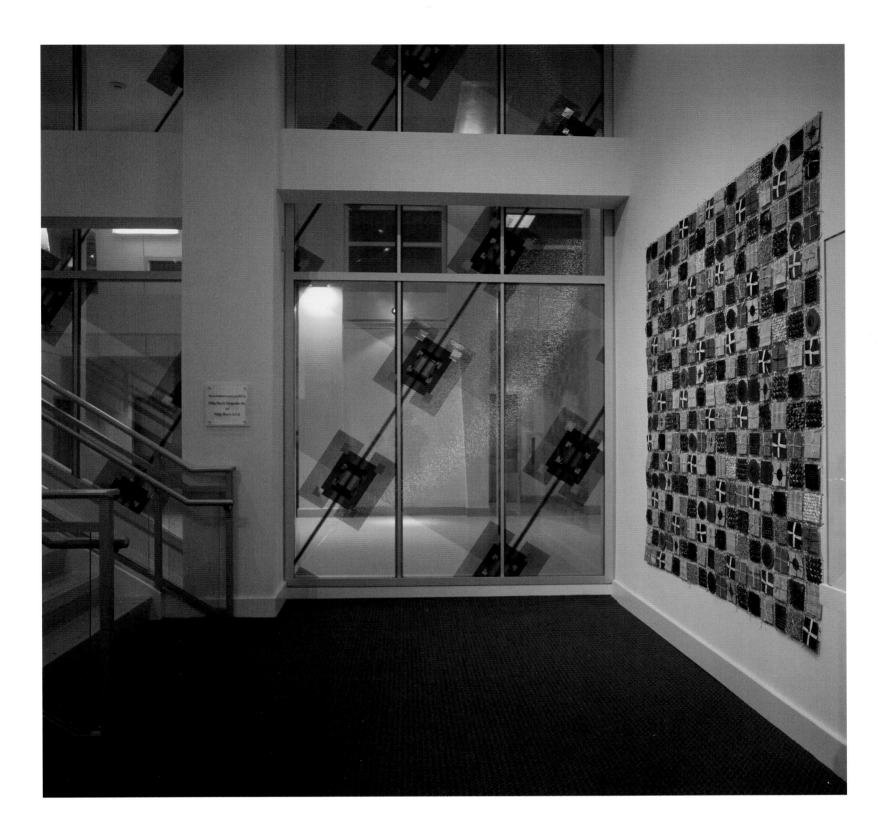

Thomas J. Patti
American, b. 1943

Spectral Boundary, 1998
Laminated and compressed glass with fabric
360 × 264 × 31 in.
Mint Museums, Charlotte, N.C., 1998.138a–o

Patti uses glass to interpret North Carolina's textile heritage.

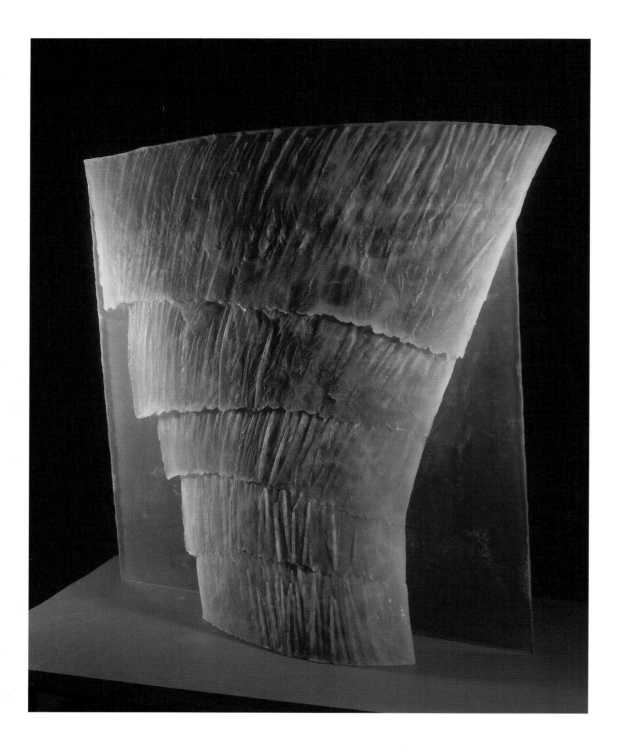

Ivan Mares
Czech, b. 1956

Wing, 2002
Kiln-cast glass
16⁷⁄₁₆ × 15³⁄₈ × 4⁵⁄₈ in.
Mint Museums, Charlotte, N.C., 2003.113
Museum Purchase: Funds provided by Dan Greenberg
and Susan Steinhauser and exchange funds from the gift
of Mrs. Ruth S. Weir, the Charles Stone Endowment Fund,
and the Harry and Mary Dalton Collection. Additional funding
provided by Lisa S. and Dudley B. Anderson and Jane and
Arthur Mason

Stanislav Libenský and Jaroslava Brychtová
Czech, 1921–2002, and Czech, b. 1924, respectively

Relations, 2001
Cast glass and welded steel
144 × 144 in.
Mint Museums, Charlotte, N.C., PG2001.84
Promised gift of Stanislav Libenský, Jaroslava Brychtová,
Katya Kohoutova-Heller, Lisa S. Anderson, and Dudley B.
Anderson
(For additional credits, see p. 223)

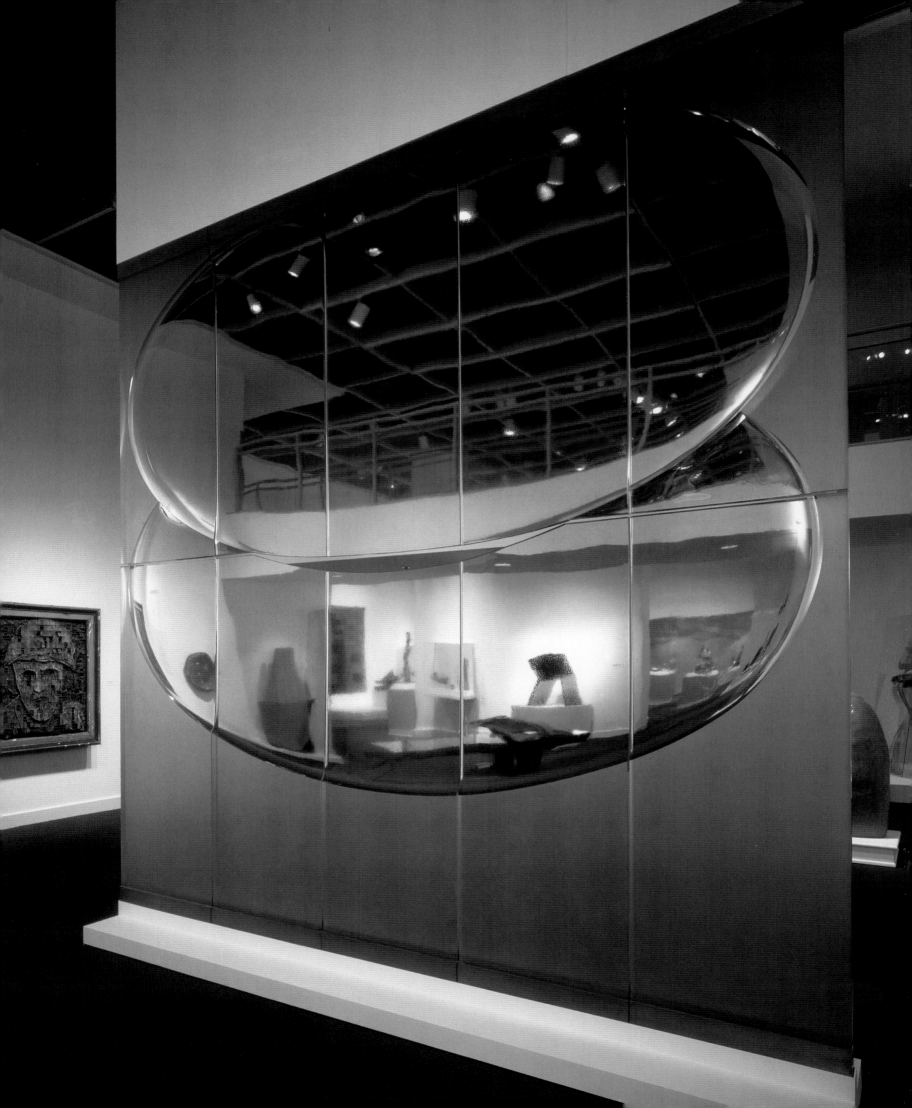

MUSEUM OF ARTS AND DESIGN
New York

The Museum of Arts and Design describes itself as the premier institution dedicated to the collection and exhibition of contemporary objects created in clay, glass, wood, metal, and fiber. Opened as the Museum of Contemporary Crafts in September 1956, it was the vision of Aileen Osborn Webb, a wealthy philanthropist.[36] Webb was also the force behind the founding of American House, a gallery where crafts objects were displayed and sold, and the American Craft Educational Council (a forerunner of the American Craft Council and publisher of the periodical *Craft Horizons*).[37] Over time the publishing and museum structure expanded. Webb's museum was renamed the American Craft Museum and *Craft Horizons* became *American Craft* magazine. In 2004 the museum was renamed yet again, to become the Museum of Arts and Design, and there are plans to relocate it to a renovated facility on Columbus Circle in New York.

Many of the institution's activities in its various components and iterations have aided the development of sculptural glass. American House had a direct impact on the expansion of studio glass. During the first World Congress of Craftsmen, held at Columbia University in New York in 1964, the work of the glass artist Joel Philip Myers (see pp. 84–85, 177, 209) was exhibited in the window of American House on Fifty-third Street across from the conference. While glass was being discussed as a potential art material, American House was offering concrete examples and an opportunity to purchase them.

From its founding in 1956 until 1991, the museum, bolstered by its prominent location in New York City, strove to be the preeminent craft museum in the country. During that period, the museum mounted three dozen exhibitions in which contemporary glass was included and sixteen that were devoted exclusively to the medium. It was one of the first institutions to recognize the studio glass movement in the early 1960s and to see that American glass should appropriately be linked to the larger international glass movement. In 1961, the museum mounted the exhibition *Artist-Craftsmen of Western Europe* to show glass by Hans Model (West Germany), Roberto Nierderer (Switzerland), and Alfredo Barbini (Italy). In 1964, the museum mounted similar displays of Czech and Italian glass, and the cast double-panel *Blue Concretion,* made by the preeminent sculptural glassmakers Stanislav Libenský and Jaroslava Brychtová, was brought temporarily to New York in 1968 as part of the exhibition *Architectural Glass* at the museum.

Other exhibitions included a survey of six private collections in *The Collector* exhibition in 1974, glass being represented by works from the collection of Sy and Theo Portnoy of Scarsdale, New York, who had begun collecting (and then selling) glass after seeing *Objects: USA*. Later, in 1977, the museum restructured its *Young Americans* show into three separate exhibitions organized by medium. Dale Chihuly was invited to serve as a juror for the reconstituted *Young Americans: Clay/Glass,* which opened in 1978 with the works of twenty-five glassmakers and sixty-seven clay artists. Ten years later, the Saxe Collection, first seen at the Oakland Museum of California (see p. 158), was exhibited.

Recent exhibitions included *Breathing Glass: An Installation by Sandy Skoglund,* in which the artist and photographer created a fully animated environment with glass dragonflies, mosaic life-sized figures, small bouncing marshmallows, and tiny plastic people, and *Venetian Glass: 20th Century Italian Glass,* both in 2000. *Libenský and His Students* (2003) was a return to the 1968 theme of honoring the influence of those glass artists on the aesthetic of modern Czech glass. Solo exhibitions of the work of important glassmakers have also been mounted, among them, *William Morris: Elegy* (2003), showing seventy of Morris's cinerary urns, and *Paul Stankard: A Floating World, Forty Years of an American Master in Glass* (2004). Exhibitions have augmented the permanent collection: one-third of the collection of S.C. Johnson and Son, Inc., of Racine, Wisconsin (which formed the core of the traveling exhibition *Objects: USA*) was donated, after its run, to the museum in 1977.

The millennium began dramatically for the museum as it made plans to move to Columbus Circle and a renovated space that will greatly facilitate the exhibition of art. As David McFadden, the chief curator, noted, the glass collections "will grow dramatically as the museum moves into its new building" and will include works from around the world that reflect the "ongoing dedication to the engagement with materials and process that is a hallmark of art, craft, and design."[38]

Installation view of the exhibition *Four Acts in Glass* (1995),
showing *Wall of Artifacts,* by William Morris (American,
b. 1957), Museum of Arts and Design, New York

Stanislav Libenský and Jaroslava Brychtová
Czech, 1921–2002, and Czech, b. 1924, respectively

The Metamorphosis V, 1987
Cast glass
23⅝ × 17¾ × 17¾ in.
Museum of Arts and Design, New York
Promised gift of Jerome and Simona Chazen, 2000

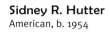

Sidney R. Hutter
American, b. 1954

Vertical Vase #1, 2001
Plate glass
17½ × 10⅞ × 9½ in.
Museum of Arts and Design, New York
Gift of Andrea and Charles Bronfman, 2001

José M. Chardiet
American, b. 1956

Baboon Still Life, 1987
Cast and blown glass
30 in. high
Museum of Arts and Design, New York
Gift of Daniel Greenberg and Susan Steinhauser, 2000

MUSEUM OF FINE ARTS

Boston, Massachusetts

With a mandate to serve the people of Boston, greater New England, and the nation, the Museum of Fine Arts in Boston, an encyclopedic museum with strengths in American painting, American decorative arts, and Near-Eastern art and strong holdings in textiles and costume, "houses and preserves preeminent collections and aspires to serve a wide variety of people through direct encounters with works of art."[39] Holding more than sixty works by the American painter John Singleton Copley and fifty by the portrait painter Gilbert Stuart, the museum presents these in concert with American and European impressionists. In the late twentieth century, the Museum of Fine Arts reorganized its curatorial departments and now expresses a particular interest in identifying and exploring new and neglected areas of art and other aspects of visual culture. Sculptural glass is a beneficiary of this enlightened goal.

Established in 1805 as a private library and art gallery that became the Boston Athenæum, the museum was incorporated in 1870 by the Massachusetts legislature shortly before the Metropolitan Museum of Art was established in New York and, like the Met, was patterned after the South Kensington Museum (later the Victoria and Albert Museum) in London.[40] The city of Boston donated land near Copley Square and commissioned the architectural firm of Sturgis and Brigham to build a Gothic-style structure that reflected the appearance of the Victoria and Albert Museum. At first, again like that of the Met, the collection included plaster casts of Greek and Roman sculpture and early collections included armor and the Jarves Collection of Italian pictures. Over time, American and European masters of painting, sculpture, and decorative arts became the focus and, in recent years, the collection has broadened beyond those confines.

When the director Malcolm Rogers reorganized the museum into cultural groupings that mirrored the new thinking emerging from academia, traditional departments such as decorative arts and American art were eliminated, and expertise was aligned under geographic categories instead of by medium, time, or culture. The museum now has departments of Art of the Americas, Art of Europe, and Contemporary Art, to name a few. Sculptural glass, as curated by Gerald R. Ward, the Carolyn and Peter Lynch Associate Curator of American Decorative Arts and Sculpture, Tracy Albainy, and Kelly H. L'Ecuyer, is part of all three.

The museum has extensive holdings in European historical glass, including a fine collection of French lampwork figures in the Elizabeth Day McCormick Collection, significant pieces by the French nineteenth-century glassmaker Charles Schneider from the John P. Axelrod Collection, and contemporary works from the Memphis/Milano group, which was active in the 1980s. The commitment to contemporary sculptural glass was indicated by the exhibition *Glass Today by American Studio Artists* (1997–1998), curated by Jonathan Fairbanks and Pat Warner. The exhibition consisted of seventy-five pieces by twenty-five American artists. Kelly H. L'Ecuyer, the assistant curator of decorative arts and sculpture, Art of the Americas Department, noted that "this well-received exhibition, which included the work of twenty-eight artists, presented a cross-section of the field at a time when a generation of American glass artists had reached a critical level of professional maturity."[41] Dale and Doug Anderson, the major lenders to this exhibition, encouraged their friends in the collecting community to lend work and to support the exhibition's catalogue. Daniel Greenberg and Susan Steinhauser made a major gift in support of the education program. The exhibition, culled from private collections and the museum's own holdings, was described in the museum's own promotional information as "a rich and colorful sampler of a major field in American Art."[42] *Glass Today* was the seventh most well-attended American museum show in 1998. Gerald Ward, Tracy Albainy, and Kelly H. L'Ecuyer continue to oversee all aspects of the museum's sculptural glass.

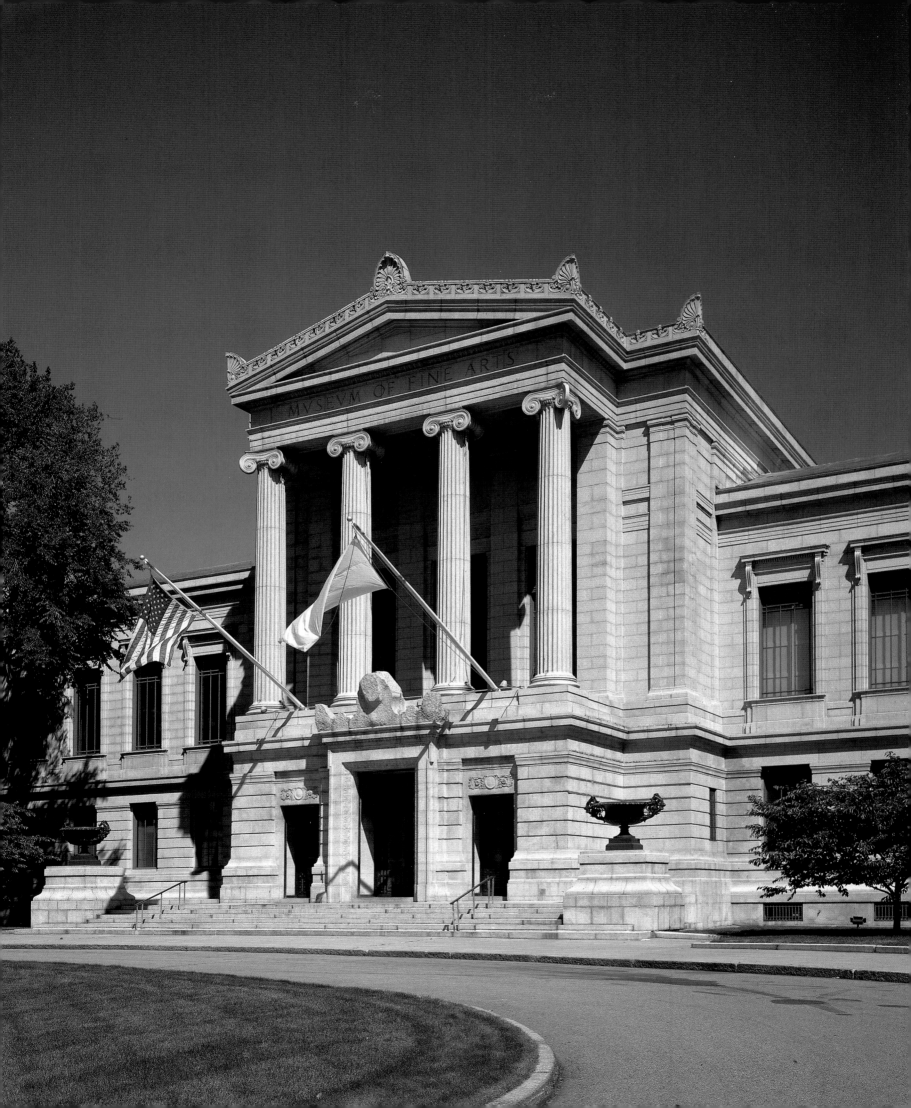

Preston Singletary
Tlingit (Native American), b. 1963

Raven Steals the Moon, 2002
Blown red glass with black overlay, sandblasted design
19½ × 6 in.
Museum of Fine Arts, Boston, 2003.350
Gift of Dale and Doug Anderson and Preston Singletary
Photography © 2004 Museum of Fine Arts, Boston

Danny Lane
American, b. 1955

Stacking Chair, 1993
Plate glass
40⅜ × 26 × 23½ in.
Museum of Fine Arts, Boston, 1993.130
Edwin E. Jack Fund
Photography © 2004 Museum of Fine Arts, Boston

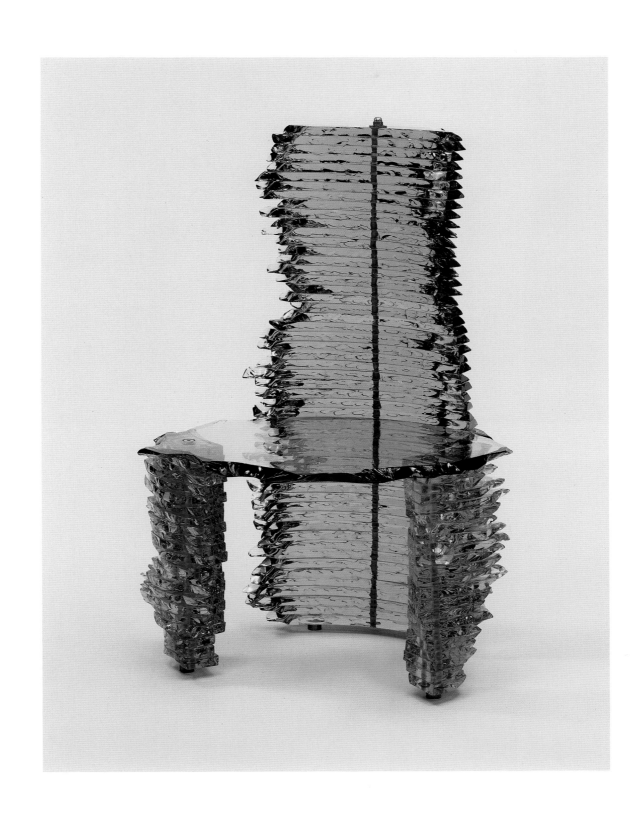

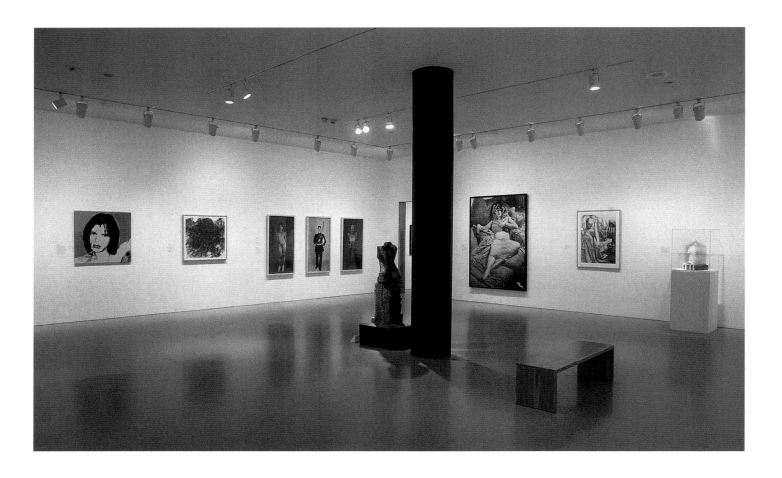

Installation with piece by Carol Cohen
Photography © 2004 Museum of Fine Arts, Boston

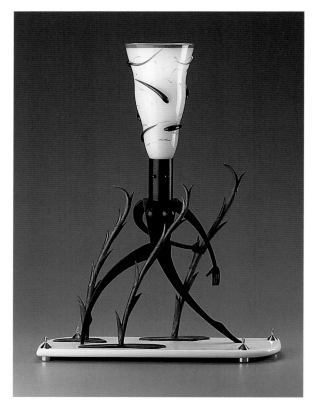

Dan Dailey
American, b. 1947

Lamp: "Nude Walking in Tall Grass," 1993
Steel; fabricated, patinated, and gold-plated bronze;
cut and polished white Vitrolite base; blown-glass shade
30½ × 22 × 6 in.
Museum of Fine Arts, Boston, 1999.533
Gift of Andrea and Charles Bronfman
Photography © 2004 Museum of Fine Arts, Boston

Carol Cohen
American, b. 1939

Glass Sculpture: Greek Revival, 1994
Painted flat glass and painted wood
24 × 12 × 11 in.
Museum of Fine Arts, Boston, 1996.192
American Decorative Arts Curator's Fund
Photography © 2004 Museum of Fine Arts,
Boston

MUSEUM OF FINE ARTS
Houston, Texas

The Museum of Fine Arts in Houston is the leading encyclopedic art museum in Texas. Founded in 1900 as a museum devoted to collecting and displaying all areas of the visual arts and with an affiliated art school, it took on "real substance" in the mid-1940s.[43] The collections now include American art and Native American artifacts; Asian, Central and South American, and African art; and a sculpture garden. In 1975, support from the Target Stores, a division of Dayton-Hudson Corporation in Houston, jump-started the photography collection.

Although it was chartered in 1900, the museum did not open to the public until April 12, 1924, when it had fifty works of art and the goal of teaching its citizens about art and encouraging the collecting of art.[44] Growing out of the Houston Public School Art League (founded by five women in 1900) and operating under a series of names, the museum embodied the nationwide late nineteenth-century enthusiasm for creating arts institutions. During the early years, collecting interest was split between old-master works and the wish to present contemporary art.[45] Fine collections of American art and new collections of photography and costume joined the film collections established in 1939. Seeking from the beginning to encourage "art culture," the museum attracted generous gifts from the legendary Ima Hogg, Edith A. and Percy S. Straus, and Samuel H. Kress. As a result of Miss Hogg's largesse, the museum collected artwork made of all types of materials: paint on canvas, paper, metals, ceramics, glass, and wood. These materials were soon augmented by photography and sculptural glass. In 2002, the museum acquired Manfred Heitlight's collection of 3,760 photographs dating from 1840 to 2000.

Housed originally in a Beaux-Arts building designed in 1924 by William Ward Watkins, the museum was enlarged twice in the 1950s by Ludwig Mies van der Rohe in his characteristic International style. Mies was engaged in 1954 to create a master blueprint for the growth of the museum; the result was a symmetrical, axial plan and the building of Cullinan Hall in 1958. By the 1980s, the museum complex comprised three buildings—the museum itself (with various halls), Bayou Bend (a house of regional note), and the Alfred C. Glassell Jr. School of Art, which had been built in 1979 and linked the resources of the museum to the teaching of art, much as the Toledo Museum of Art does with its Visual Arts Center. Along with its collection of European decorative arts, Rienzi, the former home of Carroll and Harris Masterson III, was donated in 1992. The Audrey Jones Beck building, completed in March 2000, was designed by Rafael Moneo, a leading Spanish architect. All of this expansion has resulted in the sixth-largest museum in the United States.

By the early 1970s, a professional staff was in place and corporations and private donors were important patrons. A taste for the avant-garde was fostered by the director James Johnson Sweeney, who had previously worked in New York, at the Museum of Modern Art and at the Solomon R. Guggenheim Museum. An internationalist, Sweeney encouraged the collection of innovative work from Spain, Italy, and the United Kingdom, in addition to American art. The Hirsch Library, a major reference library in the Southwest, serves as a regional office of the Archives of American Art. Sweeney's approach spurred the growth of the collections toward contemporary material and encouraged an acceptance of new art. In 2004 the museum signed an agreement with the Foundation for the Research of the State of São Paulo to recover and publish writings about twentieth-century Latin American and Latino art movements, an agreement that places Houston at the forefront of this scholarship.[46]

Later in the 1970s Philippe de Montebello became director and focused the museum on historical works. Benefiting from this successive interest in the contemporary and the historical, the institution has developed into an encyclopedic museum holding "objects of the fine arts from all important civilizations."[47] As the director since 1982, Peter C. Marzio has supervised a further expansion, with a new building for the Latin American and African American departments.[48]

In 1976, the Decorative Arts Department was founded with a strong historical collection, and contemporary works were displayed "in three distinct ways: on their own, with other craft media, and in conjunction with twentieth century painting and sculpture."[49] Early acquisitions of glass reflected the studio movement and by 1990, had matured into an international collection of sculptural glass, exemplified by the commissioning of the light artist James Turrell to create an underground

passageway entitled *The Light Inside* (1999) to connect the Beck and Law buildings. Supported by an active collecting community in Houston, gifts and purchases are featured in regular exhibition programs, and Houston has taken a lead in creating an institution that honors new artistic expressions. Cindi Strauss, the curator of modern and contemporary decorative arts and design, is committed to expanding the collection and to featuring emerging artists, with the work being displayed within the setting of major art movements in all media. "Sculptural glass has a vital role to play in the story of contemporary art—one that is just beginning to be told," she noted.[50] The sculptural glass collection includes a diversity of artists from around the world.

Exterior of the Museum of Fine Arts, Houston, Caroline Wiess Law Building, Brown Pavilion, 1974; Ludwig Mies van der Rohe, architect

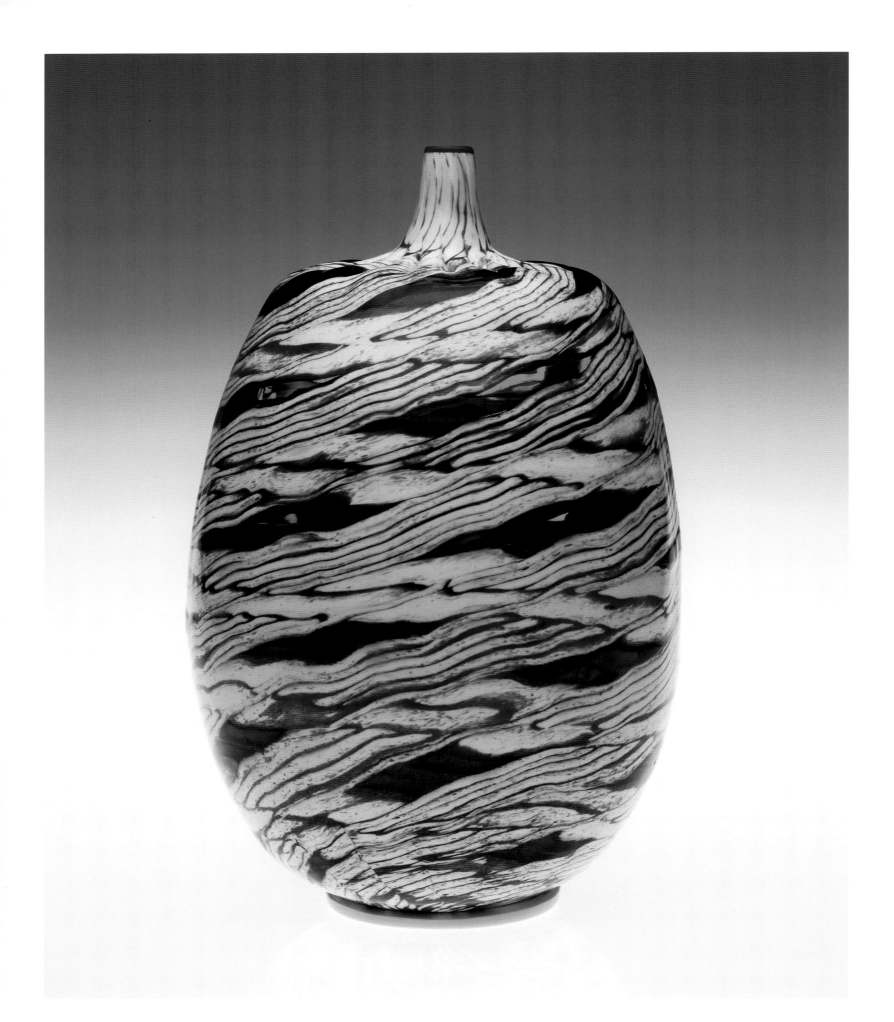

Yoichi Ohira and Livio Serena
Japanese, b. 1946, and Italian, b. 1942, respectively

Laguna, 1998
Hand-blown canes with transparent *murrine* and powder
ground (glass)
9½ × 5½ in.
Museum of Fine Arts, Houston, 99.245
Museum purchase with funds provided by J. Brian and
Varina Eby, by exchange

Barry R. Sautner
American, b. 1952

Mended Fence II, 1991
Glass
14 × 5³⁄₁₆ × 5³⁄₁₆ in.
Museum of Fine Arts, Houston, 91.63
Museum purchase with funds provided by J. Brian
and Varina Eby, by exchange

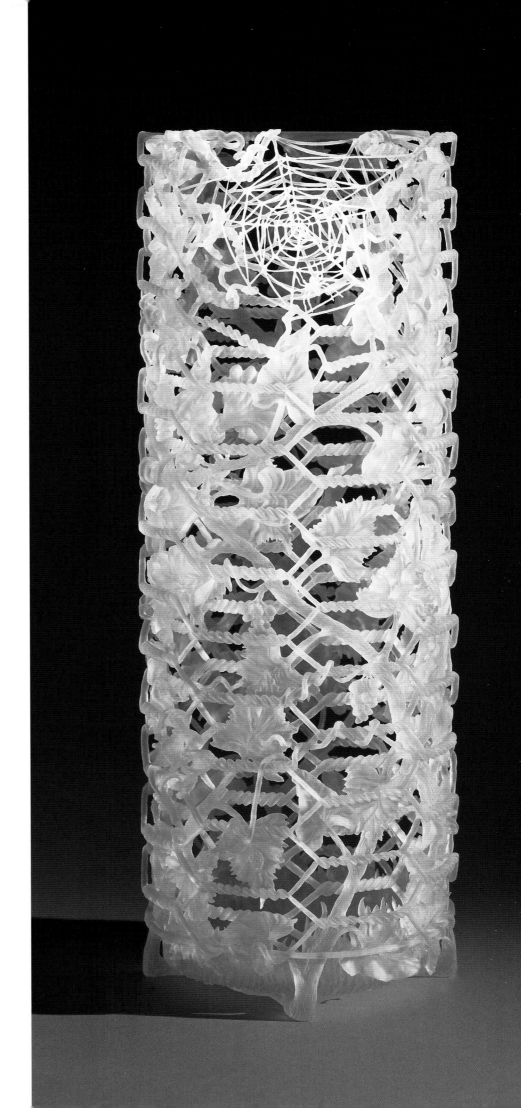

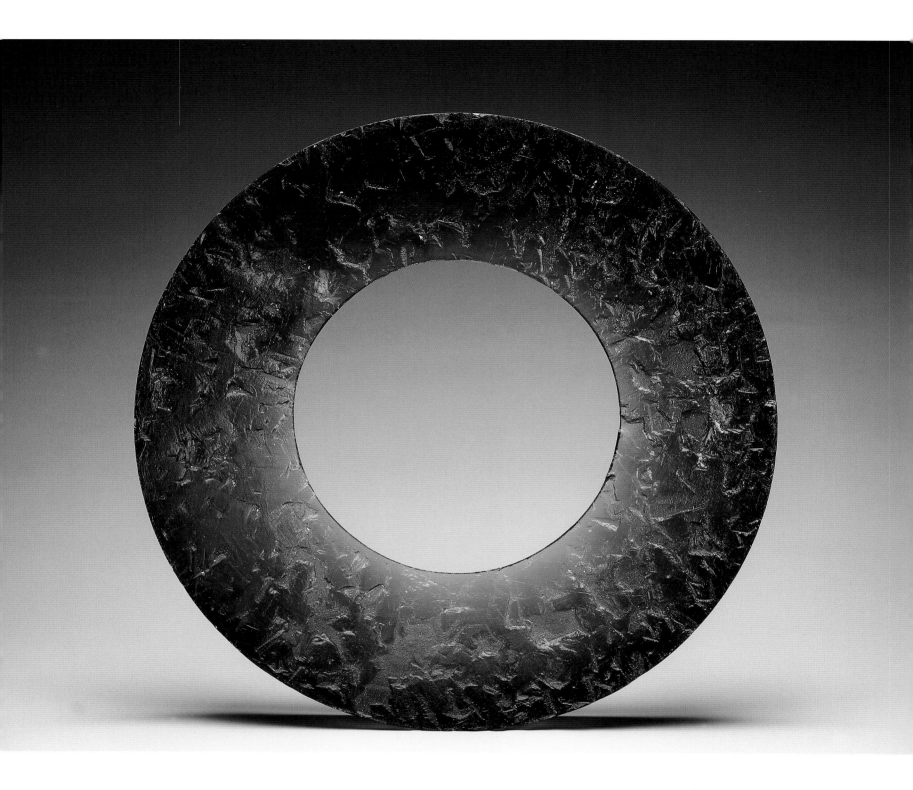

Alês Vasicek
Czech, b. 1947

Green Ring, ca. 1990
Glass
2⁷⁄₁₆ × 22⁵⁄₈ in.
Museum of Fine Arts, Houston, 99.268
Gift of William J. Hill in memory of Mrs. Margaret Wiess Elkins

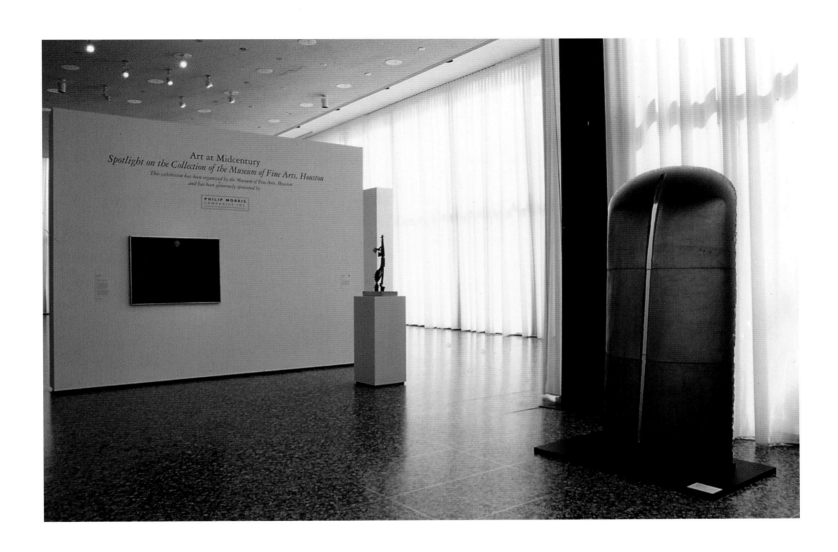

Installation view of the exhibition *Art at Midcentury:
Spotlight on the Collection of the Museum of Fine Arts,
Houston,* April 13–September 3, 2001

Façade of the Museum of Modern Art, New York, in about
1990; center designed by Philip L. Goodwin and Edward D.
Stone, 1939; east wing (right) by Philip Johnson, 1964;
west wing (left) by Cesar Pelli and Associates, 1984

MUSEUM OF MODERN ART
New York

The Museum of Modern Art (MOMA) in New York was the first American museum to be devoted to modern art (which at the time meant contemporary art) and the first American museum to position the modern artist as a central cultural figure. Founded in the inauspicious year of 1929, it sought to present and popularize new artistic expressions (primarily abstraction) and came to exert considerable control over the canon of modern art. Three perceptive collectors were vital to the launch of this progressive institution: Lillie P. Bliss, Mary Quinn Sullivan, the wife of Cornelius J. Sullivan, and Abby Aldrich Rockefeller, the wife of John Rockefeller Jr. The impetus for a modern art museum came from the unfavorable reception of an exhibition of contemporary art (ranging from impressionism to Picasso's pre-cubist works) in 1921 at the Metropolitan Museum of Art. The press attacked the exhibition and the Met decided not to pursue similarly progressive ventures.

The first and widely influential director was Alfred H. Barr Jr., then a young man who had studied at Princeton under the medievalist Charles Rufus Morey.[51] As part of his proselytizing for modern and abstract art, Barr created a schema, based on concepts used to analyze medieval art, for understanding and explaining modern art to himself and to the public (see pp. 10–11). His passion for contemporary work, which shaped the exhibition and collecting policies at the museum for the first twenty-five years of its existence, influenced other museum professionals across the country. Before he was thirty years old, Barr had curated many seminal exhibitions, including *Cubism and Abstract Art* and *Fantastic Art, Dada, Surrealism,* both in 1936.[52] Barr's sensibility is still seen in MOMA's collection of sculptural glass.

As discussed in the introductory essay (see pp. 9–33) the museum's preference for industrial design and painting over the unique crafted object meant that the collection came to contain thirty-three Italian-made, limited-production glass objects by the painters Jean Arp, Max Ernst, Pablo Picasso, Oskar Kokoschka, and Jean Cocteau. These merited an exhibition entitled *Sculpture in Glass* in 1965.[53] Between 1975 and 1990, the museum's interest in glass was manifest in only two exhibitions of work from its collections: *Crafts from the Collection* (1986–1987), an exhibition of twenty-four objects, and *Glass from the Collection* (1990), which presented a mixture of works made in various styles and with a range of production practices that had been collected since 1934 by the Department of Architecture and Design.

One anecdote illuminates MOMA's acquisition policy toward sculptural glass during the second half of the twentieth century. In 1964, a work by Harvey Littleton, one of the proponents of sculptural glass, entered the permanent collection. The piece in question had first been offered to the nearby Museum of Contemporary Crafts (now the Museum of Arts and Design) and rejected. Annoyed, Littleton smashed the piece, but subsequently showed it anyway to the professional staff in MOMA's design department. Looking for new work, they purchased it for the permanent collection. The museum acquisition committee initially ruled that, for two reasons, the design department could not buy the piece: it was made of glass and it did not have a hole in it. Without a hole, it could not be classified as utilitarian, a deficiency that placed it technically outside the design department's purview and within the category of art—it was a piece of sculpture. This somewhat convoluted logic reflected the museum's guidelines, which permitted only the acquisition of works that could be defined as examples of architecture, film, photography, industrial design, manual industry, dance, and theater design. These guidelines have subsequently been reframed to permit the acquisition of glass, and MOMA now boasts sculptural glass pieces by Marcel Duchamp, Kiki Smith, Christopher Wilmarth, Josiah McElheny, Sydney Cash, Dale Chihuly, Harvey K. Littleton, Tom Patti, and Toots Zynsky, among others.

Kiki Smith
American, b. Germany 1954

Untitled, 1987–1990
Twelve silvered glass water bottles
Each bottle, 20½ in. high × 11½ in. diameter at widest point
Museum of Modern Art, New York, 565.1990.a–l
Gift of Louis and Bessie Adler Foundation, Inc.

Thomas J. Patti
American, b. 1943

Solar Bronze Riser, 1978
Blown and laminated glass
6 × 2½ in.
Museum of Modern Art, New York, 258.79
Zaidee Dufallo Fund

Designing with the materiality of glass in mind, Patti builds
forms by cutting sheets of glass (some of which may be
colored or textured), sandwiching them together, laminat-
ing them with heat, and then blowing them into shapes. It
is his display of intellectual discipline that lend his pieces
a classic serenity. This work was purchased for the museum
in 1979 by J. Stewart Johnson, curator of design, Department
of Architecture and Design.

Mary Ann "Toots" Zynsky
American, b. 1951

Water Spout #4, 1979/1994
Blown glass and hot applied thread
11½ × 8 in.
Museum of Modern Art, New York

NATIONAL LIBERTY MUSEUM
Philadelphia, Pennsylvania

Located on the Liberty Trail on the former site of the Philadelphia Maritime Museum, the National Liberty Museum was founded in January 2000 by Irvin J. Borowsky. The son of Polish immigrants, Borowsky is the founder of the North American Publishing Company, which produces twenty-four national magazines, including *Printing Impressions,* and has published more than forty books and journals. The museum is directed by his daughter Gwen Borowsky in the role of executive vice president and chief executive officer. In the words of its mission statement, the museum is dedicated "to defusing violence and bigotry by celebrating America's heritage of freedom and the diverse society it has produced."[54] Exhibitions focus on inspirational themes that have included the honoring of heroes, an exploration of the concept of freedom, peaceful ways to resolve conflict, and, most importantly for sculptural glass, an equation of liberty with glass. This notion is related to Irvin Borowsky's belief that "whether it lies shattered on the street or prominently exhibited in a gallery, glass is a reminder of both the strength and fragility that lie within all of us and within liberty itself."

The museum offers many activities for visitors, and its galleries display dioramas, paintings, text panels, and tableaux, including one that depicts Nelson Mandela's incarceration on Robben Island, in South Africa. The collection of artworks includes bronze sculptures, "original oil paintings" (presumably commissioned to meet the mission statement goals of the museum), and "several unusual works in unexpected mediums." The sculptural glass holdings number more than 110 pieces and include works by Dale Chihuly, Harvey Littleton, Stanislav Libenský and Jaroslava Brychtová, Dan Dailey, and other lesser-known glassmakers.

Education for all ages is a focus of the museum; numerous school and civic groups visit the exhibitions and participate in activities that reflect the mission and the inspirational themes that it presents. Among the museums profiled here, only the National Liberty Museum sees glass as a metaphor for liberty and uses it to advance a social agenda. The involvement with sculptural glass also provides an opportunity for fundraising. On the occasion of the fifth anniversary, the museum held the *Glass Now* auction that offered more than a million dollars' worth of glass in a silent and a live auction conducted by David Rago, the noted arts and crafts expert and auctioneer.

Because glass is construed as a metaphor, it will continue to be a part of the museum's collections and exhibitions. The curator William Warmus, previously of the Corning Museum of Glass and an independent author and appraiser, seeks to carry out the mission and to position glass as representing "liberty—beautiful and strong, yet easily broken and impossible to truly fix."[55]

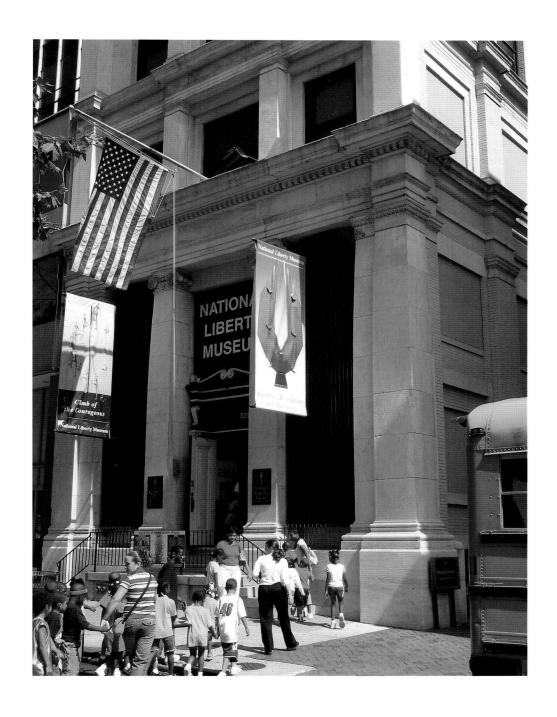

Exterior view of the National Liberty Museum,
Philadelphia, Pennsylvania

Colin Reid
British, b. 1953

Jagged Edges, 1990
Kiln-formed glass
24 × 12 × 2 in.
National Liberty Museum, Philadelphia
Gift of Irvin J. Borowsky

Karla Trinkley
American, b. 1956

Stray Bullet . . . Missing Child, 1986
Pâte de verre
42 × 15 × 4 in.
National Liberty Museum, Philadelphia
Gift of Irvin J. Borowsky

Steve Linn
American, b. 1943

Dialogue Is Necessary for Truth, 1988
Sandblasted glass, bronze, and wood
36 × 36 × 6 in.
National Liberty Museum, Philadelphia
Gift of Irvin J. Borowsky

Robin Grebe
American, b. 1957

Angel, 1999
Cast glass
33 × 20 × 3 in.
National Liberty Museum, Philadelphia
Gift of Irvin J. Borowsky

NORTON MUSEUM OF ART
West Palm Beach, Florida

The Norton Museum of Art was launched in 1941 by Ralph Hubbard Norton (1875–1953), an executive officer of Acme Steel Company in Chicago, and his wife Elizabeth Calhoun Norton (1881–1947) just two years after they relocated to enjoy the warm weather of Florida. The original museum structure was erected in Pioneer Memorial Park (previously a gathering place and cemetery for early settlers) on land that had been ceded to the city by the Lake Worth Pioneers Association. Founded to "preserve for the future the beautiful things of the past while providing education and enjoyment for the public," the museum embodied a civic impulse, spurred by the impending war, to uplift the local citizenry through art.[56] The mission statement was broadened in 1992 with the declaration that the Norton "strives to preserve, develop, exhibit, and interpret its outstanding permanent collection and to educate the public through special exhibitions, publications, and programs."[57]

The Nortons' initial gift of 250 works of art included paintings by Paul Gauguin, Claude Monet, Pablo Picasso, Paul Cézanne, Constantin Brancusi, George Bellows, and Georgia O'Keeffe. Their gift also included Chinese art—rare archaic jades and bronzes—and Buddhist sculpture and early ceramics. The Nortons established an endowment to support acquisitions and general operating activities. This, as well as community support, has permitted the museum to expand its holdings and house them safely. The collection branched into photography with a gift of 670 European and American photographs from the collection of the baroness Jeane von Oppenheim. As in other museums at the end of the twentieth century, contemporary art became a focus of collecting, with works on paper and sculptural pieces in the forefront. In concordance with the Norton and von Oppenheim gifts, the board and professional staff have made high artistic quality the necessary requirement for inclusion in the permanent collection.

The first building was designed by Marion Wyeth, of Wyeth, King, and Johnson, one of Florida's leading architects. By the early 1990s, the museum's aggressive collection building made new facilities necessary. A fundraising campaign generated nineteen million dollars for the physical plant and eleven million dollars for endowment from private individuals, the state of Florida, and the National Endowment for the Arts. In 1995 the museum commissioned Chad Floyd of Centerbrook Architects, Centerbrook, Connecticut, to restore the original structure and add forty-five thousand square feet of galleries, office space, art library, café, and museum store, and a sophisticated climate control system. In the late 1990s the museum hired Floyd a second time to add thirty-five thousand square feet of space to accommodate eleven new galleries. The new addition opened in 2003 and provides 75 percent more space for displaying the permanent collection.

The museum's interest in glass has expanded as its commitment to contemporary art has grown. Mark Rosenthal, the adjunct curator of contemporary art, states that "the field of sculptural glass is replete with genuine accomplishments as well as enticing potential. The Norton Museum will continue to selectively acquire outstanding examples of the genre."[58] To that end, the museum has displayed glass sculpture along with other works of art, as it did in the *Side by Side* exhibition of 1997. Drawn from works in the permanent collection, the installation juxtaposed historical art dating from 1400 with contemporary works, resulting in, for instance, a sculptural glass piece by William Morris being placed next to an etching by Albrecht Dürer. The museum has taken the lead in presenting glass by organizing the exhibition *Dale Chihuly: Installation* (1998) in collaboration with the Seattle Art Museum and *Fire and Form: The Art of Contemporary Glass* (2003), an exhibition, with an accompanying catalogue, for which the guest curator was William Warmus. The Norton also commissions pieces from contemporary artists; Ginny Ruffner's *Norton Palm Trees* (see p. 156) is an example.

Exterior of the Norton Museum of Art,
West Palm Beach, Florida

Installation view of the *Side by Side* exhibition,
August 2–November 16, 1997
Norton Museum of Art, West Palm Beach, Florida

The objects in this exhibition were drawn from the permanent
collection and were displayed so as to juxtapose historical art
dating from 1400 with contemporary works.

William Morris
American, b. 1957

Canopic Jar: Fawn, 1992
Hand-blown and formed glass
27 × 11 in.
Norton Museum of Art, West Palm Beach, Fla., 96.10
Gift of Dale and Doug Anderson

Ginny Ruffner
American, b. 1952

Norton Palm Trees, 1997
Painted glass sculpture
17 × 21 × 16 in.
Norton Museum of Art, West Palm Beach, Fla., 98.48
Gift of Dale and Doug Anderson

Mary Ann "Toots" Zynsky
American, b. 1951

Untitled, from the *Chaos* series, 1993
Glass filaments
6¾ × 10 × 9 in.
Norton Museum of Art, West Palm Beach, Fla., 96.11
Gift of Dale and Doug Anderson

OAKLAND MUSEUM OF CALIFORNIA
Oakland, California

The Oakland Museum of California (consisting of the Oakland Art Gallery, the Cowell Hall of California History, and the Hall of California Ecology) has its roots in the Panama-Pacific International Exposition held in San Francisco in 1915. At the exposition, local California artists bravely displayed their work alongside that of esteemed artists from the East Coast and Europe. Thus emboldened, several local artists banded together, under the leadership of Robert Harshe, and one year later mounted a display of their work, featuring West Coast and California subject matter. World War I caused a halt to funding from the City of Oakland and only the financial aid of Dr. William S. Porter, a collector, permitted the new museum to survive. At about the same time, the Oakland Public Museum (with holdings of historical and anthropological artifacts) opened, as did an exhibition of the natural science collection amassed by Henry Snow. By 1950, the three groups had merged into one that was renamed the Oakland Museum of California. Paul Mills became the director in 1953 and established the collecting parameters, which focus on the art of California.

Situated in downtown Oakland, adjacent to the Alameda County courthouse near Lake Merritt, the building that houses the unified museum edifice was completed in 1969. The architect, Kevin Roche of Roche, Dinkeloo and Associates (formerly Saarinen and Associates), designed it as "not a shrine for the cultural elite, but [as] a rallying point for people and groups with every kind of diverse interest."[59] Featuring the rough concrete surface associated with the avant-garde architecture of the period, the building is a three-tiered blend of galleries, patios, sculpture gardens, and ponds. The Vermont landscape architect Dan Kiley designed the gardens with local assistance from Geraldine Knight Scott.

When it opened in its centralized location, the museum developed its mission to collect only the art of California, defined as that made by any artist who was born, raised, studied in, moved to, or worked in the state. In the case of those who worked for only a time in California, the museum restricted its holdings to works made during that limited period. Unique among the museums highlighted here, Oakland is the only one dedicated to a geographical location. With California as the defining concept, the usual arrays of French impressionists, out-of-state American colonial works, and European old masters are not to be found. Instead the museum displays art in chronological order to convey the sweep of California's history, providing a visual record of the development of the sixth-largest economy and cultural center in the world. As would be expected, the geography of the state is a dominant feature of the historical works displayed; in more contemporary areas, California's leadership in the various arts (clay, painting, and sculpture) is seen. Because Oakland has a unique mission, the collections of glass, originally subsumed under the Department of Crafts led by Hazel Bray, are of necessity contoured to fit the larger mission. Traveling exhibitions did not, however, need to conform. The museum has hosted several important exhibitions of glass, including *Americans in Glass* in 1985, and mounted *Art/Culture/Future: American Craft '86* in conjunction with the national conference of the American Craft Council that year.

Most importantly for sculptural glass, Oakland was the site of a national, groundbreaking sculptural glass exhibition. By the mid-1980s, George and Dorothy Saxe of Palo Alto, California, had assembled a unique collection of sculptural glass that included the work of many California glass artists. Kenneth R. Trapp, the curator, honored the collection by installing a selection of works in an exhibition entitled

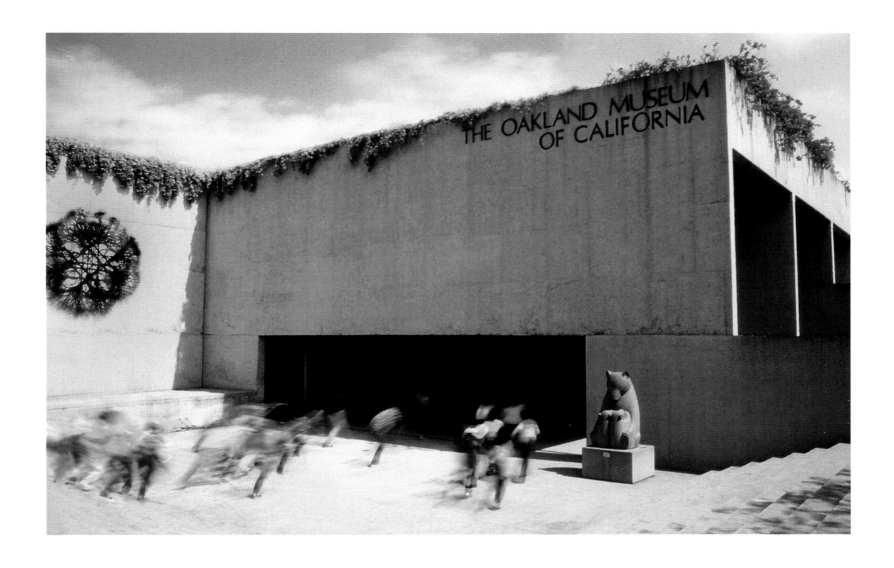

Entrance of the Oakland Museum of California

Contemporary American and European Glass from the Saxe Collection. The widely popular exhibition traveled to the Museum of Arts and Design (then the American Craft Museum) in New York. Trapp produced a fine illustrated, sixty-four-page catalogue that placed the artworks within the continuum of art and glass history. This event (and the publication) was the first to celebrate a cohesive sculptural glass collection, and it garnered many new converts to the possibilities of glass as an art medium. The museum has continued its support of glass by adding works to its permanent collection and by initiating the retrospective exhibition *Marvin Lipofsky: A Glass Odyssey* (2003), a review of the life and work of this influential first-generation American glass artist, who trained many subsequent makers during his tenure at the nearby California College of Arts (previously the California College of Arts and Crafts). Oakland continues to add appropriate sculptural glass works to its unique collections.

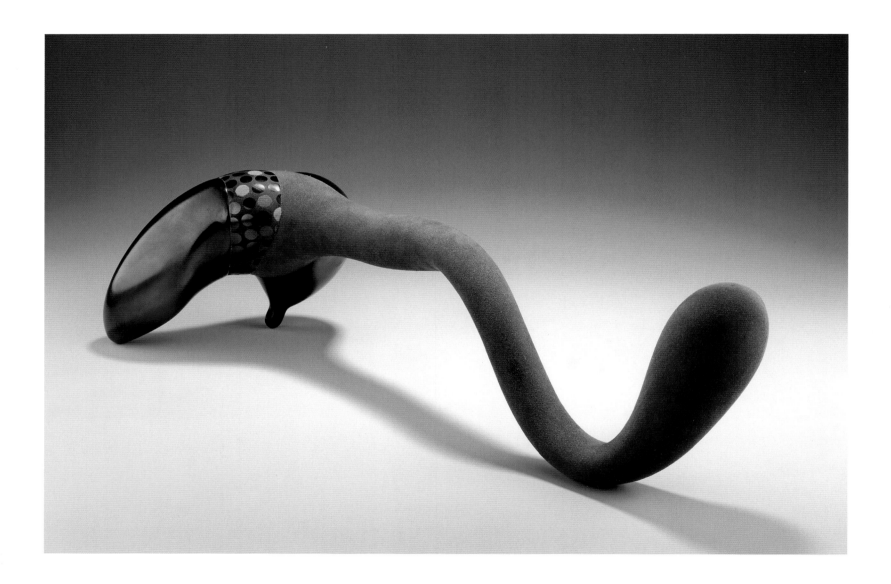

Marvin Lipofsky
American, b. 1938

California Loop Series, 1970
Blown glass and rayon flocking
8 × 27 × 8½ in.
Oakland Museum of California
Bequest of Mrs. Dorothea Adams McCoy

Installation view of *Marvin Lipofsky: A Glass Odyssey,* July 19–
October 12, 2003, with Lipofsky's *California Loop Series*

California Loop Series

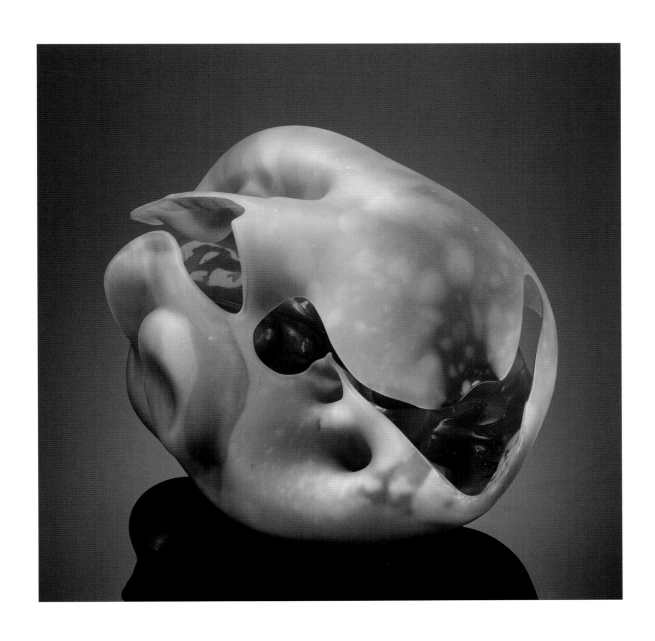

Marvin Lipofsky
American, b. 1938

Pilchuck Series, #23—Summer Sun, 1984
Mold-blown glass, cut, sandblasted, and acid etched
14 × 15 × 20 in.
Fabricated with help from Rich Royal and Ronnie Miller
Oakland Museum of California
Gift of the Women's Board

RACINE ART MUSEUM

Racine, Wisconsin

The Racine Art Museum has been energetically collecting and displaying fine craft since 1990. The museum was founded in 1941 as the Charles A. Wustum Museum of Fine Art by Jennie E. Wustum in memory of her husband. Begun as a noncollecting museum located in a house, the original holdings served as the "nucleus of a public art museum for the collection, preservation, and exhibition of painting, sculptures, curios, and art objects of any and all kinds."[60] The first director, Sylvester Jerry, turned the focus of the museum toward a regionally important collection of works on paper and textiles. As the result of a long affiliation with the Michigan State Works Progress Administration, the collection soon included objects from 275 gifts and long-term loans, principally the work of artists based in Wisconsin and New York. But change was brewing for the museum when it hired Bruce W. Pepich in the early 1970s. Pepich began his museum career as the curator of the art museum at Northern Illinois University in DeKalb, where he frequently displayed craft and fine arts side by side, using his discriminating eye and curatorial skills to reveal the parity between them.

On the occasion of the fiftieth anniversary in 1991, Pepich declared craft to be the museum's primary focus in its collecting and exhibition program, taking precedence over other components of the collection. A review, in 1990, of the museum's structure, programs, and future, and the shrewd realization that its neighboring institutions (the Art Institute of Chicago and the Milwaukee Art Museum) had extensive collections of regional materials that were duplicated in its own holdings, the Wustum (later renamed the Racine Art Museum) formally inaugurated a program to dedicate between 40 and 50 percent of its programming and physical plant to collecting and displaying "works of craft media by American artists within the context of international developments."[61] This decision was clearly a bid to carve out a leadership position within the museum community and to place craft objects on a par with painting, sculpture, and photography. The new program was bolstered by funds from the National Endowment for the Arts and a highly successful local capital campaign.

Racine's interest in fine craft was not without precedent. The local Samuel C. Johnson family had sponsored the *ART USA NOW* exhibition in 1962 and the seminal *Objects: USA* traveling exhibition of 1969. The latter was particularly important because of the widely read catalogue, which presented a narrative of the post-1945 craft movement—the predecessor of sculptural glass. With this historic link, the decision to focus on crafts of all kinds was vindicated by the gift, made in 1991, of more than two hundred works from Karen Johnson Boyd, a benefactress of the museum, and the sister of the chief executive officer of S. C. Johnson and Son, Inc.[62] With that gift, and annual gifts of art from Doug and Dale Anderson, who began supporting Pepich's efforts in 1989, the expanding collection had outgrown the existing exhibition and storage space. A new forty-six-thousand-square-foot facility on Main Street was created by renovating a commercial building. The newly reworked building has been judged elegant and praised for offering minimal intrusion of the architectural features, avoiding "competition with the craft works, [and] compensat[ing] for their eccentricity."[63]

Sculptural glass, together with the other media of ceramics, fiber, metals, and wood, has always been included in the collecting mission of the museum, as is evident in the number of donations and exhibitions of sculptural glass. In the mid-1980s, the Brillson Foundation was formed by Michael Brillson of Michigan and Catherine Brillson of Chicago, and in 1995 the foundation donated twenty-eight pieces of glass. Many of the pieces dated between 1972 and 1987 and they fill out the historical side of sculptural glass.[64] Other donors, including Dale and Doug Anderson, who have given the museum more than five hundred works to date, continue to make significant gifts of time, resources, and artwork to strengthen the collection and to connect the museum to the collecting community. The current acquisition policy "encourages an evaluation of the regional clusters of artistic production that have developed in various parts of the United States."[65] In that way the glass holdings seek to provide an international point of view that adds richness to the collection of American artists, which fosters the museum's fine representative collection from glass centers in Seattle and on the East Coast—each one revealing the characteristics that illuminate regional differences.

The South façade of the Racine Art Museum, Racine, Wisconsin,
and the sculpture courtyard (behind the walls) at dawn;
photographed in 2004

Judy Bally Jensen
American, b. 1953

After Breakfast with the Cannibals, 1988
Glass, paint, mixed media, and board
33½ × 28 × 12⅞ in.
Racine Art Museum, Racine, Wisc.
Gift of Dale and Doug Anderson

Jay Musler
American, b. 1949

Mosaic Teapots, 1995
Glass and oil paint
Each approx. 5½ × 8 × 5½ in.
Racine Art Museum, Racine, Wisc.
Gift of Dale and Doug Anderson

Richard Marquis
American, b. 1945

Shotglass Sample Box #3 (Pettijohn's),
1992
Glass, sheet glass, wood, wire, found
objects, and paint
14 × 11 × 3 in.
Racine Art Museum, Racine, Wisc.
Promised gift of Donald and Carol Wiiken

Ginny Ruffner
American, b. 1952

Tower of Fruit and Flowers, 1995
Glass; oil and enamel paint
24½ × 14 × 12 in.
Racine Art Museum, Racine, Wisc.
Gift of Dale and Doug Anderson

RENWICK GALLERY, SMITHSONIAN AMERICAN ART MUSEUM
Washington, D.C.

The Smithsonian American Art Museum's Renwick Gallery, which came into being only in 1972, has an unusual tripartite identity: it is a curatorial department within the Smithsonian American Art Museum; it is a *kunsthalle* "that collects, exhibits, studies, and preserves American craft and design";[66] and it is an architectural landmark. The original building was designed by James Renwick Jr. (1818–1895) to display William Wilson Corcoran's collection of historical paintings and sculptures. When the Corcoran Gallery became part of the larger Smithsonian organization, it was rechristened the Renwick Gallery in honor of its architect.

In 1965 President Lyndon B. Johnson transferred title of the building to the Smithsonian Institution, endowing the Corcoran with a hazy mission and no money. The building had fallen into disrepair and only after Johnson's decree was it renovated to make it suitable again for art exhibitions. The first administrator (and later the director), Lloyd E. Herman, was appointed in 1971. He envisioned the new gallery as a showcase for arts, crafts, and design and made his plan known in a paper entitled "The Renwick Design Centre," which he submitted to S. Dillon Ripley, the secretary of the Smithsonian. Ripley presented the notion to President Johnson and the gallery was launched. It formally opened on January 28, 1972, with eight separate exhibitions and an ambitious agenda that offered a steady stream of both national and international exhibitions. As curator, Herman strove to "jar the viewer into seeing the unfamiliar in the familiar and to affirm that the manmade is consciously planned."[67] Because it was located in the national capital, initially there was a desire to coordinate exhibitions with diplomatic visits, but this proved too cumbersome, as notoriously fickle world events often disrupted the travel plans of heads of state.

The original plan that the Renwick Gallery would be a noncollecting institution (*kunsthalle*) fell by the wayside; by 1981, collecting craft became recognized as an important mission. This, however, raised issues with the other museum entities in the Smithsonian: how was the Renwick's growing collection to fit in with the collecting goals of the other art venues under the institution's umbrella? The answer for the Renwick has shifted through the years. Indeed, changes were afoot in the early 1980s. First came new leadership at the Smithsonian, then a shift of focus to American makers, and then the founding of the James Renwick Collectors Alliance (later the James Renwick Alliance), a group that provides funds for art purchases and supports the focus of collecting American works while advancing scholarship in the field of American crafts.

Meanwhile, Lloyd Herman developed the collections through private donations and limited purchases of art. In 1986, after serving for twelve years as associate curator, Michael W. Monroe replaced Herman and worked to expand the collections and to produce scholarly catalogues. Monroe left in 1995 and was succeeded by Kenneth R. Trapp, previously of the Oakland Museum of California, who was curator-in-charge for the next nine years.

During Herman's tenure, at least two solo exhibitions of the work of significant glass artists were mounted: *Dale Chihuly* (1978–1979) and *Harvey K. Littleton* (1984). The Renwick also took the traveling exhibition *Objects: USA* (1969) and acquired ten works from it for the permanent collection. Dr. Jeremy Adamson and Alastair Duncan, the noted authority on art deco, curated *Masterworks of Louis Comfort Tiffany* in 1989. Later, in 2000, Ken Trapp mounted *Glass! Glorious Glass*. In *Glassworks,* pieces by Bruce Chao, Richard Harned, Mark McDonnell, Therman Statom, Judith Schaechter, Ginny Ruffner, and William Morris were included in an exhibition of glass sculpture installations that were tailored to the nineteenth-century gallery spaces.

As the Renwick is charged with displaying and collecting all art, craft, and design, glass has not been the central focus of its activities. Limitations inherent in the restrictions placed on buildings of historical significance have also hampered the permanent display of large glass installations and sculptural works. But there have been activist collectors at the Renwick, both individually and in conjunction with the James Renwick Alliance. Among these are the longtime supporters Dr. Paul and Mrs. Elmerina Parkman, Mike and Annie Belkin, Dr. Robert G. Loeffler, Doug Ring and Cindy Misikowski, Don and Carol Wiiken, and Dale and Doug Anderson.

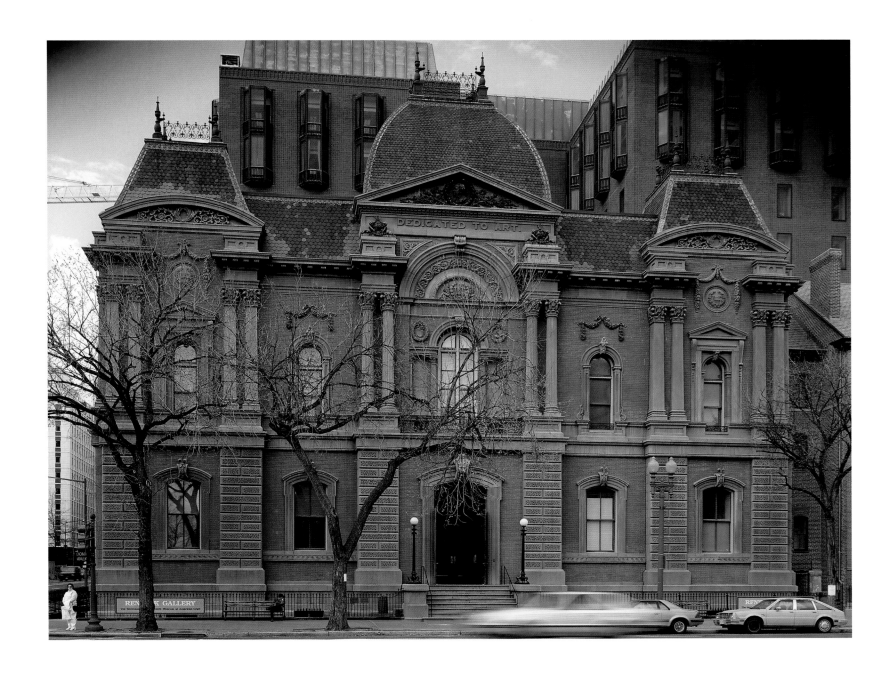

Exterior of the Renwick Gallery of the Smithsonian American Art
Museum, Washington, D.C.; built in 1858

Installation of Dale Chihuly's work at the Renwick Gallery,
Washington, D.C., April 13–May 10, 1994

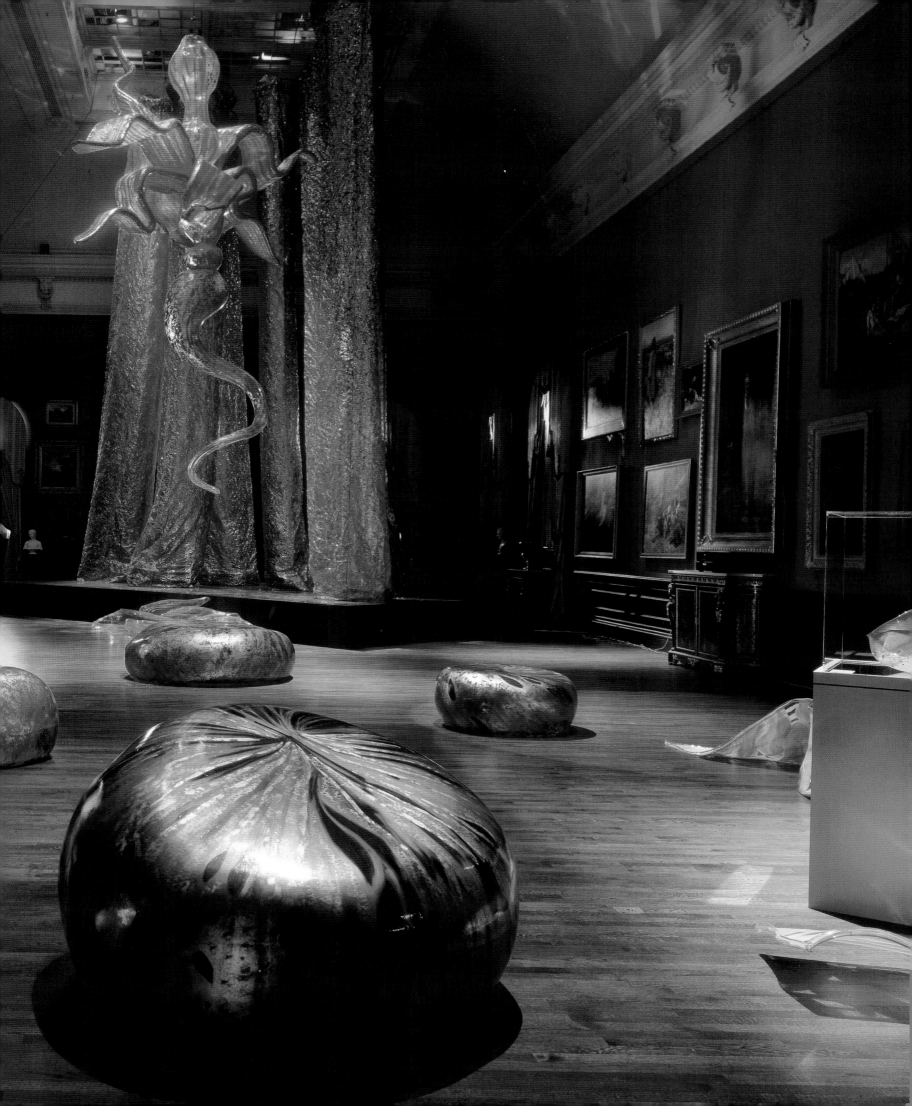

Hank Murta Adams
American, b. 1956

Ogunquit Outing, 1982
Glass and enamel
Approx. 12 in. × 4 in. in diameter
Renwick Gallery, Washington, D.C., 2002.73.1
Smithsonian American Art Museum, partial and
promised gift of Elmerina and Paul Parkman

Steven Weinberg
American, b. 1954

Untitled, 1989
Cast glass
8¼ × 8 × 8 in.
Renwick Gallery, Washington, D.C., 1991.178
Smithsonian American Art Museum, gift of
Annie and Mike Belkin

Mark Peiser
American, b. 1938

Mountain by Moonlight, 1984
Compound cast glass
8⅞ × 4⅝ × 2¾ in.
Renwick Gallery, Washington, D.C., 1996.85.1
Smithsonian American Art Museum, gift of
Dale and Doug Anderson

Joel Philip Myers
American, b. 1934

Red Spiral Fish, 1989
Blown, cold-worked, and polished glass
8 × 24½ × 3¾ × 3¾ in.
Renwick Gallery, Washington, D.C., 2000.23
Smithsonian American Art Museum, gift of
the James Renwick Alliance

SEATTLE ART MUSEUM

Seattle, Washington

The Seattle Art Museum is located at the epicenter of West Coast glassmaking: the Seattle/Tacoma area of Washington State. Close to the renowned Pilchuck Glass School, the city of Seattle boasts a large number of leading figures in glass: Dale Chihuly, William Morris, and Ginny Ruffner, to name a few. There is also a thriving gallery community that supports the glass artists and showcases their work. Even with important contemporary glass readily at hand, the Seattle Art Museum is an encyclopedic institution, with collections that range from ancient to contemporary art and with particular strengths in Asian art.

Founded in 1931, the museum opened in 1933 as a consolidation of several arts institutions, some dating back to the 1880s, including the Seattle Fine Arts Society, which was established in 1908, and the Art Institute of Seattle, dating from 1928. The founding directorship and early patronage was supplied by Dr. Richard E. Fuller (1897–1976), who led the museum from 1933 to 1973. A collector of Japanese and Chinese art, he modeled his museum on the Metropolitan Museum of Art in New York. Dr. Fuller, who served as an unpaid director, wanted to make the museum representative of international art from all cultures. In time this purview broadened into an interest in Native American materials as well. Fuller (as well as his colleague Sherman E. Lee)[68] established contacts with the University of Washington that endure to this day, lending depth to the scholarship surrounding the collection.

After the 1930s, the museum collecting was guided by the painter Kenneth Callahan, who purchased works by Morris Graves, Mark Tobey, and Guy Anderson, among others. In the 1970s, after Fuller had retired, several private collectors emerged to express their interest in other collecting areas. Museum councils appeared, with members supporting their particular areas of interest, and Northwest studio glass entered the collection.

The relationship between glass and the museum began during the tenure of Charles Cowles, who served as a curator of modern and contemporary art from 1975 to 1980. He later became the owner of a gallery in New York, where he showed the work of Dale Chihuly and Howard Ben Tré. In 1987, when Jay Gates was director, Patterson Sims,

long an advocate for glass as an art medium, became associate director for art and exhibitions and curator of modern art. The collections, including that of glass, have continued to grow, and by 1990 the museum had developed nine curatorial departments with accompanying expertise.

In a financial arrangement similar to that by which the Los Angeles County Museum of Art operates, the city of Seattle services and maintains the building while the museum is responsible for funding construction and ongoing operations and building the art collections. The original Volunteer Park location is now the Seattle Asian Art Museum and, in conjunction with the soon to open Olympic Sculpture Park, the downtown site (designed by Robert Venturi) houses the rest of the collection. With its expanding collections and various locations, the museum, as expressed in its mission statement, strives to display art that "is a reflection of the human experience in all its forms."

Two donations in 1978 generated important links with sculptural glass: John and Anne Hauberg, who, along with Dale Chihuly and Ruth Tamura, were the co-founders of the Pilchuck Glass School, donated a collection of paintings and Mark Tobey's personal art collection. At the same time, a generous gift from Katherine C. White and the Boeing Company brought the African art collection up to par with the extensive Asian collections.[69]

During the annual Glass Art Society conference in 2003, an exhibition of glass by Preston Singletary, an Alaskan Tlingit artist, was mounted. Anna Skibska and Dale Chihuly have also been included in displays. Tara Reddy Young, the assistant curator of modern and contemporary art, who herself is trained in painting and sculpture, chooses works for the collection on artistic merit and not by material alone; works that have been added to the collection all meet that standard.[70] As sculptural glass continues to excel as an artistic medium, gifts from such donors as Jon and Mary Shirley and Jack and Becky Benaroya (of both artworks and the resources to support glass) have meant that the Seattle Art Museum will increasingly expand its holdings and refine its collections.

Preston Singletary
Tlingit (Native American), b. 1963

Keet Shagoon (Killer Whale), 2003
Fused and sand-carved glass
72 × 92 × ⅜ in.
Seattle Art Museum, 2003.12
Purchased in honor of John H. Hauberg with funds from the
Mark Tobey Estate Fund, John and Joyce Price, the Native
American Art Support Fund, Don W. Axworthy, Susan and
Jeffrey Brotman, Marshall Hatch, C. Calvert Knudsen, Christine
and Assen Nicolov, Charles and Gayle Pancerzewski, Sam and
Gladys Rubinstein, SAM Docents, SAM Supporters, Frederick
and Susan Titcomb, and Bagley and Virginia Wright

This monumental screen, made of fused and carved glass and
created in honor of John Hauberg, has affinities with historical
carved and painted house screens used by Native American
chieftains.

Richard Marquis
American, b. 1945

Blizzard's Suspense, 1995
Glass
26¾ × 25½ in.
Seattle Art Museum, 97.52
Purchased with funds from Kate Elliott, the
Northwest Acquisition Fund, and Margaret E.
Fuller Purchase Fund

Christopher Wilmarth
American, 1943–1987

Gnomon's Parade (Over), 1980
Etched glass and steel
94 × 44 × 38 in.
Seattle Art Museum, 98.39
Gift of Mr. and Mrs. Barney A. Ebsworth

Speed Art Museum

Louisville, Kentucky

The Speed Art Museum was founded in 1925 by Hattie Bishop Speed as a memorial to her husband, James Breckinridge Speed, a successful businessman and philanthropist.[71] Kentucky's first museum, it now holds works from antiquity and has distinguished holdings in seventeenth-century Dutch and Flemish and eighteenth- and nineteenth-century French painting, including Rembrandt van Rijn's *Portrait of a Woman* (1634), Jacob van Ruisdael's *Landscape with Cottages and a Blasted Tree* (1653), and Paul Cézanne's *Two Apples on a Table* (ca. 1895–1900). The museum also collects African and Native American material. The significant contemporary collection of 153 works donated by Sheila M. and Paul W. Chellgren underscores the interest in international contemporary art and joins a partial and promised gift of contemporary sculptural glass from Adele and Leonard Leight. The Speed's collection is rounded out by a selection of fine work by regional artists. All of these ensure that the museum fulfills its mission to "discover the joy and power of art."[72]

Located next to the Belknap campus of the University of Louisville, the original museum was designed in the Renaissance Revival–style by the architect Arthur Loomis. The growth of the collections and needs of the visiting public have spurred several expansions: the Preston Pope Satterwhite addition came in 1954, the North addition in 1973, and the South addition in 1993. An impressive renovation was undertaken in 1996 under the directorship of Peter Morrin, with a fourteen-million-dollar expansion that added state-of-the-art lighting, the Tapestry Gallery, and a new decorative arts gallery. Further enhancements were made to the infrastructure, including improved parking and a five-level operations and storage facility. Also in 1996 the museum received further largesse from the Speed family in the form of a fifty-million-dollar bequest from Alice Speed Stoll, a granddaughter of James Breckinridge Speed.

The Speed's connection to glass began in 1971 when it received a gift of twenty fine art moderne pieces by the French painter and glassmaker Maurice Marinot (1882–1960). These were soon joined by the work of contemporary sculptors such as William Morris, Harvey K. Littleton, Mark Peiser, and Concetta Mason. In 1992, Adele and Leonard Leight made donations from their collection of glass and, to date, have given more than 150 pieces. One of four contemporary glass exhibitions organized in 2003 around the annual running of the Kentucky Derby, *The Light Within: Glass Sculpture from Louisville Collections,* on display from April 15 to June 29, 2003, included fifty examples of contemporary sculpture from the Leight collection.[73] Scott Erbes, the curator of decorative arts, notes that, given the "size and resources, the museum would never have been able to acquire such a significant collection without such dedicated and knowledgeable collectors."[74] The Leight Collection is often presented side by side with masterpieces in other media (see pp. 184–85). Such presentations, which Erbes aptly terms "insertions," illustrate the point that sculptural glass is the equal of art in all media.

Exterior of the Speed Art Museum, Louisville, Kentucky, ca. 2000

Anna Dickinson
British, b. 1961

Vase, 2001
Glass, copper, and gold
4½ × 5½ in.
Speed Art Museum, Louisville, Ky.
Partial and promised gift, Adele and Leonard Leight Collection

Anna Dickinson's *Vase* is a petite vessel that packs a totemic sensibility into its meticulously detailed form. The skillfully controlled proportions and surface conjure notions of melded pre- and post-industrial worlds.

Installation view, Speed Art Museum, Louisville, Kentucky, June 2000–October 2001. Among the works on view: Adélaïde Labille-Guiard (French, 1749–1803), *Portrait of Madame Adélaïde de France,* ca. 1787; Stanislav Libenský (Czech, 1921–2002) and Jaroslava Brychtová (Czech, b. 1924), *Queen II,* 1992; Clifford Rainey (Irish, b. 1948), *The Boyhood Deeds of Cu Chulaind II,* 1986
(For additional details and credits, see p. 223)

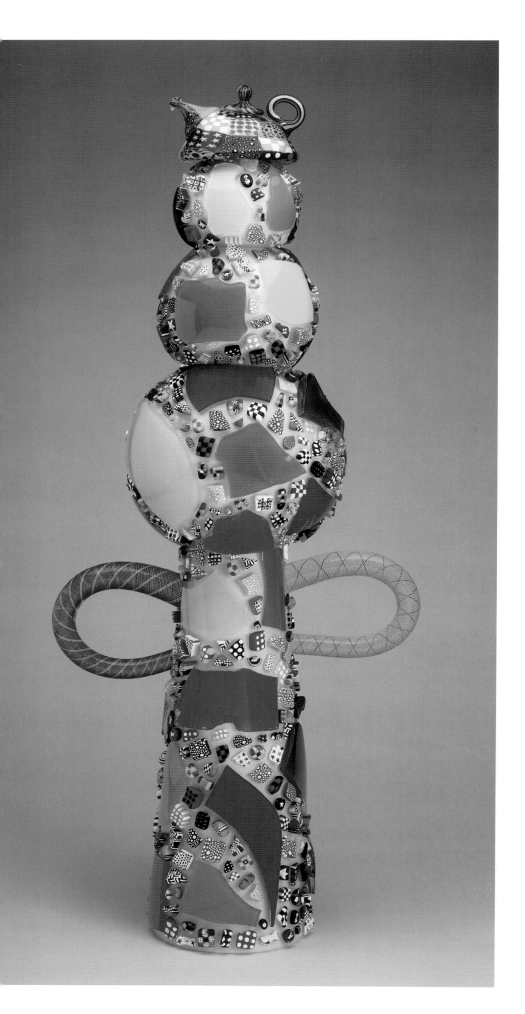

Richard Marquis
American, b. 1945

d'Marquis Bubbleboy #2, 1998
Blown glass, glass shards, and *murrine*
29½ × 12 × 7 in.
Speed Museum, Louisville, Ky., 1999.16.8
Partial and promised gift, Adele and Leonard Leight Collection

Marquis moved his decorative technique into a content-driven application, which includes both mirror and *murrine,* arrayed over a tall spare form.

Erwin Eisch
Germany, b. 1927

Self-Portrait, 1997
Mold-blown glass enameled and painted
21 × 8 × 10 in.
Speed Art Museum, Louisville, Ky., 1998.22.3
Partial and promised gift, Adele and Leonard Leight Collection

Eisch's *Self-Portrait* reveals his painting and sculpture back-ground. For him, the figurative, expressive, and colorful are life-affirming attributes of art. His aesthetic partakes of sculpture concerns that are executed in glass. Indeed, he is not seduced by the beauty of glass, but instead chose to obscure it by painting over its shiny surface.

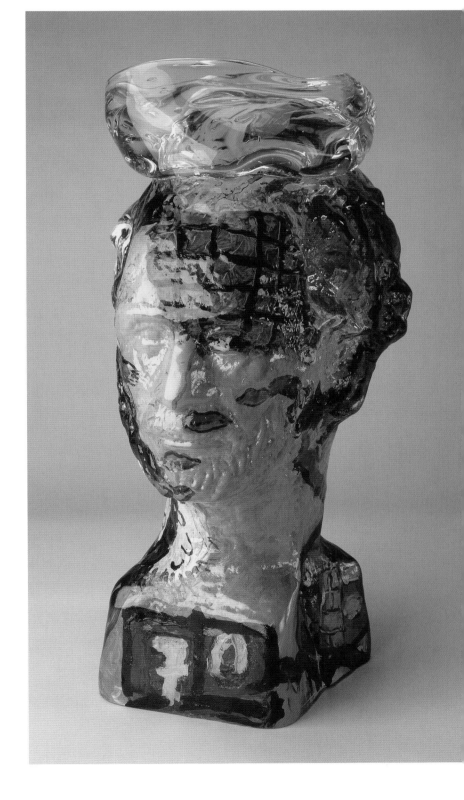

Tacoma Art Museum

Tacoma, Washington

Calling itself "a model for the Nation," the Tacoma Art Museum "strives to be a cultural center and a dynamic museum, building community through art."[75] True to its mission of "connecting people through art . . . it serves the diverse communities of the Northwest through its collections, exhibitions, and learning programs, emphasizing art and artists from the Northwest."[76]

The Tacoma Art Museum began in 1935 as a women's volunteer organization called the Tacoma Art Association; in 1946 the name was changed to the Tacoma Art League as the organization strove to become more professional. During the early decades, the museum, headed by women, mounted between four and six exhibitions each year. Even as the field of museum studies emerged from art history and became an established discipline for museum professionals, the museum continued to be run predominantly by volunteering women until the 1970s. These origins have established a valuable legacy of community support that continues today.

Over the years, the museum had several homes, including a city jail, a storefront next to a Bible outlet, a liquor store, and a former bank. The bank served until 2003, when the museum relocated to its new building adjacent to the old Union Station (which now houses a history museum) and to the Museum of Glass and International Contemporary Art Museum on a waterfront pier in Tacoma. Linked by the famous *Chihuly Bridge of Glass* designed by Dale Chihuly, this inviting complex offers a compelling center for sculptural glass, Northwest history, and Chihuly's work.

One manifestation of the museum's dynamic support for regional art is its association with the Northwest Biennial, which features artworks from Washington, Oregon, Idaho, and Montana. Another, which accords with its regional mission, is its collection of works by Dale Chihuly, a native son and an internationally known glass artist, who has found inspiration in the regional Native American art. The collection, dating back to an exhibit of his work in 1968, chronicles Chihuly's major periods throughout a prolific career. The major holdings of the museum consist of three main historical collections: the Carolyn Schneider Collection of works on paper by midcentury American artists, the Constance R. Lyon Collection of Japanese prints from the Edo period (1615–1868), and the Lindberg Collection of nineteenth- and twentieth-century European works. Other collections in the museum include art made in all media, as well as historical artifacts that illuminate the history of the Northwest. Early collections included art of the Northwest and works from the realist-linked Ashcan school of American painters.

Most important for sculptural glass is the fact that Tacoma is the birthplace of Dale Chihuly. As one of the second-generation leaders of the field of glass art, Chihuly has given sculptural glass a public face and stature that has compelled the inclusion of glass in major museum collections. In keeping with the museum's mission to feature artists from the Northwest and to honor his achievement, an installation of Chihuly's sculptural works, which is on permanent display on the first floor, gives a comprehensive overview of his work and of the development of glass from a vessel-dominated medium to a content-driven art. The remaining upper floors offer historical exhibitions that relate to local or Northwestern themes.

Recent exhibitions of sculptural glass include *Clearly Brilliant: A Decade of Pilchuck Glass School's Emerging Artists in Residence* (2000–2001), documenting the new talent coming out of the nearby Pilchuck Glass School, and *Dale Chihuly: Mille Fiori* (2003–2004). The *Bridge of Glass* connects the various waterfront art venues and displays a single wall of work by Chihuly in stacked, egg-crate-shaped cubicles, reminiscent of the Chinese display shelves of previous eras. The crest of the bridge is punctuated with four blue glass forms that look like cracked ice or delicious rock candies suitable for any passing giant in need of a sugar hit.

Exterior of the Tacoma Art Museum, Tacoma, Washington;
designed by Antoine Predock in 2003

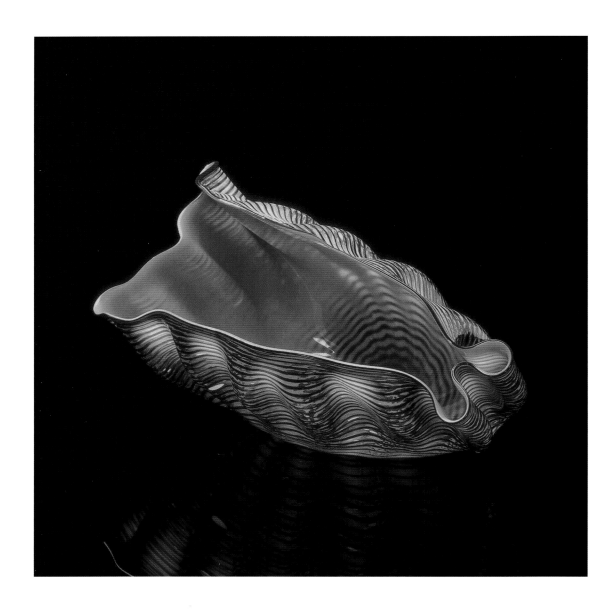

Dale Chihuly
American, b. 1941

*Cobalt Violet Macchia with Cobalt
Lip Wrap,* 1984
Blown glass
7 × 18 × 8 in.
Tacoma Art Museum, Tacoma, Wash., 1990.10
Gift of the artist in honor of his parents,
Viola and George, and his brother George W.
Chihuly

Interior installation view,
Tacoma Art Museum, 2003

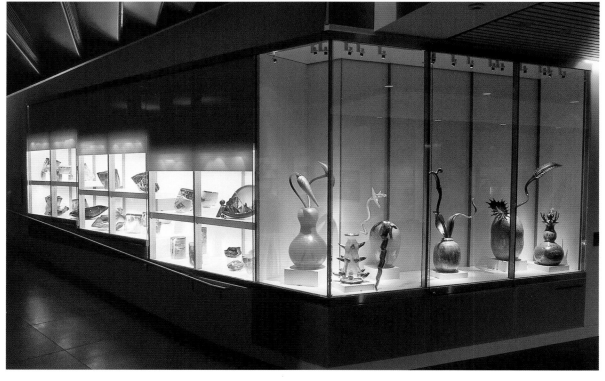

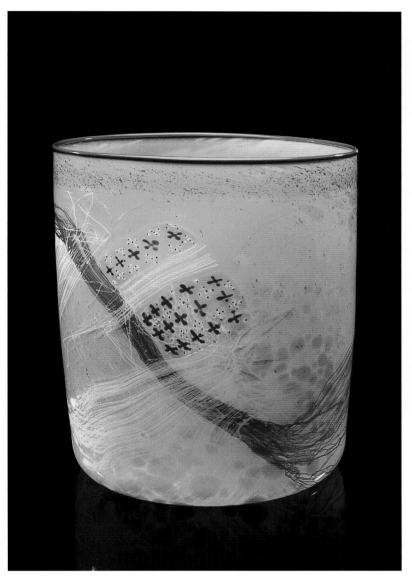

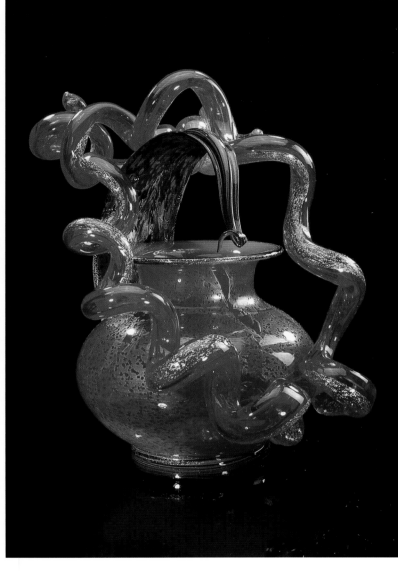

Dale Chihuly
American, b. 1941

Peach Cylinder with Flesh Drawing, 1985
Blown glass
11½ × 10 × 10 in.
Tacoma Art Museum, Tacoma, Wash., 1990.10.8
Gift of the artist in honor of his parents, Viola and George,
and his brother George W. Chihuly

Dale Chihuly
American, b. 1941

Cadmium Red Venetian with Green Leaf, 1991
Blown glass
21 × 22 × 17 in.
Tacoma Art Museum, Tacoma, Wash., 1991.12
Museum purchase

Rendering of the exterior of the new Tampa Museum of Art,
Tampa, Florida, designed by Rafael Viñoly

TAMPA MUSEUM OF ART
Tampa, Florida

The Tampa Museum of Art, founded in 1979, is housed in a sleek and elegant white limestone building erected in 1979 and renovated in 1986. As befits its location in a near-tropical climate, the museum is adjacent to a large reflecting pool, and its contemporary design is appropriate for one of the youngest museums profiled here. The museum focuses on several diverse areas of collecting: Greek and Roman antiquities (assembled by Joseph Veach Noble), modern and contemporary art, and decorative arts. Unusually for a museum, the overall emphasis is on sculptural work, and the collection includes three-dimensional artworks by Jacques Lipchitz, Hiram Powers, and Charlotte Dunwiddie. In the late 1970s, the estate of the academic sculptor C. Paul Jennewein (1890–1978) donated 2,150 of his sculptural works and, interestingly, a one-third-scale, painted maquette of the pediment of the Philadelphia Museum of Art. The museum later developed a large collection of works on paper and important photographs (including a piece by the controversial artist, Robert Mapplethorpe), as well as twentieth-century works by Robert Motherwell, James Rosenquist, and Frank Stella, among others.

In recent years, the museum has become noted for its sculptural glass collection, a development of its collection of decorative arts, which includes European and American porcelains, with pieces designed and made by the Manufacture nationale de Sèvres in France and by Edward Marshall Boehm, of Boehm, New Jersey. The glass holdings include works by Louis Comfort Tiffany, Emile Gallé, the Cristalleries de Nancy (Daum), and contemporary sculptural glass. Active support for contemporary glass artists was seen in the exhibition *Clearly Inspired: Contemporary Glass and Its Origins,* mounted in conjunction with the Glass Art Society's twenty-ninth annual conference in 1999. The exhibition was accompanied by a catalogue with essays by Karen Chambers and Tina Oldknow, who offered new insights into the compelling history of glass as a medium for artistic expression. Further commitment to sculptural glass is seen in the installation of Toots Zynsky's dark street (see p. 199) in the Terrace Gallery. Sculptural glass fits comfortably with the other sculptural works and fulfills the museum's collecting goals.

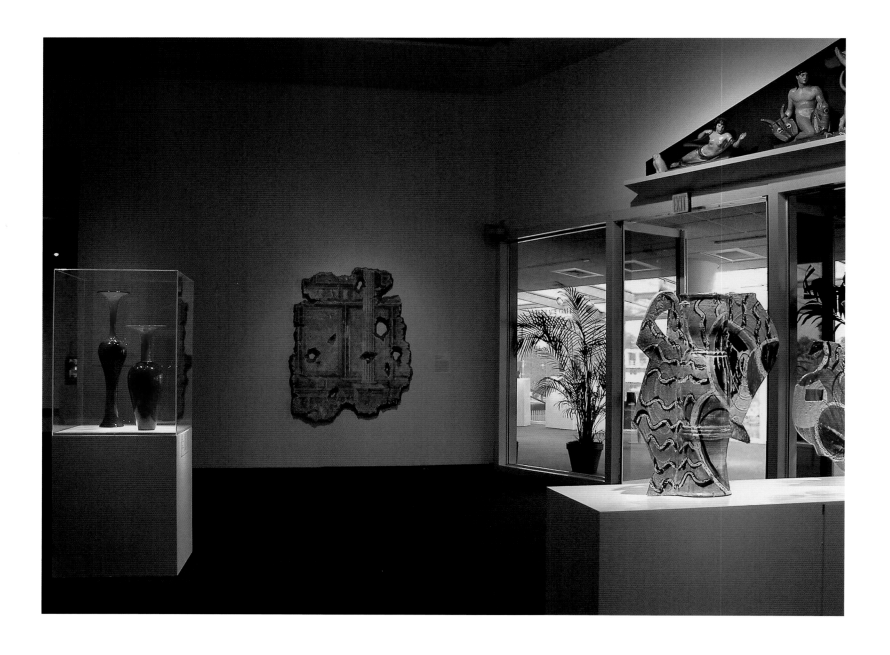

Installation photographs of sculptural glass,
Tampa Museum of Art, Tampa, Florida

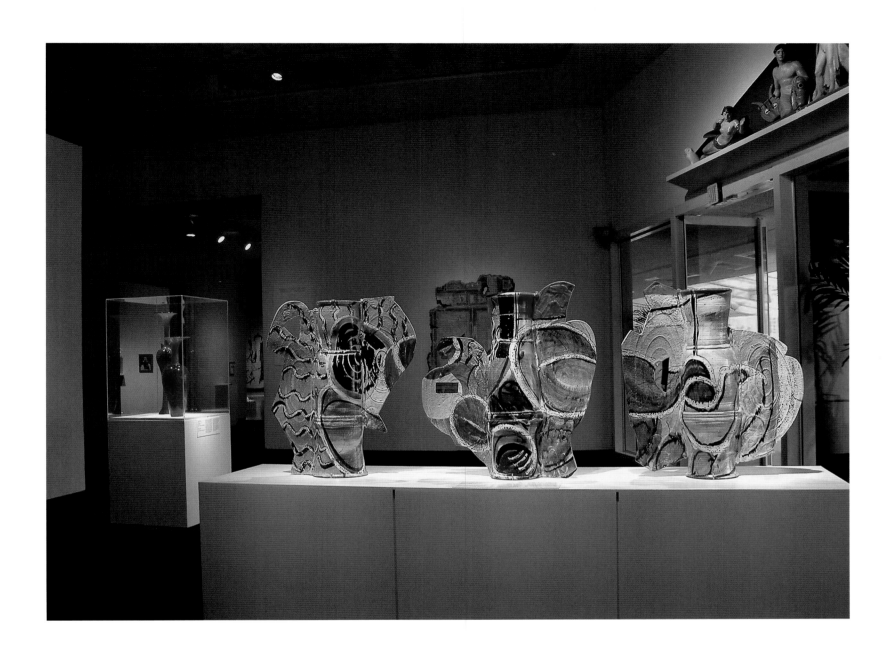

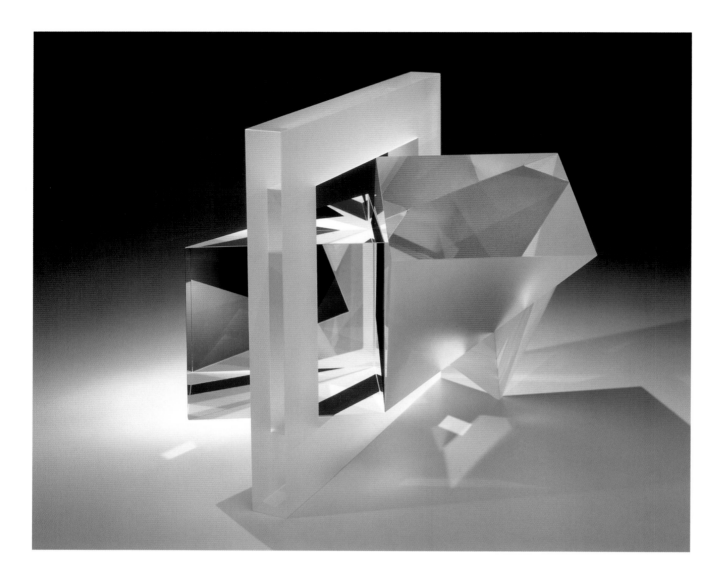

Michael Pavlik
Czech, b. 1941

Gate to Blue Illusion, 1995
Cut, polished, and laminated glass
12½ × 16 × 12 in.
Tampa Museum of Art, Tampa, Fla.
Promised gift of Dr. Richard and Ms. Barbara Basch

Livio Seguso
Italian, b. 1930

Incontro Astrale, 1999
Blown, cut, polished, and cold-worked glass
23½ × 12 × 12 in.
Tampa Museum of Art, Tampa, Fla.
Promised gift of Dr. Richard and Ms. Barbara Basch

Daniel Clayman
American, b. 1957

Untitled, 1995–1996
Cast glass and bronze
18 × 13 × 2 in.
Tampa Museum of Art, Tampa, Fla.
Gift of Dr. Richard and Ms. Barbara Basch

Mary Ann "Toots" Zynsky
American, b. 1951

Night Street Chaos, from the *Chaos* series, 1998
Fused and thermoformed glass threads
Approx. 12 × 9 × 5 in.
Tampa Museum of Art, Tampa, Fla., 1999.003
Gift of Dale and Doug Anderson

Jon Kuhn
American, b. 1949

Rainbow Bloom, 1992
Glass
Tampa Museum of Art, Tampa, Fla., 2001.036
Gift of Jan Gordon, Ken Dickson, Michael Dickson,
Robert Dickson, Harvey Gortner, and Terri Kenefsky
in memory of Will and Bettie Gortner

Therman Statom
American, b. 1953

Cinco Fortunadas (Five fortunes), 2001
Glass and mixed media
Approx. 40 × 20 × 25 in.
Tampa Museum of Art, Tampa, Fla., 2002.017
Gift of the artist

Toledo Museum of Art
Toledo, Ohio

Although still rooted in its tradition of collecting the finest paintings and sculpture by established artists, the Toledo Museum of Art has become an active collector of sculptural glass, taking the advice of Davira Taragin, a former curator of glass at the museum: "Go for the masters of the movement . . . the mediocre works will not survive."[77] Founded in the Glass City with a mission to ignite the "imagination, stimulate thought, and provide enjoyment,"[78] the Toledo Museum of Art boasts an important and broad international collection, with especially fine glass art and artifacts from ancient to contemporary times.

This focus on glass is fitting, for the city of Toledo's story began with glass. In 1886 Edward Drummond Libbey brought his New England Glass Company from Massachusetts to Toledo, where it flourished as the Libbey Glass Company. The institution was later founded with a gift of land and money from Libbey and his wife Florence Scott Libbey in 1901, with the hope that the museum would one day hold an inspirational collection of the visual arts. This hope has been fulfilled: the current museum now contains works by Rembrandt van Rijn, Hans Holbein the Younger, Jusepe de Ribera, Edouard Manet, John Constable, El Greco (Domenikos Theotokopoulos), J.M.W. Turner, Winslow Homer, George Bellows, Childe Hassam, and a version of the famous staple of art history survey courses, Jacques-Louis David's *The Oath of the Horatii* (1786), purchased with funds from the Libbey Endowment. The sculpture collection includes works by Louise Nevelson, Augustus Saint-Gaudens, Constantin Brancusi, and Aristide Maillol.

Although the museum matured into a fine general art museum of international fame, its first significant collections were of production glass.[79] To this day, one of its most popular and revered works is the *Libbey Glass Punch Bowl and Stand* (1903–1904), which is usually displayed with its twenty-three surviving cups. Claimed to be the largest cut-glass object ever made, it was produced for the Louisiana Purchase Centennial Exposition in St. Louis, to display the high level of skill among the craftsmen in the Libbey factory. Unlike later works added to the collection, the punch bowl was not envisioned as a traditional sculpture, but as an opulent, utility-referent tour de force.

With its strong regional roots in the manufacturing of production glass, the museum's prominent position in all types of glass is understandable and was enhanced by its early encouragement of American sculptural glass. In 1962, the museum bestowed vital recognition and support when the director Otto Wittmann provided the location (a garage on the museum grounds) and the cultural imprimatur of the museum for the seminal Toledo Workshops. It was these workshops that proved that sculptural glass could be made outside the factory.[80] This recognition was followed by the dedication, in 1972, of the Boeschenstein Art-in-Glass Gallery, and by the Bigger Glass Study Room in 1976. It is significant for the wider acceptance of glass that the words *glass* and *art* were linked prominently in a first-tier museum as early as 1970. The museum continues its leadership today with an active collecting policy and its links to the University of Toledo, Center for Visual Arts, which maintains an art school that augments its teaching with the study of the museum's masterpieces.

Commissions, too, have been used to augment the collections: in 1995 Therman Statom was asked to create a "sculptural canvas of glass" for the entrance of the museum's School of Art and Design, as part of the Art to Art program. The piece references works found in the museum's collection, evoking "memory [and] occupying that ambiguous area between the viewer's dreams and [his] own work."[81]

The purchasing of artworks for the collections is a key aspect of the museum's activities. With a businessman's clear eye, Edward Libbey wisely directed that half of the income from his endowment be reserved for art acquisitions, with the result that there is a substantial fund available for the purchase of art. Acquisition funds, which, as noted in the introductory essay, are rare among collecting institutions, are invaluable for permitting curators to use their expertise in bringing high-quality works into the collection and to the public's attention.

Donations, also, have enriched the collections. In the late 1980s, the growing collection of contemporary glass was transformed through a happy confluence between the glass heritage of the museum and the enthusiasm for clay, glass, wood, and metal that the California-

Exterior of the Toledo Museum of Art,
Toledo, Ohio

based collectors George and Dorothy Saxe felt. In 1988, at the urging of Paul J. Smith, a former director of the American Craft Museum (now the Museum of Arts and Design), Roger Mandle, the director of the Toledo museum, contacted the Saxes about the possibility of a donation of their renowned collection. The arrangement was concluded by the new director, Roger Steadman, who was previously the director of the Chrysler Museum of Art in Norfolk, Virginia (see p. 36).[82] The donation marked the meeting of activist-collector with activist-director and curator, successfully completing the circle begun earlier by Otto Wittmann.

The collecting policy of the museum, in line with patterns evident in other encyclopedic museums, is to focus on established, not emerging, artists. Happily, the selections from the Saxe Collection continued that policy, consisting of works by leaders in the field who were "trained in the 1960s and 1970s and were doing their mature work by the 1980s."[83] In response to this important donation and to the recommitment to glass, the museum published a catalogue documenting the Saxe collection. The transfer of sixty-three glass objects (and many other pieces in other craft media) from the Saxes to the museum in 1990 made the Toledo collection, because of its strong historical glass holdings, second only to that of the Corning Museum of Glass in its importance to the studio glass community. Indeed, the acceptance of the Saxe donation signaled institutional validation for sculptural glass and positioned the Toledo Museum of Art in the vanguard of contemporary glass collecting.

An equally bold affirmation of the importance of glass is seen in the museum's desire to present "the interrelationship of all the arts,"

a desire that is reflected in its display policy: the chronological grouping of the so-called minor arts side by side with the high arts, which effectively ensures that many galleries are jointly curated. This policy encourages the even-handed treatment of all art media and underscores the acceptance of sculptural glass as art.

Acquisitions and exhibitions continue the commitment to glass. In 1995, William and Maxine Block began donating works to the Toledo Museum of Art and to the Carnegie Museum of Art. By 2003, Toledo had received twenty works. The two museums celebrated the gift in a joint exhibition *Contemporary Directions: Glass from the Maxine and William Block Collection* (2003–2004), with an accompanying catalogue.[84] Other objects made of glass, including Howard Ben Tré's *Bearing Figure with Amphora* (1995) and Bert Frijns's *Bowl on Stone* (1999), have been accessioned through the contemporary art department. These join (among others) the Saxes' gift of Dana Zámečníková's *Theater* (1983) and Dale and Doug Anderson's donation of *Still-Life with Pear* (1992–1994) by Flora Mace and Joey Kirkpatrick.

The present director, Don Bacigalupa, is overseeing the construction of a new twenty-five-million-dollar Glass Pavilion (designed by SANAA Ltd., an architectural firm based in Tokyo) that will be located on the museum's thirty-two-acre campus and is scheduled to open in 2006. Constructed out of glass, the one-story pavilion adds 57,600 square feet of museum space, with 12,500 devoted to exhibitions; it will house the re-installed historical and contemporary glass galleries. Jutta-Annette Page, a well-regarded scholar of European and American glass, will manage the glass and decorative arts collections as they move into the next phase.

203

Rendering of the Glass Pavilion, Toledo Museum of Art, Toledo, Ohio

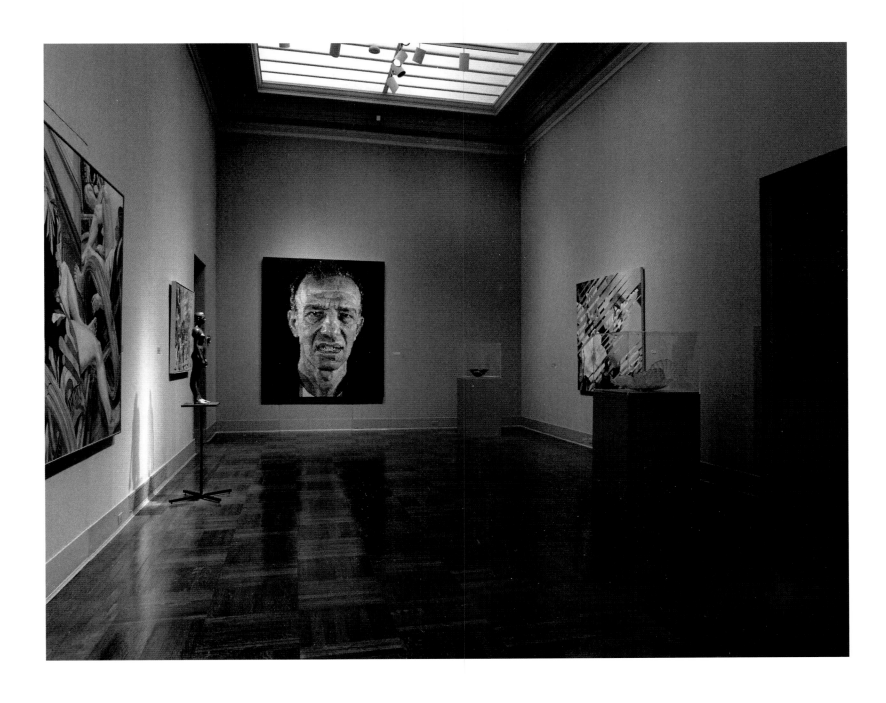

Gallery view, after the renovation in 1990, Toledo Museum
of Art, Toledo, Ohio

Bert Frijns
Dutch, b. 1953

Bowl on Stone, 1999
Glass and stone
Bowl: 43⅛ in. in diameter; stone: 28¾ × 28¾ × ¾ in.
Toledo Museum of Art, Toledo, Ohio, 2000.38
Purchased with funds given by Byron and Dorothy Gerson,
John D. Nichols, the estate of Norma M. Sakel, Harold and
Arlene Schnitzer in honor of George and Dorothy Saxe, Jean
Sosin, and the estate of Martha Zimmerman

Executed in uncolored glass and placed on a rectangular sheet
of stone, the minimalist work incorporates elusive water as a
third art material, articulating the glass container and the meet-
ing point of the transparent glass and the hard, dark stone. The
piece stimulates contemplation and evokes serenity.

Howard Ben Tré
American, b. 1949

Bearing Figure with Amphora, 1995
Granite and glass
84 × 36 × 18 in.
Toledo Museum of Art, Toledo, Ohio, 2003.57
Gift of Georgia and David K. Welles

Howard Ben Tré's *Bearing Figure with Amphora* is a totemic
work that stands in the museum's sculpture garden. Based
symbolically on a container for grain, the work glows with a
seedlike internal structure. A half-hidden and half-revealed
golden orb signifies the human spark and represents the
knowable and unknowable soul within us all.

Dana Zámečníková
Czech, b. 1945

Theater, 1983
Sheet glass, wire, lead, and paint
18¹⁄₁₆ × 26³⁄₈ × 4 in.
Toledo Museum of Art, Toledo, Ohio, 1991.140
Gift of Dorothy and George Saxe

A painterly, fluid work, *Theater* is embellished to communi-
cate the artist's expanded meanings and offers visual delights
through skillful manipulation of light and dark on layers of
glass. With figures in various stages of dematerialization,
depicted alternately with scratchy outlines and dense pas-
sages of color, Zámečníková can tell incongruous stories,
compressed with an exuberant confusion of symbols.

Janell William, a member of the museum's staff, in the Contemporary
American Gallery, Toledo Museum of Art, about 1968; shown (left) *Blue
Dr. Zharchov* by Joel Philip Myers and (right) *Column III* by Harvey K. Littleton

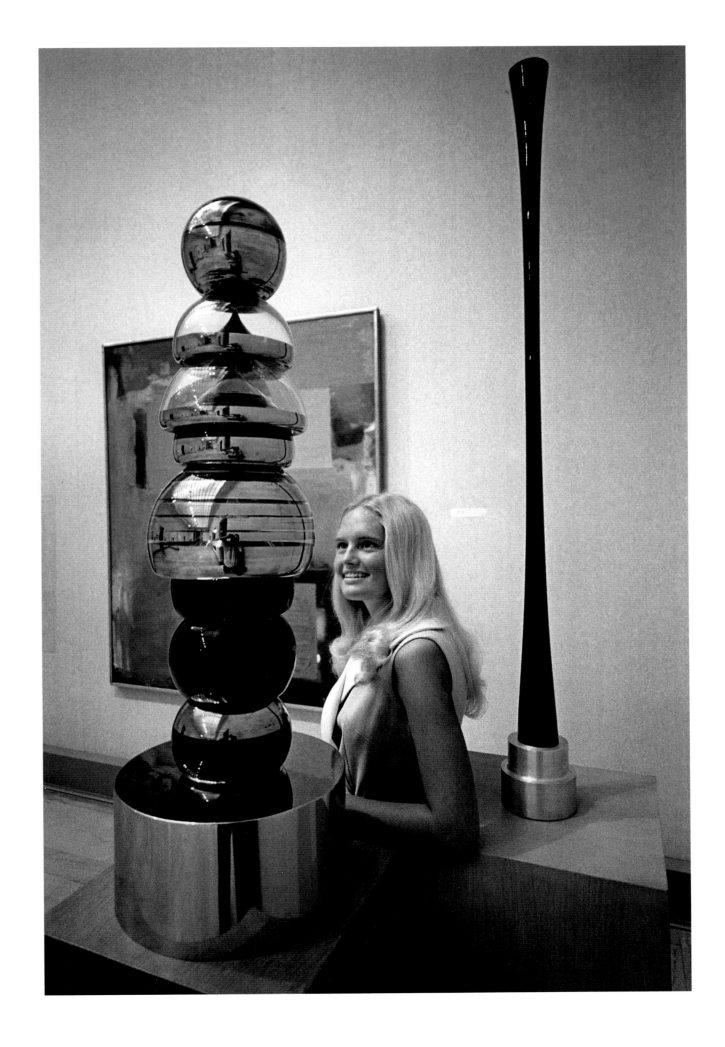

Flora C. Mace and Joey Kirkpatrick
American, b. 1949 and 1952, respectively

Still-Life with Pear, 1994
Blown glass with alder wood
28 × 45 in.
Toledo Museum of Art, Toledo, Ohio, 1996.28 a–d
Gift of Dale and Doug Anderson in honor of Dorothy
and George Saxe

With these handsomely fashioned fruits and vegetables
set on a glass plate, the artists explore the traditional
still-life format. Its potential for saturated color makes
glass well suited to communicating beauty and succulence.

Mary Ann "Toots" Zynsky
American, b. 1951

Untitled (from the *Tierra Del Fuego* series), 1988
Glass threads, fused and kiln-formed
6⅝ × 10¾ × 10 in.
Toledo Museum of Art, Toledo, Ohio, 1991.141
Gift of Dorothy and George Saxe

Zynsky celebrates the exuberance of color in the form of her
brilliantly hued fused-glass vessels. Her work provides a structure
for explorations of painterly displays of color in which swaths of
color are juxtaposed in intense passages that vibrate. In this piece,
all of the heat implied in the series title is successfully expressed
through the colors used.

Notes

1. From the museum's web site: http://www.Chrysler.org/general.html (accessed January 5, 2004).

2. China painting is painting on ceramic bisque forms (usually vessel-shaped) that were then glazed and fired. The forms were thrown by men; the decorations painted by women. The activity, unlike the more rigorous painting on canvas, was considered suitable for young ladies who had artistic aspirations.

3. From the museum's web site: www.clevelandart.org/museum/collect/mission.html (accessed November 20, 2003).

4. Corning Museum of Glass, *Annual Report* (Corning, N.Y.: Corning Museum of Glass, 1976), 6; this was the first annual report published by the museum. Ninety-two contemporary glass artworks were reported to have been acquired in 1976.

5. Tina Oldknow, e-mail to author, April 2004.

6. *The Gather* (Corning Museum of Glass, Corning, N.Y.) (winter–spring 2004): 2.

7. Oldknow, e-mail to author, April 2004.

8. Ibid.

9. William H. Peck, *The Detroit Institute of Arts: A Brief History* (Detroit: Founders Society, Detroit Institute of Arts, 1991), 31.

10. The floor plan was considered sufficiently radical to merit publication in the *Encyclopedia Britannica* of 1929; ibid., 61.

11. While he was curator of decorative arts at the Metropolitan Museum of Art, Valentiner experimented with this new approach when he installed the Pierpont Morgan Wing; ibid., 65.

12. Jason Edward Kaufman, "Curators in Disarray as Departments Are Merged," *The Art Newspaper,* no. 144 (February 2004): 17; and "Editorial and Commentary," *The Art Newspaper,* no. 146 (April 2004): 29.

13. Peck, *Detroit Institute of Arts,* 103–104.

14. Maurice D. Parrish, Foreword, in Bonita Fike, ed., *A Passion for Glass: The Aviva and Jack A. Robinson Studio Glass Collection,* exh. cat. (Detroit: Detroit Institute of Arts, 1998), 6.

15. Rebecca R. Hart, letter to author, August 12, 2004.

16. Harry S. Parker III, Foreword, in *The Art of Craft: Contemporary Works from the Saxe Collection,* exh. cat. (San Francisco: Fine Arts Museums of San Francisco; and Boston: Bulfinch Press, 1999), 7.

17. Tim Burgard, e-mail to author, April 19, 2004.

18. Ibid.

19. High Museum of Art, *Selected Works: Outstanding Painting, Sculptural, and Decorative Arts from the Permanent Collection,* exh. cat. (Atlanta, Ga.: High Museum of Art, 1987), 9.

20. Martha Drexler Lynn, *Masters of Contemporary Glass: Selections from the Glick Collection,* coll. cat. (Indianapolis: Indianapolis Museum of Art and Indiana University Press, 1997).

21. See *Indianapolis Museum of Art: Collections Handbook* (Indianapolis: Indianapolis Museum of Art, 1988); and *The Story of the Indianapolis Museum of Art* (Indianapolis: Indianapolis Museum of Art, 1998). Additional information came from Lynn's *Masters of Contemporary Glass,* and conversations with Barry Shifman, curator of decorative arts, Indianapolis Museum of Art, 2001–2004.

22. Shifman, conversation with author, April 5, 2004.

23. Ilene Susan Fort and Michael Quick, *American Art: A Catalogue of the Los Angeles County Museum of Art Collection* (Los Angeles: Los Angeles County Museum of Art, 1991).

24. The Natural History Museum moved to an adjacent location near the La Brea Tar Pits, noted for their fossil remains.

25. William Wilson, *The Los Angeles Times Book of California Museums* (New York: Harry N. Abrams, 1984), 136–38.

26. Martha Drexler Lynn, "Clay Leads the Studio Crafts into the Art World," in Davira Taragin, ed., *Contemporary Crafts and the Saxe Collection,* exh. cat. Toledo Museum of Art (New York: Hudson Hills Press, 1993), 90–99; and Lucke Thorensen, conversation with author, 1990, about Thorensen's donation of a glass plate by Glen Lukens (1940) to the Los Angeles County Museum of Art (accession number M.90.49).

27. Howard Hibbard, *The Metropolitan Museum of Art* (London: Harrison House; and New York: Crown, 1986), 10.

28. Ivan Karp, quoted in Reesa Greenberg, Bruce W. Ferguson, and Sandy Nairne, eds., *Thinking About Exhibitions* (London: Routledge, 1996), 259.

29. Thomas S. Buechner, Preface, in *Glass 1959: A Special Exhibition of International Contemporary Glass,* exh. cat. (Corning, N.Y.: Corning Museum of Glass, 1959).

30. Henry Geldzahler, *Making it New: Essays, Interviews, and Talks* (San Diego: Harcourt Brace, 1994), 321.

31. As quoted in Donald Kuspit, *Chihuly* (New York: Harry N. Abrams, 1997), 42.

32. As quoted in Tina Oldknow, *Pilchuck: A Glass School* (Seattle: Pilchuck Glass School in association with University of Washington Press, 1996), 166.

33. Penelope Hunter-Stiebel, "Contemporary Art Glass: An Old Medium Gets a New Look," *ArtNews* 80, no. 6 (June 1981): 130–35.

34. The museum also exhibited the work of Sr. Mary Remy in 1963, E. Dane Purdo in 1965, Richard DeVore in 1983, Robert Turner in 1985, and Peter Voulkos in 1979, and hosted traveling shows, among them, *Fiber R/Evolution* in 1986.

35. Glenn Adamson, e-mail to author, May 14, 2004.

36. The key players in the early years were Mrs. Aileen Osborn Webb, David Campbell, and the first director, Paul J. Smith (1963–1987).

37. Paul Smith, "Remembering the American Craft Museum," *The Studio Potter* 32, no. 1 (December 2003): 3–16.

38. David McFadden, letter to author, June 30, 2004.

39. Mission Statement adopted in 1991.

40. Walter Muir Whitehill, *Museum of Fine Arts, Boston: A Centennial History* (Cambridge, Mass.: Harvard University Press, Belknap Press, 1970).

41. Kelly H. L'Ecuyer, e-mail to author, May 19, 2004.

42. From the museum's web site: http://www.mfa.org/exhibitions/glass.html (accessed December 4, 2003).

43. William C. Agee, *The Museum of Fine Arts, Houston: A Guide to the Collection* (Houston, Tex.: Museum of Fine Arts, 1981), xiii.

44. Peter C. Marzio, *A Permanent Legacy: A History of the Museum of Fine Arts, Houston* (Houston, Tex.: Museum of Fine Arts; and New York: Hudson Hills Press, 1989), 10.

45. Ibid., 10, 37.

46. Jason Edward Kaufman, "Major Latin American Research Project Launched," *The Art Newspaper*, no. 150 (September 2004): 13.

47. Marzio, *Permanent Legacy*, 32.

48. Catherine D. Anspon, "Drawing International Attention," *ArtNews* 103, no. 3 (March 2004): 76.

49. Cindi Strauss, e-mail to author, April 28, 2004.

50. Ibid.

51. See Sybil Gordon Kantor, *Alfred H. Barr, Jr. and the Intellectual Origins of the Museum of Modern Art* (Cambridge, Mass.: MIT Press, 2002).

52. Sam Hunter, *The Museum of Modern Art, New York: The History and the Collection* (Abradale Press/Harry N. Abrams, 1997), 12.

53. "Sculpture in Glass," *Craft Horizons* 25, no. 6 (November / December 1965): 22–23.

54. All quotations are from materials supplied by the National Liberty Museum.

55. Museum reprint of article (title not supplied) by Sally Friedman, *Business and Entertainment Journal* (Princeton University), July 2, 2003.

56. Jennifer Gray, Norton Museum, communication with author, June 2004.

57. Ibid.

58. Mark Rosenthal, correspondence with author, June 2004.

59. John E. Peetz, *Creation: The Oakland Museum, the First Five Years* (Oakland: Oakland Museum of California, n.d. [1970?]).

60. Bruce W. Pepich and Davira Taragin, *Introducing RAM: The Building and Collections* (Racine, Wisc.: Racine Art Museum, 2003), 6.

61. Ibid., 7.

62. Other significant donations have come from Dale and Doug Anderson, Garth Clark and Mark Del Vecchio, Libby and JoAnne Cooper, Robert W. Ebendorf, Dorothy and George Saxe, Carol and Donald Wiiken, Donna Moog, and Jane and Arthur Mason.

63. Glenn Adamson, "Racine Art Museum: A Corner Chapel for the Crafts," *American Crafts* 63, no. 5 (October / November 2003): 52.

64. Ruth T. Summers, "Brillson Collection Donated to Wustum Museum," *Glass Quarterly* 3 (1995): 1–3.

65. Pepich and Taragin, *Introducing RAM*, 33.

66. Kenneth R. Trapp, "Dedicated to Art: Twenty-five Years at the Renwick Gallery," in *Skilled Work: American Craft in the Renwick Gallery*, exh. cat. (Washington, D.C.: National Museum of American Art, the Smithsonian Institution, 1997), 13.

67. Ibid., 17.

68. Dr. Sherman E. Lee, originally the curator of Far Eastern art at the Detroit Museum of Art, served from 1948 to 1952 as assistant curator and associate director. He later became an influential curator at Cleveland Museum of Art.

69. Patterson Sims, *Seattle Art Museum: Selected Works*, exh. cat. (Seattle: Seattle Art Museum, 1991), 8–20.

70. Tara Reddy Young, conversation with author, Seattle, Washington, spring 2001.

71. The J. B. Speed Memorial Museum became the J. B. Speed Art Museum in 1947 and is now the Speed Art Museum.

72. Speed Memorial Museum Mission Statement.

73. The three other venues in Louisville were the Kentucky Art and Craft Gallery, Glassworks, and the Louisville Visual Arts Association.

74. Scott Erbes, correspondence with author, March 24, 2004.

75. From the museum's web site: http://www.Tacomamuseum.org/general_info/about_tam.html (accessed December 2003).

76. Ibid.

77. Brook Mason, "A Real Glass Art," *Art and Antiques* 26, no. 34 (January 2003): 36–37.

78. Guiding Principles of the Toledo Museum of Art as adopted February 25, 2003. Framed, this document hangs in offices around the museum.

79. The first large gift of glass was a donation in 1923 of over a thousand pieces from Thomas E. H. Curtis of Plainfield, New Jersey, that vaulted Toledo's collection into international prominence.

80. See Martha Drexler Lynn, *American Studio Glass 1960–1990: An Interpretive History* (New York: Hudson Hills Press, 2004), for the complete story of Toledo's place in the history of studio glass.

81. *Looking Like a Memory, Therman Statom's "Hydra,"* exh. brochure (Toledo, Ohio: Toledo Museum of Art, 2002). Begun in 1995, the project was installed in 2002.

82. Like the activist directors, the curatorial staff, too, was aggressive. The first curator of glass was David F. Grose, who was followed in 1990 by Davira Taragin as curator of nineteenth- and twentieth-century glass.

83. Davira Taragin, ed., *Contemporary Crafts and the Saxe Collection*, exh. cat. Toledo Museum of Art (New York: Hudson Hills Press, 1993), 7.

84. The exhibition at Toledo was on display from November 21, 2003 to February 15, 2004.

Barker, Emma. Introduction. *Contemporary Cultures of Display.* New Haven: Yale University Press, 1999.

Benezra, Neal. "The Misadventures of Beauty." In *Regarding Beauty: A View of the Late Twentieth Century,* 17–36. Exh. cat. Washington, D.C.: Hirshhorn Museum; and Ostfildern, Germany: Hatje Cantz, 1999.

Crane, Diana. *The Transformation of the Avant-Garde: The New York Art World, 1940–1985.* Chicago: University of Chicago Press, 1987.

Crimp, Douglas. *On the Museum's Ruins.* Cambridge, Mass.: MIT Press, 1993.

Csikszentmihalyi, Mihaly, and Eugene Rochberg-Halton. *The Meaning of Things: Domestic Symbols and the Self.* Cambridge: Cambridge University Press, 1981.

Doss, Erika. *Benton, Pollock, and the Politics of Modernism from Regionalism to Abstract Expressionism.* Chicago: University of Chicago, 1991.

Duncan, Carol. *Civilizing Rituals: Inside the Public Art Museums.* London: Routledge, 1995.

Forty, Adrian. *Objects of Desire: Design and Society, 1750–1980.* London: Thames and Hudson, 1986.

Foster, Hal. *The Anti-Aesthetic: Essays on Post-Modern Culture.* Seattle: Bay Press, 1983.

Guilbaut, Serge. *How New York Stole the Idea of Modern Art: Abstract Expressionism, Freedom, and the Cold War,* translated by Arthur Goldhammer. Chicago: University of Chicago Press, 1983.

Hooper-Greenhill, Eilean. *Museums and the Shaping of Knowledge.* London: Routledge, 1993.

Krauss, Rosalind E. *Passages in Modern Sculpture.* Cambridge, Mass.: MIT Press, 1996.

Lynn, Martha Drexler. *Masters of Contemporary Glass: Selections from the Glick Collection.* Coll. cat. Indianapolis: Indiana Museum of Art and Indiana University Press, 1997.

———. *American Studio Glass 1960–1990: An Interpretive History.* New York: Hudson Hills Press, 2004.

Staniszewski, Mary Anne. *The Power of Display: A History of Exhibition Installations at the Museum of Modern Art.* Cambridge, Mass.: MIT Press, 1998.

© The Art Institute of Chicago, all rights reserved, p. 20 (bottom)

© 2004 Artists Rights Society (ARS), New York/ADAGP, Paris, p. 23 (right)

© 2004 Artists Rights Society (ARS), New York/ADAGP, Paris/Succession Marcel Duchamp, p. 23 (left)

© 2004 Artists Rights Society (ARS), New York/VG Bild-Kunst, Bonn, p. 22

Christopher Barrett © Hedrich Blessing, Chicago, p. 165

Frank J. Borkowski, p. 59

© 2004 Estate of Scott Burton/Artists Rights Society (ARS), New York, p. 14 (left)

Pat Cagney, pp. 38, 41–43

© Dale Chihuly, pp. 113, 190 (top), 191 (left and right)

© Sterling and Francine Clark Art Institute, Williamstown, Mass., p. 18

© The Detroit Institute of Arts, pp. 68–71

M. Lee Fatherree, courtesy of the artist, pp. 86, 160–63

© Corporation of the Fine Arts Museums. The new de Young Museum, Herzog & de Meuron, Primary Designers, Fong & Chan Architects, Principal Architects; rendering by Michael Sechman & Associates, p. 73

John R. Glembin, p. 113

© 2004 David Harpe, p. 183 (bottom)

Kenneth Hayden, pp. 184–87

David Heald © The Solomon R. Guggenheim Foundation, N.Y., p. 26

Erik and Petra Hessmerg, p. 19 (top)

Eva Heyd, pp. 125–29

© David Hockney, p. 14 (right)

© 2004 Estate of Hans Hofmann/Artists Rights Society (ARS), New York, p. 13 (bottom)

Timothy Hursley, pp. 111, 189 (© Timothy Hursley)

© 2004 Joseph Kosuth/Artists Rights Society (ARS), New York, p. 25

Ellen Labenski © The Solomon R. Guggenheim Foundation, N.Y., p. 27

Scott M. Leen, pp. 190 (bottom), 191 (left)

Sherry Levine, courtesy of the artist and Paula Cooper Gallery, New York, p. 100 (left and right)

Hervé Lewardowski, p. 20 (top)

© Donald Lipski, courtesy of Galerie Lelong, New York, pp. 63, 112

Michael LoBiondo, p. 121

© 2004 Los Angeles County Museum of Art, p. 99

Paul Macapia, pp. 180, 181

© Ivan Mares, p. 122

© Richard Marquis, p. 180

Bruce Miller, pp. 174–77

Jamison Miller, p. 12

William Morris, courtesy of the artist, p. 79

© Musée Rodin, Paris, p. 19 (top)

© 2004 Museum Associates/LACMA, pp. 16, 100 (left and right), 101–103

© The Museum of Modern Art/Licensed by SCALA/Art Resource, N.Y., pp. 11, 13 (top), 19 (bottom), 21, 22, 25, 143–47

© The Nelson Gallery Foundation, Nelson-Atkins Museum of Art, Kansas City, Missouri, U.S.A., p. 12

© Norton Museum of Art, p. 154

Tom Patti, courtesy of the artist, p. 146

© 2004 Estate of Pablo Picasso/Artists Rights Society (ARS), New York, pp. 19 (bottom), 21

© 2004 The Pollock-Krasner Foundation/Artists Rights Society (ARS), New York, p. 13 (top)

Réunion des Musées Nationaux/Art Resource, N.Y., p. 20 (top)

Terry Rishel, pp. 190 (top), 191 (right)

Joe Samberg, p. 159

Larry Sanders, p. 117

© Preston Singletary, p. 179

Tate Gallery, London/Art Resource, N.Y., pp. 14 (right), 23 (left)

Tim Thayer, pp. 14 (left), 206–208, 210, 211

The Toledo Blade, 8/20/71, Toledo Museum of Art Archives, p. 209

Michael Tropea, Chicago, pp. 166–69

Rob Vinnedge, pp. 107, 109, 147 (courtesy of the artist)

C. J. Walker, p. 114

Tom Walsh, pp. 47–49

© Estate of Christopher Wilmarth, p. 181

Scott Wolff, pp. 37, 39, 40

© Betty Woodman, courtesy of Max Protetch Gallery, pp. 76–77

Additional Museum Credits

Chrysler Museum of Art. Sol LeWitt, *Eight-Pointed Stars,* 1996, handmade paper, 54 × 54 in., 2002.13. Gene Davis, *Shabazz,* 1965, acrylic on canvas, 117¾ × 86¾ in., 76.79. Harvey K. Littleton, *Lemon/Ruby/Blue Vertical Group,* 1989, glass, 25½ in. high, 93.45. p. 38

Corning Museum of Glass. Stanislav Libenský and Jaroslava Brychtová: *Meteor/Flower/Bird,* 1980, mold-melted glass, 7⁵⁄₁₆ × 7⁷⁄₁₆ ft., 80.3.13, architectural commission for the Corning Museum of Glass; *Red Pyramid,* 1993, mold-melted glass, 33¹⁄₁₆ × 44⅛ in., 94.3.101, gift of the artists; *Contacts,* 1984–1987, mold-melted glass, 47⅝ in. high, 88.3.27, partial gift of Daniel Greenberg and Susan Steinhauser; *Big Arcus/Arcus III,* 1993, mold-melted glass, 41 × 33¹⁵⁄₁₆ × 6⁹⁄₁₆ in., gift of the artists. p. 61

Mint Museum. Stanislav Libenský and Jaroslava Brychtová, *Relations* (2001): installation provided by Lisa S. Anderson, Dudley B. Anderson, Rodgers Builders, Inc., Davis Steel and Iron, and Holiday Inn, Center City. p. 123

Speed Art Museum. Adélaïde Labille-Guiard, *Portrait of Madame Adélaïde de France,* ca. 1787, oil on canvas, 107½ × 73½ in., gift of Mrs. Barry V. Stoll; restored with income from the Marguerite Montgomery Baguie Memorial Trust with additional support from the National Endowment for the Arts. Stanislav Libenský and Jaroslava Brychtová, *Queen II,* 1992, mold-melted glass, partial and promised gift of Adele and Leonard Leight Collection. Clifford Rainey, *The Boyhood Deeds of Cu Chulaind II,* 1986, cast and plate glass, 22 × 8 × 8 in., partial and promised gift, Adele and Leonard Leight Collection. Collection of the Speed Art Museum, Louisville, Ky. pp. 184–85